# Soul of the Heights

"Merely climbing to the tops of high and difficult peaks was no longer enough [for Ed Cooper]. He became fascinated by bringing back to civilization detailed reminiscences of the wonders of the wilderness through the medium of superb photographs. The scores of these photographs with which this book is illustrated prove better than any words that our author is really a gifted photographer. *Soul of the Heights* is a remarkable volume, which should be read and enjoyed by everyone interested in exploration or mountaineering, and it will make a great addition to anyone's library."

—Brad Washburn, mountaineer, photographer, and cartographer

"During the 'Golden Age' of North American mountaineering, when the classic rock walls and technical new routes were being pioneered, Ed Cooper was one of the climbers in the forefront. His daring climbing accomplishments in Canada, the North Cascades, and Yosemite have become legendary. . . . In *Soul of the Heights* Cooper finally reveals to the reader the stories behind his enigmatic affair with the mountains. The narrative fulfills an important segment of climbing history. The photographs are timeless."

—Alex Bertulis, Seattle, climber and adventurer

"Ed Cooper's vision, photographic skill, and knowledge of our scenic resources are unexcelled. *Soul of the Heights* combines the recall of daring and daunting climbing challenges with quintessential images. The result is truly inspirational."

—Fred Beckey, legendary climber

"Ed was one of the original hard climbers in the 1960s, putting up outstanding and difficult first ascents without benefit of sticky rubber, perlon ropes, grigris, or any of the other modern devices today's climbers consider essential. How would *you* like to lead a 5.10 layback in clunky boots and no sit harness? You owe it to yourself to learn about the renaissance of rock climbing in the Pacific Northwest through the words of this self-styled 'original climbing bum.' You'll also have a chance to have a book of Ed Cooper photos; don't miss out."

—Midge Cross, member of 2002 No Boundaries All Women's Everest Expedition

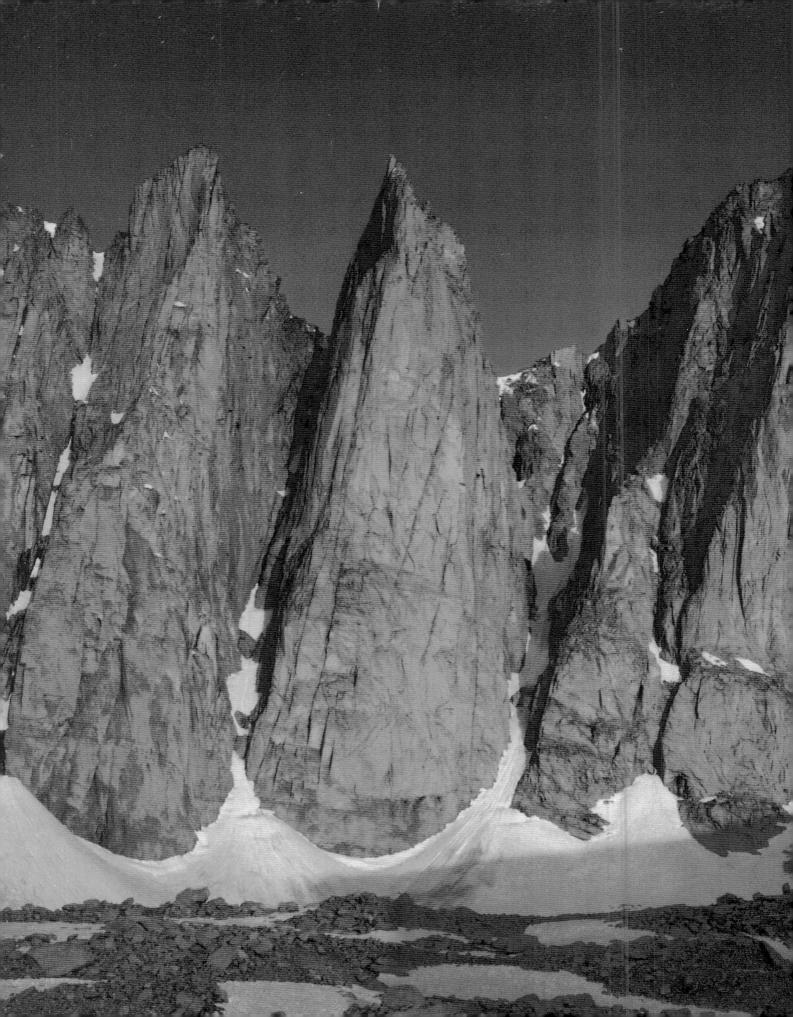

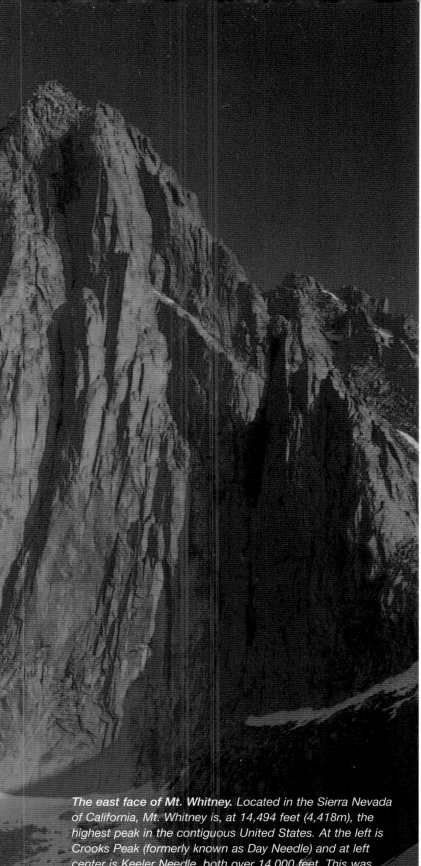

*The east face of Mt. Whitney. Located in the Sierra Nevada of California, Mt. Whitney is, at 14,494 feet (4,418m), the highest peak in the contiguous United States. At the left is Crooks Peak (formerly known as Day Needle) and at left center is Keeler Needle, both over 14,000 feet. This was taken from the upper part of the trailless North Fork of Lone Pine Creek Canyon, where I camped in order to capture the first rays of sunlight on this mighty massif.*

# SOUL

50 YEARS

# OF THE

GOING TO THE MOUNTAINS

# HEIGHTS

ED COOPER

**FALCON**GUIDES ®

GUILFORD, CONNECTICUT
HELENA, MONTANA

AN IMPRINT OF THE GLOBE PEQUOT PRESS

*This book is dedicated to the mountains, a continuing source of inspiration since I discovered them.*

**FALCON**GUIDES®

Copyright © 2007 Ed Cooper

Falcon, FalconGuides, and Chockstone are registered trademarks of Morris Book Publishing, LLC.

Text design by Casey Shain
Spine photo by Ed Cooper
Interior photos by Ed Cooper

Library of Congress Cataloging-in-Publication Data

Cooper, Ed, 1937-
  Soul of the heights : 50 years going to the mountains / Ed
    Cooper.—1st ed.
  p. cm.—(A FalconGuide)
  Includes index.
  ISBN 978-0-7627-4527-2
  1. Mountaineers—United States—Biography. 2. Photographers—United States—Biography. I. Title.
  GV199.92.C66C674 2007b
  796.52'2092—dc22
  [B]

2007004161

Printed in Italy
First Edition/First Printing

To buy books in quantity for corporate use
or incentives, call **(800) 962–0973**
or e-mail **premiums@GlobePequot.com**.

*Glacier Peak and Image Lake, right. Glacier Peak (10,541ft/3,213m) is the most remote of Washington's volcanoes. Here the mountain seems to float above the Suiattle River Valley and Image Lake, in the foreground. This is one of the prettiest mountain portraits in my collection.*

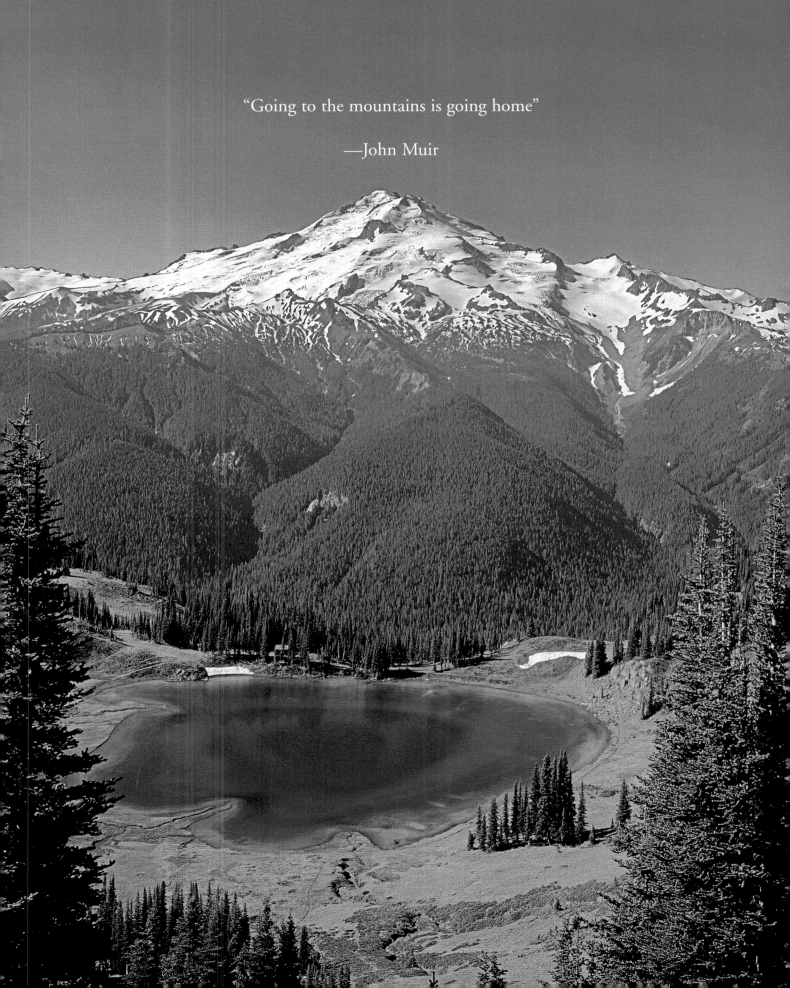

"Going to the mountains is going home"

—John Muir

**Storm clouds over Clements Mountain.** *Glacier lilies provide a colorful foreground to this dramatic view of storm clouds over Clements Mountain (8,760ft/2,670m) in Glacier National Park.*

# CONTENTS

**Rock wall in the Alaska Range.**
*This aerial view taken on the flight to Mt. McKinley is the only photo appearing in this book for which I can't provide identification. The peak is representative of the almost countless lesser peaks in the Alaska Range, many of which still await exploration and first ascents. Were this peak located in the lower forty-eight states, it would no doubt be an important climbing destination.*

# FOREWORD

With *Soul of the Heights—50 years going to the mountains*, Ed Cooper brings together some of the most impressive alpine climbing efforts of the 1950s and 1960s with some of the most remarkable mountain images ever recorded on film. Perhaps most striking is that to both arenas—climbing and photography—Cooper brought a pioneering spirit that moved him to apply innovative techniques and strategies to these disparate pursuits. Along with a bold commitment to the beautiful line came an equally strong desire to record on film the surreal mountain landscapes he visited.

While we were aware of Cooper's contribution to climbing and photography, the two of us became acutely familiar with Cooper's efforts in both respects during our efforts to write *Selected Climbs in the Cascades*, volumes I and II. Time and again when we researched the first ascents for various climbs—Coleman Glacier Headwall, north face of Mt. Terror (North Buttress of Mt. Terror route), Torment-Forbidden Traverse, Snow Creek Wall—the outcome was the same: first ascent by Ed Cooper and partners. The inescapable fact is this: Some of the finest climbs in the Cascades are routes that were pioneered by Ed Cooper and friends more than forty years ago.

Ed Cooper was arguably the best alpine climber in North America in the early 1960s. His selection of routes, and the style in which he climbed them, set him apart from other climbers of the era. His approach to climbing was bold and visionary. For Cooper, climbing meant taking on some of the most challenging peaks in North America, and he did so

in a way that was ahead of his time. Cooper climbed in a bold, direct style that even by today's standards was highly efficient and completely oriented toward success.

That was apparent to us as we gathered over the light table to look at the images Cooper sent to us for inclusion in our Cascade guidebooks. Looking at Cooper's early slides and the carefully made black-and-white prints, we were struck not just by the composition of the images but by the details: the small packs carried by Cooper, Mike Swayne, and others on their weeklong climbing trips into the Pickets and other remote corners of the Cascades. Ed Cooper's achievements forty years ago prove that "fast and light" is not a modern concept, but it is a crucial one for success.

Cooper's climbing expertise extended from the remote alpine world of the North Cascades and British Columbia to the steep granite of Yosemite Valley. Any climber making a first trip to Yosemite Valley can attest to El Capitan's being an intimidating objective. In 1962 the face of El Capitan had seen less than a handful of ascents and was considered the most challenging rock climb in the world. Ed Cooper and Jim Baldwin's climb of El Capitan on their very first trip to the Valley (by a new route no less) ranks as one of the most audacious climbs in Yosemite's climbing history. The route—which they called the Dihedral Wall—remains a classic route to this day, like so many of Cooper's first ascents.

"I started the climb with Jim Baldwin in the spring of 1962," remembered Cooper. "The attempt was halted when Jim had an accident involving prussik knots, and when we resumed the climb in

the autumn, we were joined by Glen Denny. The three of us finished the climb together." The El Capitan climb was technically several degrees of difficulty greater than some of the wild North Cascades climbs, such as the north face of Mt. Terror. But the El Capitan route was in a controlled environment, where it was always possible, albeit with some difficulty, to retreat to safety.

"The Mt. Terror adventure, on the other hand," Cooper continued, "was really laying it all on the line. It was a virtually untrodden area. There were many unknowns and much more opportunity for things to go wrong—all in a location where any rescue would have been problematic. Even today, it's hard to imagine how things might have turned out if bad weather had moved in on us while on the north face of Mt. Terror. Trying to compare an alpine route like Mt. Terror with the El Cap climb is impossible—they are apples and oranges. But I will say that I enjoyed the Mt. Terror ascent the more of the two, though I shudder a little even now when I recall the cavalier attitude with which we undertook the whole adventure."

Many of us have shared Ed's passion for climbing and the lonely beauty of the mountain world, and have experienced the transition from seeker of difficulty to seeker of beauty. For climbers, it is a familiar path of discovery, ranging from the initial excitement and challenge, moving to something close to obsession, and finally evolving into an appreciation of nature and the mountain landscape. Very few climbers, and very few photographers, have pursued their passion as keenly or as successfully as Ed Cooper. That's what makes this book so

compelling for those of us who can identify with a lifetime spent in the mountains.

Most dedicated climbers arrive at a point where they think about how they can continue to remain in the mountains for extended periods of time. Some choose the life of "climbing bum"; some choose to find a way to make a living in the mountains as a guide or as a journalist. For Cooper, the solution came in the form of a unique "master plan": He became committed to, somehow, making a living with mountain photography. It was a difficult road, full of setbacks eloquently described in the narrative that follows. But, in the end, he succeeded, and did so in a unique way, with an original approach and innovative use of equipment that in some way parallels his achievements in climbing.

Most notably, Cooper's distinct style was to capture what he called "mountain portraits." He wanted to represent them the way he saw them in his own mind. To do that, he used different types of film, various filters, lenses adapted from unusual sources, even equipment he designed himself. For some of his mountain portraits, for instance, he used a 20-inch Bausch & Lomb lens and a 36-inch Dallmeyer. These were military surplus aerial-spy lenses that he applied to his own efforts because the high-quality glass made effective telephoto lenses for view camera formats. His black-and-white photography demanded he learn different types of darkroom technique. Part of the appeal of *Soul of the Heights* is that Cooper shares with us how he came up with his unusual system for getting the images he saw in his mind's eye.

His style of photography inevitably resulted in some hard work, as his "portraits" demanded that he

backpack the large format cameras (4x5 and 5x7) to some of the most isolated (and sometimes risky) destinations. His was an approach that distinguished him from other important photographic pioneers such as Galen Rowell, who tended more to action shots. Cooper describes his own style as being closer to Ansel Adams. As Cooper himself articulates it, "I have always been more deliberate, more a member of the Ansel Adams school, using many of the same tools as Ansel Adams—large format and black-and-white films. However, my goal was similar to that of Galen's: interpreting the mountain image."

A good example of Cooper's unique style of work is his black-and-white "portrait" of the east face of Bugaboo Spire taken from Crescent Spire (see page 67). This was taken with a 5x7 view camera that he carried all the way up there, and in which he loaded infrared film. By using a red filter, Cooper obtained a striking image, with an extremely dark sky. The sun is glancing across the east face from the opposite direction, making it appear almost to shine, because Cooper had studied the composition and knew the time of day he might achieve that effect. This is just one example of the special tools and rarefied knowledge of mountain photography—not to mention strenuous physical effort—that Cooper employed to take some of the mountain portraits that adorn the pages of this book.

To many of us, Cooper is probably best known for his color work, such as the view of the northern cirque wall of the Southern Pickets. The classic

image was taken from Luna Ridge on 4x5 transparency film. Any climber who knows something about the North Cascades knows how much effort is required to reach Luna Ridge, let alone while lugging a heavy tripod and a large-view camera. Cooper knew that to get the image he saw in his mind's eye, there was no alternative.

This book is full of stories of success, both in climbing and photography, and sometimes of failure, which Cooper saw as an opportunity to learn. But for those of us who love mountains, who appreciate the success that comes from committed climbing, and who appreciate a beautiful mountain image, *Soul of the Heights* is a book that will resonate as few have done before.

Jim Nelson and Peter Potterfield
Seattle, Washington

*Cathedral Spires in Yosemite Valley.*

# PREFACE

Little did I think about where I might be fifty years hence when I climbed my first summit. As those early years rolled by, I seriously doubted I would be around for very long, but serendipity smiled on me. In those early days the mountains became like shining beacons of light. Fifty years later, they still retain that character for me. The phrase "shining beacons of light" is especially appropriate to the Pacific Northwest, where I did my first climbs. The glacier-laden volcanoes of the Northwest are the first to receive the sun in the morning and the last to relinquish its setting rays. The exciting lighting at these times of the day still fires my imagination, inspiring me to search for images.

Except for the black-and-white negatives lost in a fire (described in chapter 16), I still have almost every picture I have taken in the mountains, even those that are overexposed or underexposed, have faded or shifted in color, have light leaks or scratches, or have other defects. It was my hope that some day—when I had the time—I would be able to go back into the darkroom and—working with different color filters, different contrast film types, and other traditional darkroom techniques—restore these images.

That "some day" has now arrived, but in a manner unforeseen thirty or more years ago. Through the magic of the digital darkroom, with which I started working in fall 2003, I have begun restoring some older and defective images to their original state, in the form of digital files and prints. The details are given in the technical data in the back of this book.

*Celebration of 50 years*

This book has been several years in the making. Starting in 2002, I gathered and chose images, and wrote a rough draft of the text. My first version contained hand-written notes for the color correction (by the color separator) of old faded transparencies, together with—in some cases—published samples from years past, showing correct colors. Additional facts came to light as time went by, and I revised the main text and captions to reflect the updated information. I also began making digital prints restoring the original colors.

The final work on the book was done in 2005 and 2006 when I scanned some historic black-and-white prints at very high resolution and produced digital prints with greatly improved appearance. Those old prints represented some of the first prints I had ever made in the darkroom. I had never gotten around to printing improved copies of them before the negatives were lost in the fire mentioned above. In addition, I made new and improved scans and reprinted some of my earliest digital prints.

The photographs for the book were chosen based on one of three criteria: (1) They were historical in nature. (2) They represented what I felt were some of my best mountain portraits. (3) They illustrated a point I was trying to make, such as a photographic technique or a physical change in the mountains over time. Some of the images are chapter specific and appear with that particular chapter. Other photos are more general in nature, not relating to any chapter in particular but more to the body of the work. These are presented in the form

of three mountain portrait portfolios and another portfolio of a more general nature.

Every mountain lover sees the peaks in his or her own way and from his or her own perspective. This book contains images of how I have interpreted the mountains in the different stages of my career—my "vision quest," so to speak. It is my hope that the images set forth in this book will encourage the viewer/reader on his or her own personal exploration and interpretation of the mountains.

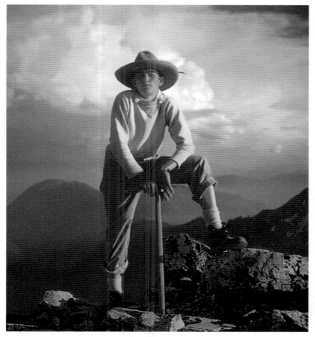

*August 4, 1953*

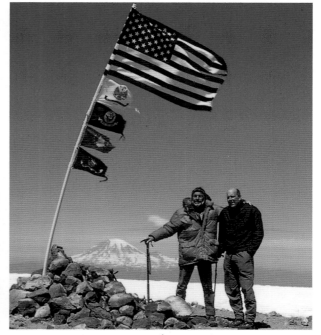

*August 4, 2003*

*Photographer/author's first mountain summit. This is at the top of Pinnacle Peak (6,562ft/2,000m), a popular practice climb in Mt. Rainier National Park. I was sixteen when this photo was taken. I believe that my sister took this picture, with my Ansco Panda box camera. I borrowed someone's ice axe for this pose. The amazing thing about this photograph is that it survived all these years without getting lost in the countless moves I made earlier in my life.*

*Dos Amigos on Mt. Adams. Accompanying me on this climb was Jim Nelson (right), owner of Pro Mountain Sports in Seattle. This is on the summit of Mt. Adams (12,276ft/3,742m) in Washington State. In the background is Mt. Rainier, 14,410 feet (4,392m) in altitude. Probably twenty to thirty people visited the summit that day, and I gave my camera to one of them to take the picture of the two of us. The flag and banners were there already and made an excellent frame for the subject. As you can see, it was windy and cold. Besides us, only one other party ascended from the north; all the other climbers came up from the south. Pinnacle Peak (left photo) can be spotted from the summit of Mt. Adams if you have binoculars.*

*Sunset on Chimney Rock.* With good reason, Chimney Rock (7,124ft/2,171m), located in the Selkirk Mountains in northern Idaho, is often referred to as "the lightning rod of northern Idaho." Here the last rays of the setting sun shine on the rock, giving it a flaming red appearance.

# ACKNOWLEDGMENTS

First and foremost, I would like to thank my wife, Debby, whose help was invaluable, although she gives most of the credit to Hazel Bullis, her junior high school English teacher. Besides correcting my errors of grammar, punctuation, and sentence structure (lack of such knowledge is typical of those educated as engineers), Debby also made a number of helpful suggestions to clarify what I was trying to say. She always let me know when the text would not be clear to someone unfamiliar with climbing terminology.

I am also indebted to the late Brad Washburn, who supplied many helpful suggestions regarding the text. He was even more of a grammarian than Debby is!

I give special thanks to Mike Swayne for allowing me to quote from the detailed climbing journals that he kept during the period of time we climbed together. I was not aware of the existence of these journals until 2001.

I would also like to thank Canadian filmmakers Angela Heck and Ivan Hughes, who produced a film entitled *In the Shadow of the Chief*, which premiered at the Whistler Mountain Film Festival in December 2003, where it won the People's Choice Award for best film of the festival. From the Canadian Broadcasting Corporation, Angela and Ivan retrieved the 1961 archival footage of the first ascent of the Grand Wall of the Chief near Squamish, British Columbia. Seeing this footage helped me recall some long-forgotten incidents of that climb.

Others who supplied helpful information or otherwise contributed to the book are (in alphabetical order): Fred Beckey, Charlie Bell, Eric Bjørnstad, Don Gordon, Jim Nelson, Peter Potterfield, and Jim Wickwire.

*Mt. McKinley camp. An igloo and snow walls form a fort-like appearance at the notorious, well-named Windy Corner at the 13,000-foot (3,960-meter) level on Mt. McKinley's West Buttress route. This was one of two igloo camps built during the 1958 climb.*

**Mt. Assiniboine.** *The pleasing pyramidal form of Mt. Assiniboine (11,870ft/3,618m) gives delight to any mountain lover gazing at this scene. This peak is a classic glacial horn, having been carved on all its sides by the action of glaciers. It is often referred to as the "Matterhorn of the Rockies." The peak itself is in British Columbia, but almost all approaches to the peak start in Alberta.*

# CHAPTER ONE
# AN AWAKENING

My sister Beverly and I had spent more than two days on the road. We staggered out of the Greyhound bus in Livingston, Montana, where we rented a car to spend several days touring Yellowstone. (I paid 65 cents for a meat loaf dinner at one of the Greyhound bus stops. The year was 1953.) Coming from New York where the speed limit was 50 miles per hour, I was ecstatic to discover there was no speed limit in Montana. Being a newly licensed driver, I eagerly pushed the rental car to 90 and more. My sister didn't share this particular enthusiasm, and I reluctantly slowed down to a more moderate 70 miles per hour.

We entered the north entrance to Yellowstone Park near Mammoth Hot Springs. I was immediately struck by the size of the mountains. I later discovered the mountains in that area are not even the higher peaks in the park, but I had never seen anything like them. I had been through the Catskill Mountains in New York State once, but they hadn't made much of an impression on me. These Rocky Mountain peaks were very big by eastern standards.

And of course there were the bears—lots of them! Tourists were feeding bears along the roadside, and "bear jams" were frequent. One bear even climbed into our car and stole some food when we left the car door open while carrying our belongings to a rental cabin at Roosevelt Lodge.

Since I had decided to go out west with my sister at the last minute, there had really been no time

to plan carefully. I grabbed my then-current camera, an old Ansco Panda box camera, to take along. When we saw a bear on a hillside several hundred yards away, I took snapshots of it. After we returned home and had all the processed photos back, the pictures looked like those of many amateurs who attempt wildlife shots. When I showed the picture to friends, I would have to say, "See that black dot on the hillside? That's a bear."

We continued our adventure by driving south to Jackson Hole. We pitched a tent at Jenny Lake, and I looked up at Teewinot Mountain, thinking, How could anyone ever climb that? I thought I was looking at the Grand Teton itself, a mistake common to many first-time visitors to Jenny Lake.

After returning our rental car, and more bus travel, we arrived in Seattle. We stopped at the Recreational Equipment Cooperative (commonly known as the REI) on the second floor at 523 Pike Street, where we purchased memberships. Memberships are numbered consecutively as new members join; mine is four digits. Membership numbers today are in the many millions, and there are many branches of REI throughout the western United States. At that time, however, everything REI had to sell was located in about 1,000 square feet on that second floor at the Pike Street store.

We purchased more camping gear and took a bus up to Mt. Rainier, where we set up a tent at the campground at Paradise (this campground was later closed in order to help restore the meadows in the

area). It was originally my sister's idea to climb the mountain. I was game but I looked up at all the crevasses that could be seen on the glaciers and had my doubts about whether we could do it.

We spent almost two weeks there, part of it in the typical rainy and foggy weather that is often encountered in the Northwest. On August 4, we climbed Pinnacle Peak, my first summit ever (not counting the Durkee's Bread–sign hill near Tully, New York, that I climbed when I was three). Amazingly, I still have the photo that my sister took of me on the top of Pinnacle Peak. Four days later, we climbed Unicorn Peak, and then we hired guide Paul Gerstmann to take us to the summit of Mt. Rainier. Paul was accompanied by Larry Wold, an assistant guide, who helped shepherd us along.

The next two days to the top of Mt. Rainier were to change my life. As we camped in the guide hut at Camp Muir, at about the 10,000-foot level, my excitement started to mount. The guides pulled us out of warm sleeping bags at what seemed like an ungodly hour—about 2:00 a.m. They insisted we

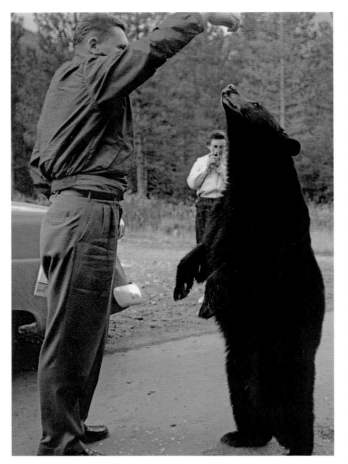

*Bear and tourists, the way it used to be. This is something that was once common in the national parks of Canada and the United States, but that you will never see now—feeding the bears. This photo was taken in 1957 along the Banff-Jasper Highway in the Canadian Rockies. Here an ill-informed tourist from one of the eastern provinces poses while his wife takes movies of him feeding the bear. Luckily he was not injured, and he probably had no idea of the risk he was taking in thinking these bears were tame.*

eat and drink even though we weren't hungry or thirsty. I struggled in the cold trying to put these metal spikes called crampons on my boots. After I had been flailing helplessly for some time, one of the guides attached them for me. It wasn't even light when we got under way. We arrived at an area where we had to climb down and traverse under Gibraltar Rock. That was a misnomer if I've ever heard of one! It was anything but the rock of Gibraltar. Even in the frozen pre-dawn light, rocks were falling at unpredictable intervals onto the ledges across the line of traverse. (This was in the days before wearing protective helmets was standard procedure in such situations.) I thought to myself, "What have I gotten myself into?"

The cold seemed especially bitter as each of us waited for our turn to cross the ledges. When it was my turn, I ran; I didn't want to be the reason for anybody turning back. I thanked God that I successfully made the crossing, but the thought lurked in my mind that we were going to have to cross the ledges

again on the way back. The guides led us through a maze of yawning crevasses, the likes of which I could never have imagined if I hadn't been there.

As we gained altitude, I found it harder and harder to put one foot in front of the other, experiencing for the first time the effects of high altitude on the respiratory system. I noticed something else—the increase in the velocity of the wind as we gained elevation. Whatever heat we were producing from the physical exertion was more than offset by the windchill. (I later learned that high winds are common on the Northwest volcanoes. You are actually feeling the lower levels of the jet stream, which blows almost continuously from west to east.) The wind was strong enough that it was difficult to stand up straight when we reached the summit. On the way down, one of our party of six suffered from altitude sickness, which delayed all of us, but we made it safely across the ledges (with more falling rock than in the early morning).

The sensations I felt and emotions I experienced were unlike anything in my life experience to that point. Deep blue sky, sparkling ice crystals, and never-ending panoramic views were etched into my mind. At first, I thought I would never repeat the experience of this climb. But the sense of accomplishment was overwhelming. Weeks after, as I continued thinking about it, I realized that mountains would be my raison d'être. I had found a direction for my life.

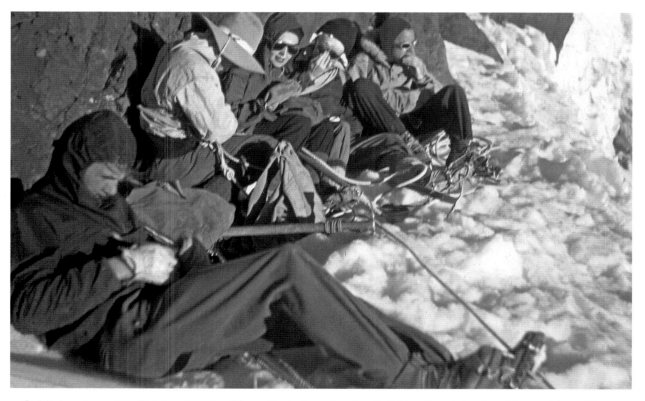

*Guided party on Mt. Rainier. A party of four clients (I am the fourth, taking the picture) and two guides of the Mt. Rainier Guide Service take a rest stop on the Gibraltar Ledges route. Note the difference in gear between modern guided parties and this one of August 12, 1953. Here no one is wearing a protective helmet, despite the rockfall danger, and the manila ropes seen here were replaced by stronger materials a few years later. Guide Paul Gerstmann is on the right; my sister Beverly is in the center, and assistant guide Larry Wold is on the left. Flanking Beverly are friends Leon Blumer, a New Zealander (wearing the large hat), and Bill Dolan.*

# CHAPTER TWO
# GROWING UP COOPER

Even though I didn't sign up for this (my wife disagrees with me on this point), things started out well enough—on February 8, 1937. I was born to middle-class parents in Syracuse, New York (in central New York State). They provided the love and discipline needed by a child. My father was an Episcopal clergyman, and my mother was a stay-at-home mom, common at that time.

I learned likes and dislikes early on. One "like" was nature. Another "like" was appreciating my "likes" at my own pace, not at a pace dictated by somebody else. One incident in August 1940 stands out in my memory. It was the day my father, my sister, and I climbed the Durkee's Bread–sign hill (with DURKEE'S BREAD spelled out on the hillside) near Tully, New York. I needed some cajoling to reach the top, but once there it seemed like I was on top of the world. I would never forget that feeling. The hill was probably 200 to 300 feet high but it seemed much higher. This turned out to be my only hiking/climbing experience until I was sixteen years old.

The first eight to nine years were an idyllic time. Summers were spent at my parents' cottage on Tully Lake near the Finger Lakes, formed by ice age glaciers that overran the area. I explored the forests, swamps, and lakeshore. One of my favorite activities was "turtling"—going out in a rowboat and cruising the swampy edges of the lake to catch turtles. This set me apart from most of my friends, as they were more interested in fishing.

There was one turtle who was my favorite—I named him Clarence (in honor of a friend of my parents; I'm not sure whether the human Clarence was flattered or not). Clarence was a very personable and friendly turtle and didn't seem to mind at all being handled, unlike most turtles. I had learned to recognize individual turtles by their color markings and the irregularities on the front and rear edges of the upper shell. I caught him a number of times several years running.

Even now I can see in my mind, more than fifty years later, the early morning summer sun reflecting off Tully Lake in thousands of sparkles, calling me to a day of exploration and adventure. The fact that these images remain so strongly imprinted in my brain may explain my later interest and career in photography.

My "dislikes" included organized activities and classes of most kinds, peas and tomatoes, and Saturday opera. I could slip peas into my napkin, and I gagged on tomatoes. But organized activities and Saturday opera were harder to ignore.

When I was nine, my parents sent me to summer camp for two weeks. Its name was Camp Touzy (or Tousy)—I wasted no time in renaming it Camp Lousy (with which it rhymed exactly). I resented the camp's organized activities when I could have been exploring on my own, and I was quite vocal about it.

I also complained about piano lessons when I was eight years old. Finally I took direct action. When my mother called me in that certain tone of

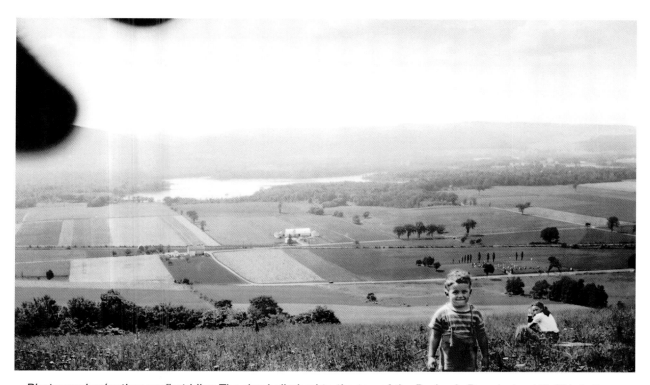

*Photographer/author on first hike: The day I climbed to the top of the Durkee's Bread-sign hill. This is the only hike that I can remember taking until I was sixteen years old; I was three and one-half years old in 1940. My sister Beverly is sitting on the right. My father took the picture while my mother waited at the car, which may be seen as a dark dot on the lonely highway. In the background is Tully Lake in central New York State. Our summer cottage was on the opposite shore of the lake. Also in the photo are my father's fingers partially obscuring the lens. Times haven't changed much; this is still a failing of many would-be photographers!*

voice, I ran across the street to a park and hid. From my vantage point I could see the front door of the house and hear my mother frantically calling for me. I did not return to the house until I actually saw the piano teacher leave the area. When I returned, I was appropriately punished, but there were no more piano lessons after that. My stubbornness had won out.

When it came to Saturday opera, my mother wasn't content to listen at a moderate volume. For an opera fan to truly enjoy it, opera must be heard at full volume. Even my father left the house at times. Since my mother sang along with opera scores, I tried hiding the scores in the light fixtures. As I grew older, I discovered I could cause static in the Metro-politan Opera radio broadcasts by adjusting the new medium of television between certain of the channels. Alas, even this did not deter her, and I had to endure not only the opera but also the static.

Then we moved. Everything changed. Until my graduation from high school, I went to six different schools. There was never enough time to fully adjust to each new school or to make lasting friends.

For this first move, my father accepted a new pastorate in Mt. Vernon, New York, when I was about nine years old. I left a community where country and nature were relatively close at hand and now was living in an urban setting in the early stages of decay.

Without nature as a companion, I was forced to

look inward for activities. I decided to collect stamps. Longfellow Grade School was located not too far from the city dump, and I spent many happy hours after school scouring the dumpsite for stamped envelopes.

I gave up stamp collecting for two years when my parents sent me to a private school in New York City, the Cathedral Choir School associated with the Cathedral of St. John the Divine, right on the edge of Harlem. Never have I hated a place so passionately or been so unhappy as in those two years. To me it was like a prison. In fact, I soon gave it my own name—Sing Sing—after the famous prison in Ossining, New York. The name seemed doubly appropriate because with all the services we had to attend, it seemed to me that we were singing constantly.

No doubt my parents felt that this experience would give me a good musical background; they already had me singing in the choir at my father's church. I came to realize that they had a plan for me: a New England prep school, Trinity College, then divinity school and the priesthood. And the start of all this would be the advancement of my musical and religious training at the Cathedral Choir School.

We sang at two services daily Monday through Friday and three on Sunday. There were no services on Saturday, but we spent the day rehearsing for Sunday. Morning communion was the worst. We were rousted out of warm beds into the cold dormitory at some ungodly hour and marched to a side chapel behind the main altar of the cathedral. In all but the coldest weather, we wore our school uniform shorts. The chapel itself was dark and gloomy, and in the winter it was dark outside as well. Even the stained-glass windows were tinted dark, and I don't remember the early morning sun ever shining onto those windows even in the longer days of late spring.

The communion service of the Episcopal Church

contains much kneeling, and we had to do it on hard wooden kneeling benches without resting our rears on the seat behind us. At intermittent periods, we sang and chanted while we turned blue from the cold.

Not until this was all over did we get to eat breakfast. More often than not, we had cream of wheat, which I learned to truly detest. But that was not nearly as bad as the creamed tripe, which was sometimes served for lunch or dinner. It was sort of like trying to eat rubber in the form of a long string.

I endured two school years at the Cathedral Choir School. I put up such a fuss when my parents wanted to send me for a third year that they finally relented and allowed me to go back into public school. Surprisingly, I came away from the experience with a great appreciation for the beauty of Gothic and Romanesque architecture, which has stayed with me to this day. Both types of architecture are incorporated into the cathedral.

I was ill prepared for what was to come. Just as I was entering puberty, I moved from a very protective environment to one where gangs were a major influence on my age-mates. I entered George Washington Junior High School in Mt. Vernon, where half the students were preparing to go on to regular high school, and the other half were either going on to trade high school or dropping out altogether. My dislike of group activities served me well in this instance, as I never became involved with gang activity.

Moving on to A. B. Davis High School, there were about 400 students in a grade. In a little over a year and a half, my father took on a new pastorate in the relatively small community of Tuxedo, New York, and I entered the George F. Baker High School. What a contrast to my prior high school: Our entire grade was composed of thirteen students. Another big adjustment to make!

I developed some new interests during these

high school years. While we still lived in Mt. Vernon, Herbert Seer, who was about six years older than I, introduced me to photography. The darkroom process was like magic. Once the photographic paper was placed in the developer, an image would gradually form.

I acquired an inexpensive enlarger and experimented in the darkroom. After about six months, my interest in this activity waned. What I lacked was a photographic subject that I felt passionate about. Little did I realize that I would later make this activity—photography—my life's work.

Chemistry became an obsession, both in school and in my parents' basement in Mt. Vernon. I liked the immediate results. One day in the school lab, we were supposed to generate sulfur dioxide. Directions called for adding *dilute* sulfuric acid to some other ingredient. I figured if dilute was good, concentrated would be better. Ignoring directions, I looked around and found some concentrated acid.

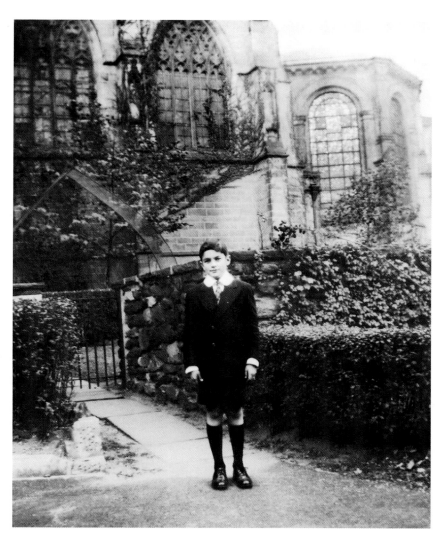

Photographer/author at age eleven in 1948 in Cathedral Choir School uniform. This uniform shows the short pants we wore in all but the coldest weather. The fabric was wool, which to this day I cannot stand next to my skin. I came to hate this outfit and the school itself, which was associated with the Episcopal Cathedral of St. John the Divine in New York City. Part of the cathedral can be seen in the background.

I cheerfully poured it into the beaker containing the other chemical and bent down to take a good sniff of my results. I nearly passed out on the spot. Dizzily, I yelled something to the classroom full of students and ran out of the room, all of them following very quickly. A teacher, holding a handkerchief over his nose, raced back into the classroom to open the windows. I had irritated eyes and nasal passages for several days.

I was conducting numerous experiments with all sorts of chemicals in our basement, somewhat to the dismay of my parents. Several times I disrupted power to the entire house when I connected carbon electrodes to the main house current while working with electrolytic solutions. I decided to make my own concentrated hydrochloric acid generator, which

involved generating both hydrogen gas and chlorine gas separately but simultaneously, and then lighting the jet of hydrogen and inserting it into the chlorine. The concentrated acid would then condense and fall to the bottom of my makeshift acid generator. At least, this was the theory.

Almost as an afterthought, I decided to take precautions in case things did not go according to plan. I hung a heavy blanket between the chemical apparatus and myself. Very carefully, I passed a lighted wick around the blanket to the tip of the hydrogen generator.

The resulting explosion blew out two of the basement windows and was heard several blocks away. The explosion also blew me across the room and gave me numerous cuts and bruises. Glass shards were everywhere. Only the blanket saved me from what would have been—at the least—serious injury. I don't remember how I explained this event to my parents (both of whom were out at the time), but that was the end of my chemistry experiments in the basement.

I replaced these experiments with another activity. *Popular Mechanics* magazine carried an ad for blueprints to build a small hydroplane racing boat, so I sent away for them. This project occupied me for four or five months, but I was not able to use the boat until early September, when we finally took it to the lake. I borrowed a 10-horsepower motor and set off. The speed I achieved was both thrilling and frightening; it was probably as fast as anybody had ever gone on that small lake. There was no one around to appreciate it, however, as almost everybody had left for the season.

The boat was stored under the summer cottage, and I never used it again because my parents continued to rent out the cottage for several summers before selling it. The last I heard, some relative of the purchaser raced the boat on Lake Erie, where it sank.

In the meantime, I was sent to another summer camp. St. Peters, near Saugerties, New York, was co-ed. While my social skills advanced remarkably in a short period of time, it was still a camp with the organized activities I disliked so much. When my sister (older by nine and a half years) visited me after three weeks, I prevailed on her to take me away so I could be free to pursue my own activities at my own pace.

The summer I was sixteen, my sister planned her adventure trip to the western United States. As the time drew near, the talk turned to whether I would want to go along or *should* go along. In the end, my parents gave their blessing, and I embraced the idea as well. This trip was to give a new direction to my life. As described in chapter 1, this trip provided a broader spectrum on the possibilities in life, led to a greater acceptance of myself, and helped me understand that it's okay to be different from others. It explained some of my dislikes, like structure—but unfortunately not peas! Above all, the love of the mountains awakened in me was not deterred by others' disapproval, no matter how strong. I became my own person.

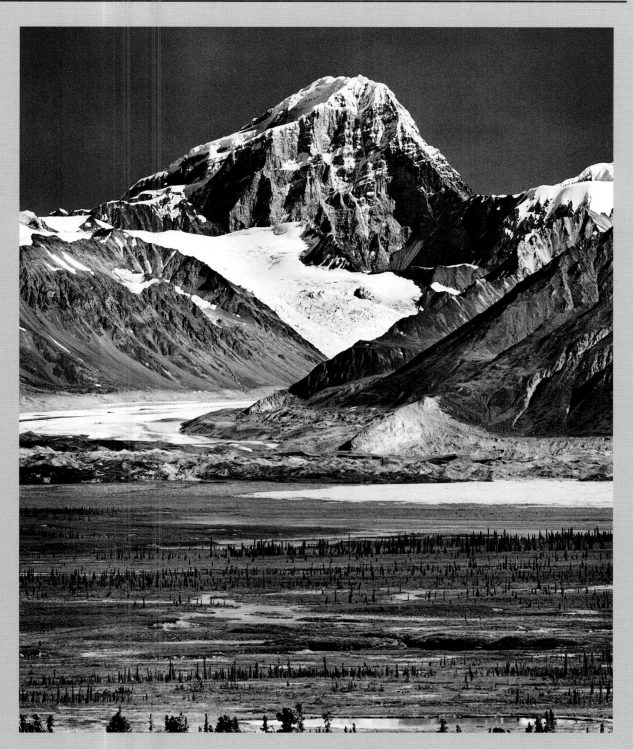

*The great south face of Mt. Deborah. This peak (12,339ft/3,761m) rises above the taiga forest in the Alaska Range. This view is from the Denali Highway some 30 miles distant. The glacier spreading out on the plains below the peak is referred to as a "piedmont" glacier.*

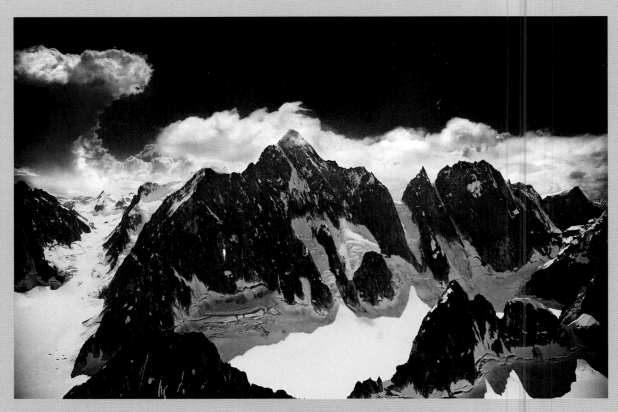

*The northwest face of Mt. Augustin in the Cathedral Spires. This nearly 4,000-foot face of Mt. Augustin (circa 8,600ft/2,621m) is located in the Cathedral Spires, in Alaska southwest of Mt. McKinley. This group is also sometimes referred to as the Kichatna Spires.*

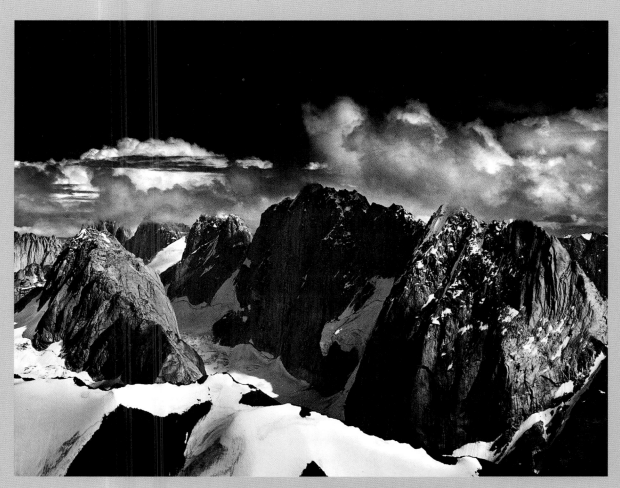

*Middle Triple Peak in the Cathedral Spires. Center: the 3,600-foot west face of Middle Triple Peak (8,835ft/2,692m), southwest of Mt. McKinley. To the immediate left of Middle Triple Peak is North Triple Peak (circa 8,400ft/2,560m); to the right is South Triple Peak (renamed Sasquatch Peak) (8,303ft/2,531m). Mt. Nevermore (circa 8,100ft/2,469m) is at the left in the picture.*

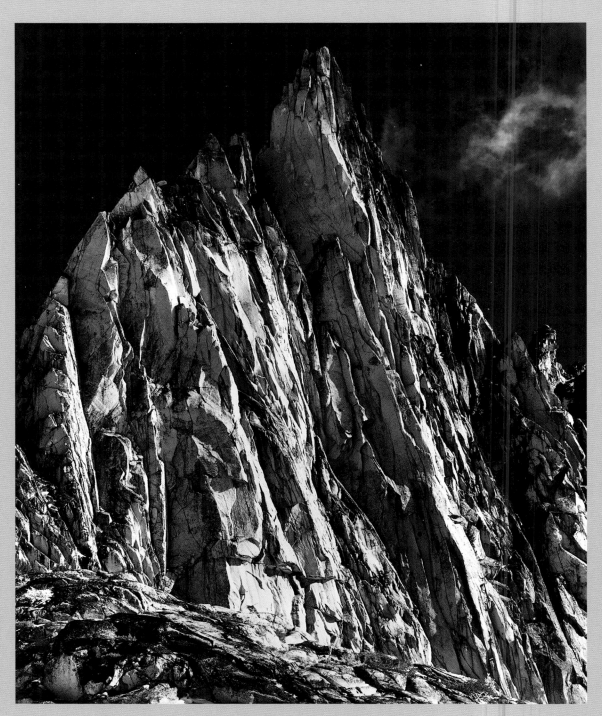

*South face of Prusik Peak. This aesthetic granite form (circa 8,000ft/2,438m) is located in the Enchantment Basin of the Central Cascade Mountains of Washington State. This photo was taken while doing photography for* The Alpine Lakes, *published by the Seattle Mountaineers in 1971.*

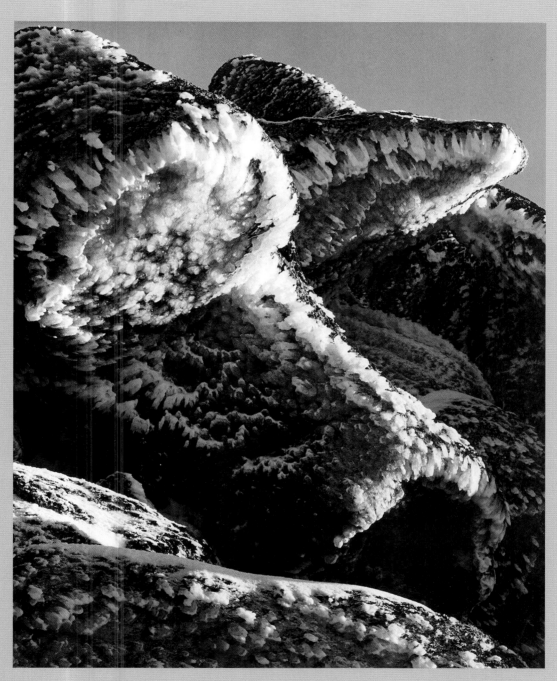

*Ice rime on Enchantment Peak. This unusual formation presented itself to me at the summit of Enchantment Peak, above Enchantment Basin in the Central Cascade Mountains of Washington State. The rime formed during the first large storm of the autumn that had struck two days before. Photo was taken while doing photography for* The Alpine Lakes, *published by the Seattle Mountaineers in 1971.*

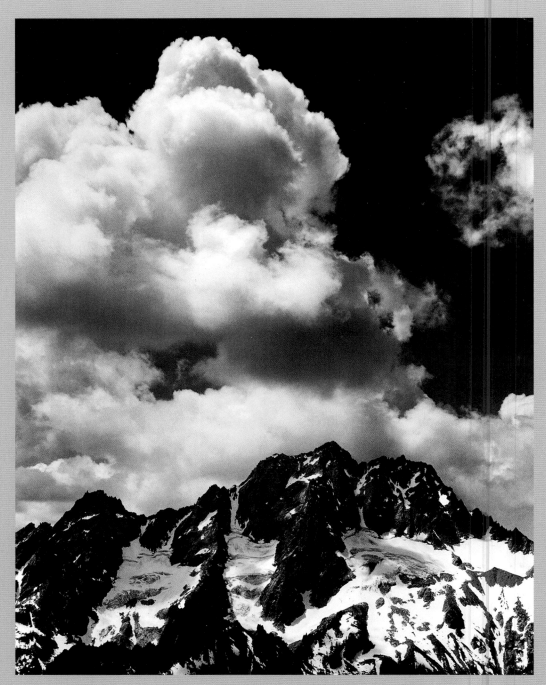

*Clouds over Mt. Stuart. At 9,415 feet (2,870m), Mt. Stuart is the highest peak in the Central Cascade Mountains of Washington State. This is the single greatest mass of exposed granite in the entire Cascade chain of mountains running from southern British Columbia to northern California. The excellent quality of the rock makes Mt. Stuart popular with climbers.*

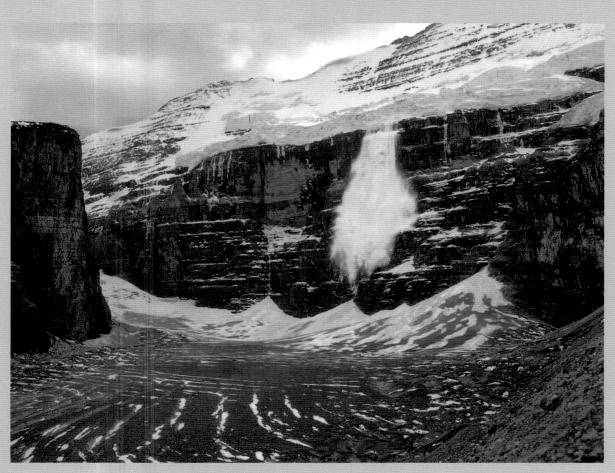

*Avalanche on Mt. Victoria. This view looks across the Plain of Six Glaciers toward the avalanche-swept east face of Mt. Victoria in the Canadian Rockies. The Death Trap route to Abbot Pass follows the glacier and angles up to the left between the shoulder of Mt. Lefroy on the left and the cliffs of Mt. Victoria to the right of it.*

*Olympic Mountains, "deer in love," Hurricane Ridge. This location in Washington State is not only a great place for mountain viewing, but also a great observation area for wildlife. This unusual shot of a buck and doe interacting is one of those shots that can't be set up; you just have to be at the right spot at the right time with a camera ready.*

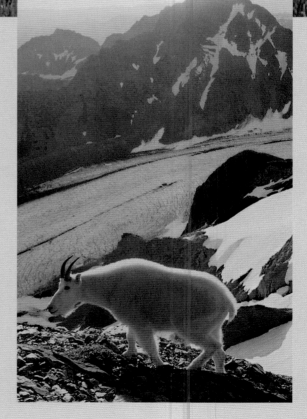

*Mt. Olympus, mountain goat, and Blue Glacier. This glacier on Mt. Olympus is the largest in the Olympic Mountains of Washington State. The National Park Service now has in place an official policy of removing all mountain goats from Olympic National Park, by capture or otherwise, and their numbers have been reduced considerably since this picture was taken. It is unlikely you will encounter one now. While mountain goats have inhabited the Cascade Mountains since before the arrival of white settlers, it is said that goats never colonized the Olympics. It is believed that all the mountain goats in the Olympics descended from some that were introduced by humans into the area in the 1920s.*

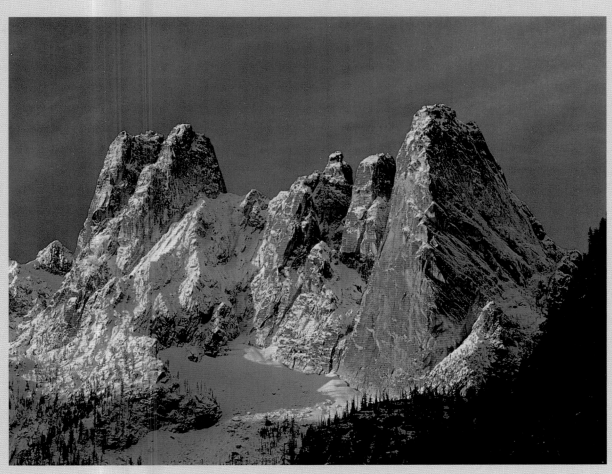

*Sunrise seen on Liberty Bell Mountain above Washington Pass. This pass is located on the eastern side of the North Cascade Mountains of Washington State. The North Cascades Highway, State Route 20, passes right underneath these peaks. On the right is the peak known as Liberty Bell (7,720ft/2,353m). On the left rise the Early Winter Spires with the higher South Spire (7,807ft/2,380m) being the left of the two.*

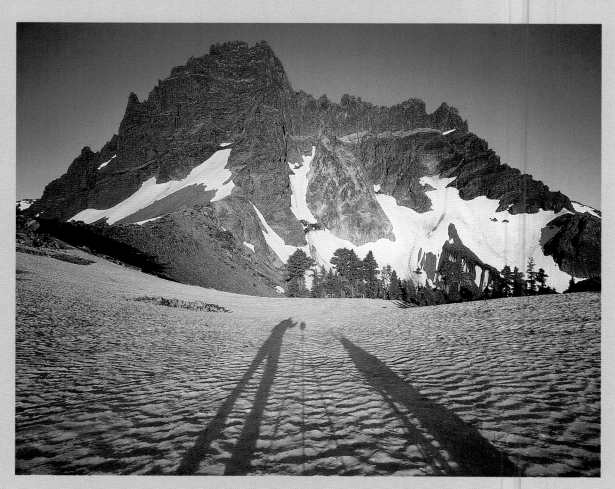

*Three Fingered Jack Mountain. This peak is located in Oregon's Central Cascade Mountains. This view is from the east shortly after sunrise, with the shadow of the photographer/author in the foreground. Three Fingered Jack (7,841ft/2,390m) is situated just north of Santiam Pass in a region that has seen considerable volcanic activity in the past and will no doubt see volcanic activity in the future.*

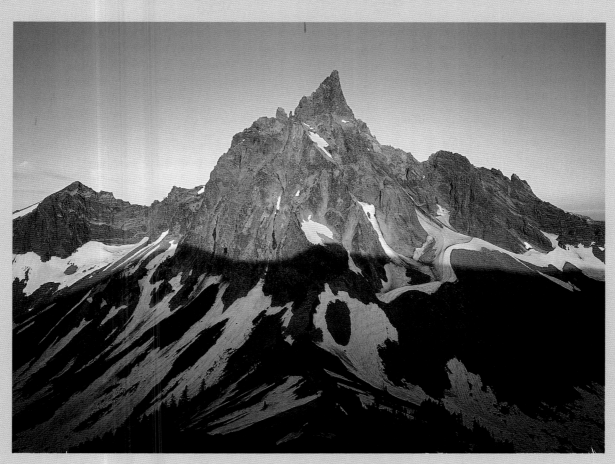

*Sunrise on Mt. Thielsen. This sharply pointed summit in the Cascade Mountains is a southern Oregon landmark. Mt. Thielsen (9,182ft/2,799m) is located just north of Crater Lake and is here viewed from the east.*

# CHAPTER THREE

# AN IMPORTANT LESSON

The sense of freedom and open spaces of the mountains filled my mind. How different from the ordered—almost rigid—existence I had been living. In the grand landscape of the West, I felt free to be whatever I wanted to be.

I returned back East for my senior year of high school. I spent considerable time planning and dreaming about how I might return to the mountains. School now became something I did when I wasn't in the mountains; I was like the person with a dull job who passionately devotes all his free time to his hobby. I read everything about the mountains that I could get hold of and—as I sat through boring classes—carried out in my mind numerous difficult ascents. That school year dragged on. None of my classmates could understand where I was coming from, as they were all thinking about college or a job and marriage. I did have to face a decision . . . my parents were unwilling (and rightfully so) to support me financially if I left school and started working.

I couldn't imagine working at any job, so I chose the alternative of going to college. Further, my parents, who were very worried about my future, pushed me in this direction. To gain admittance to college required keeping my grades fairly high. I wound up getting two letters of acceptance—one from Harvard and one from Cornell. Because of financial arrangements, we chose Cornell.

Conveniently for me, my newly married sister and her husband were in Alaska, where he flew jet fighter planes for the Air Force. So the summer after my graduation from high school (1954), it was arranged for me to visit my sister and her new husband. Everybody concerned felt it was better for me to go out West under controlled circumstances rather than for me to charge out on my own—in this there was much truth! I took a bus to Seattle and from there flew to Anchorage on a twin engine prop plane. The flight seemed to last forever (probably nine to ten hours), but we flew over marvelous mountain terrain, which I still remember.

In Alaska I did climb 6,500-foot Sheep Mountain with my brother-in-law and (by myself) another peak in the Girdwood area above the Raven Glacier. For the most part, however, I could only look at the tantalizing peaks in the distance. The Alaskan experience only whetted my appetite for close encounters of the mountain kind.

In order to raise a little extra money, I took my first job since having a newspaper route when I was about twelve. This job involved washing dishes, mopping floors, cleaning toilets, etc., for a large medical institution in Anchorage. There was a prescribed work routine, which I learned rapidly. I devised a number of ways to shorten the assigned tasks so I would have (I thought) more free time.

Was I ever mistaken! My reward was to receive a pile of extra work in addition to my prescribed duties. Naturally resentful, I slowed down to the point where I finished only the "normal" duties, whereupon I was fired. Perhaps if I'd felt that this

kind of job was going to be my life work, I would not have minded the extra duties, but I had known from hour one on the job that this was not the direction I wanted to take in life.

When it was nearly time to return home, I decided to climb Mt. Baker in the Cascade Mountains of Washington State. In the state (and the contiguous United States) it is second only to Mt. Rainier in the number of glaciers it bears. After arriving in Seattle in late August, I took a bus to the town of Glacier and walked to a nearby campground and set up my small tent. I couldn't find anyone interested in climbing Mt. Baker. I was met with responses like, "Why should I climb it? I didn't lose anything up there." Enthusiasm for the mountains was wasted on such people.

The weather was cool and overcast, with occasional rain (not unusual for late August in the North Cascade Mountains). Deferring to the weather, I decided to climb—as a warm-up exercise—Church Mountain, which was near my camp. The summit, at 6,315 feet, represented almost a 5,000-foot elevation gain from where I was camped. There was even a trail to the top. Dark-looking clouds that were forming didn't bother me in the least; I was practically unaware of their meaning. I thought to myself: "Why take the trail? That's too easy. Instead I will shortcut the trail and forge a direct line to the summit right from where I am." I had forgotten my map and compass, which I had read that you should always carry, but that didn't matter because I would be back before dinner. Although my tremendous enthusiasm was carrying me quickly upward, I was learning in earnest the realities of bushwhacking at the lower altitudes in the North Cascade Mountains.

Soon I emerged from the trees into alpine country. The cool snow and beautiful meadows I had dreamed of all year surrounded me. The views were quickly disappearing, however. In their place began a quiet, steady rain. I gained the summit ridge, but it was long and level. A compass and map would have shown me on which end of the ridge a Forest Service manned lookout was located. There I could have gotten help locating the trail back down, although the upper portions of the trail would still have been covered with snow from the near record snowfall the previous winter.

After wandering aimlessly for a while and finding no trace of the trail or the lookout, I decided to descend the same way I had ascended. By now I was soaking wet, all the brush was soaking wet, and I was disoriented to the point that I couldn't recall which side of the ridge I had ascended. Everything looked the same in the gray mist.

For the first time in my life, I became really scared. I had not even thought of telling anyone where I was going. I flipped a coin to decide which side of the mountain I would descend—the wrong side would have led me to wild country close to the Canada-U.S. border. I had read somewhere that the best course of action when lost is to follow a watercourse until reaching something, presumably civilization. Up there on the steep mountainside, however, this course of action seemed to be getting me into trouble.

I continued descending, shortly finding myself in a watercourse. As it became steeper, I climbed out of it into another one. The brush alongside the creek was near impenetrable. I followed the creek down to where it joined the original watercourse. The walls were very steep, and it soon became impossible to climb out, as I descended on steep, wet, moss-covered rock. At one point I fell about 20 feet into a large pool. The torrent swept me on. Ten feet from an additional 40-foot drop I grabbed a log, where I

spent five minutes in that chill water recovering from the shock of realizing what nearly had happened.

Now not only was I totally drenched and numb from the cold, but I had torn clothing and numerous cuts and bruises and was bleeding. It was cold and getting dark. I kept pushing on and finally staggered out onto the road in the last light of day. By great good luck, and definitely not mountaineering skill, I had chosen to descend the correct side of the mountain.

A kind motorist stopped to give me a ride, perhaps thinking from my appearance that I had been the victim of some kind of attack. He left me at my camp, where I licked my wounds. Deciding that discretion was the better part of valor, I headed home, leaving the climb of Mt. Baker for the following year.

I learned several very important lessons, which have served me well over the years. Among these are never, ever, take a shortcut unless you are absolutely sure it is safe, and never, ever, underestimate a climb and the effect of changing weather on your situation.

In the autumn I entered the school of chemical engineering at Cornell University in Ithaca, New York. I had chemistry, physics, and math classes, as well as the more traditional liberal arts courses. I applied myself as necessary in order to obtain passing grades, but my heart was in the mountains, not in my college courses.

As part of the program to help support myself in college, I obtained a summer job for the following year with the Mt. Hood National Forest Service. I was a member of a survey crew based in Zig Zag, Oregon (yes, that is the real name!). The job itself was forgettable, but I was close to the mountains.

Mt. Hood was some 20 miles away.

In anticipation of a mountain adventure every weekend that summer, I paid the then princely sum of $20 for my first pair of mountaineering boots. They were nice-looking and had Vibram soles. What pride they gave me! Even before starting my job, I set out on a practice overnight hike to break in the boots. Typical of early June in the Cascade Mountains, the trail was wet and muddy, so by the time I reached my campsite, the new boots were soaked. I built a fire and placed the boots close by to dry them out. I checked the boots several times to see how they were doing, but then the warmth of the fire caused me to doze off. When I woke and next checked the boots, the heat had warped the side of one of them. I continued using the boots the next day (I had no choice) but a great blister developed on my foot next to the warped area. What a letdown! I needed another pair right away if there were to be any mountain adventures.

Government Camp on the lower slopes of Mt. Hood was close to Zig Zag. There I met Everett Darr (himself a climber), who managed a shop with climbing and skiing gear. For a few dollars I obtained an old pair of rental boots—Tricounis—that had small metal spikes on the soles to help give good purchase in snow and ice. These boots were still in fashion with Northwest climbers in the mid-1950s, though their common use dates back to the 1930s and earlier. I still remember the scratching sounds and the sparks given off when using them on rock, to which they were ill adapted. I suffered through the summer with these torture instruments until they fell apart at the end of the season.

# VOLCANO SUMMER *and* ADIRONDACK WINTER

Mountain excursions in the summer of 1955 ranged from Mt. Baker in northern Washington State and a repeat ascent of Mt. Rainier (by the less frequently used Kautz route) to Mt. Shasta in northern California. And (of course) I climbed Mt. Hood—six times! I made some climbs with the Mazamas (a nonprofit mountaineering club) of Portland, usually large groups of people making a mass ascent of one of the volcanic peaks. I didn't really fit in well with the organized group structure, and on more than one occasion the leader reprimanded me for straying too far from the group. Early August marked the end of my participation in such groups, some of which were very large. On June 12 of that year, I climbed Mt. St. Helens with three friends. That same day a party of fifty-five Seattle Mountaineers also assaulted the mountain!

On the fourth of July weekend, near the summit of Mt. Shasta on a Mazama climb, we were struck by a lightning storm. Sparks were jumping off our ice axes, crampons, and other metal objects, and everybody started running down the mountain. It wasn't until we had descended between 500 and 1,000 feet that we realized one member of our party was missing. The leader went back up the mountain with two of the stronger members and found the missing man wandering around disoriented. He had

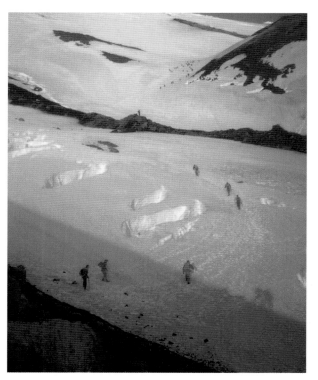

*Mass assault on Mt. St. Helens. This is the photo in my collection that best illustrates the type of ascents that were popular with many climbers in the 1950s and 1960s—large group outings to tackle the major volcanic peaks in the Pacific Northwest. Pins were awarded for the "six majors" and other accomplishments. That day in 1955 there were fifty-five Seattle Mountaineers on the mountain. I was able to count forty-five in this picture, the climbers farther up on the Forsyth Glacier looking almost like ants. This glacier was taken out by the May 1980 eruption. The two shadows on the glacier are those of me and my rope-mate, Walt Sellers (two other friends comprised a second rope team).*

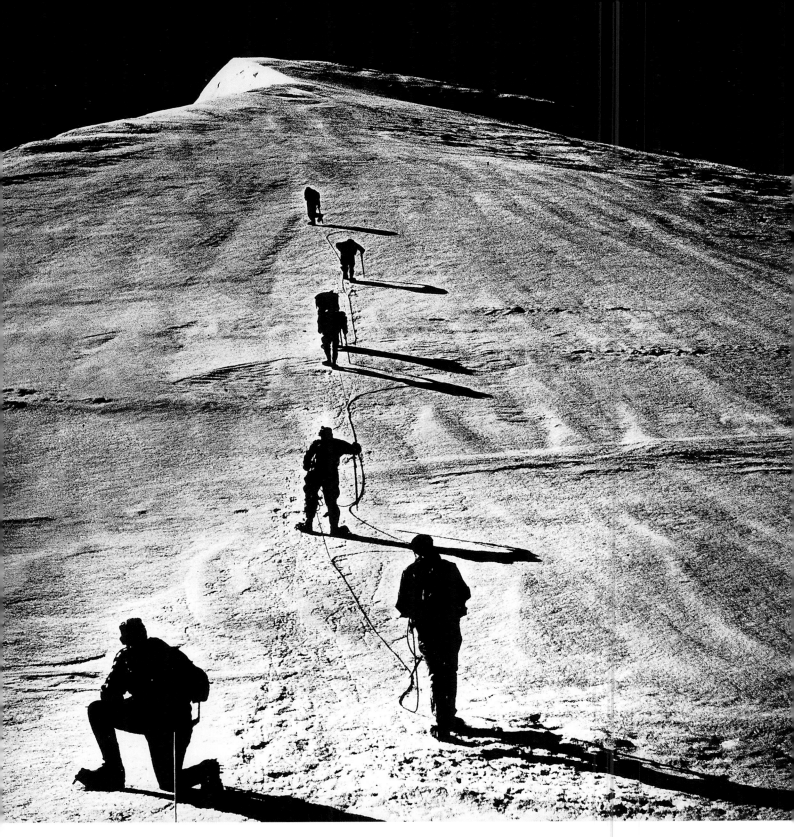

*Memorial Day 1957 on Mt. Hood. The Hood River Crag Rats (a mountain rescue and climbing group) approach the summit of Mt. Hood after climbing the Sunshine Route.*

to be restrained from continuing to the summit in dangerous conditions. After this man had been guided safely down the mountain, he had no memory of any of the events near the summit.

Later in the summer after several climbs of Mt. Hood, another climber and I decided to have a little mischievous fun with one of the larger groups. In late August we knew there was a Mazama climb of Mt. Hood scheduled. On the appointed day, we took our regular backpacks and stuffed them with paper and sticks in such a way that they looked extremely large and heavy. Also, we carried suits,

street shoes, cocktail glasses, and mixer, along with a bottle of whiskey.

After the Mazamas had a good head start, we started out with our enormous packs. Being in excellent shape and having the advantage of youth, we virtually ran by them just below the crater. We made sure to stay well clear of them so they wouldn't recognize us. You can imagine the discouragement of out-of-shape climbers observing other climbers with monstrous packs running past them going uphill.

Upon arriving at the summit, we switched out

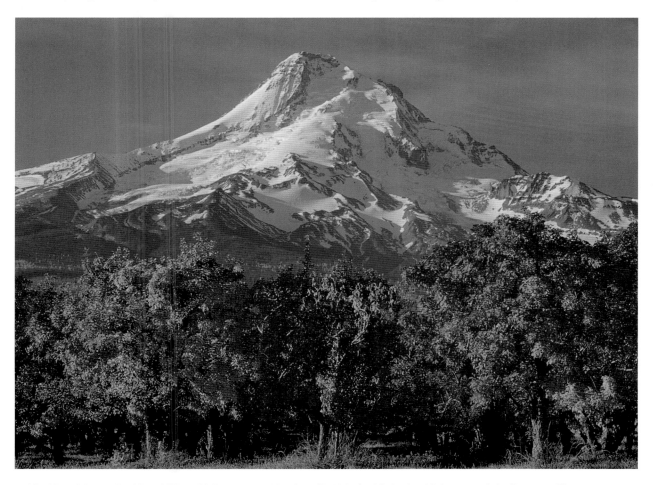

*Mt. Hood from the Hood River Valley. At 11,239 feet (3,426m), this is the highest peak in Oregon. The autumn colors of the orchards made a dramatic foreground for this lovely peak in the chain of Cascade volcanoes.*

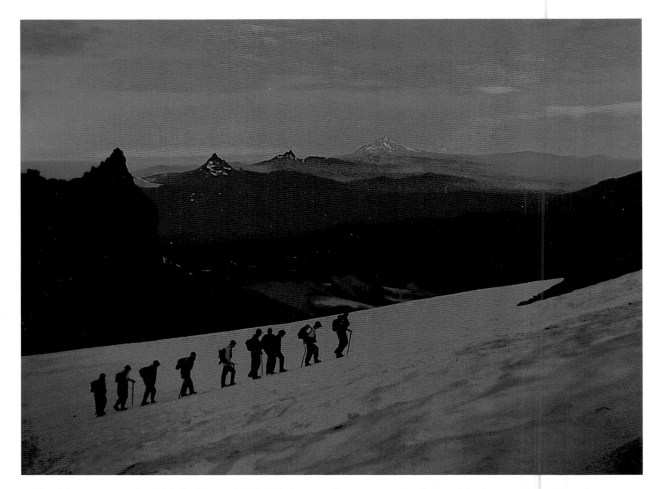

*The Mazamas on the Middle Sister, 1955. This is one of my very early photos. I broke out of the line of climbers to move to a vantage point to be able to capture this picture. This is a group of Mazamas (a mountaineering club from Portland), led by Joe Leuthold, on their way to the summit of the Middle Sister in Oregon. Peaks seen from left to right are: Little Brother, Mt. Washington, Three Fingered Jack, Mt. Jefferson, Mt. Hood, and (just barely visible) Mt. Adams in Washington State. All peaks seen here resulted from volcanic activity.*

of our climbing clothes and put on our suits and street shoes. After hiding our packs, we set ourselves up on comfortable rocks right at the summit with cocktails in hand and waited for the group to catch up. (It was an unusually warm day for the summit of Mt. Hood, with very little wind.)

Before long, the Mazamas arrived. They all seemed shocked by what they saw. Nobody said anything except the leader, who asked where we had come from. We just pointed down Cooper Spur (a very steep ice route on the other side of the moun-

tain from the standard ascent route that we, and the Mazamas, had just climbed).

The group leader was not content to leave it at that; it soon became clear that he was going to insist that we go down the mountain with his party—possibly by force, if necessary—for our own safety. I don't remember how the situation resolved itself, but I know it was the last time I pulled a prank like that.

At the end of the summer before returning home, I made several bus connections to reach Lone Pine, California. Arriving there early in the morn-

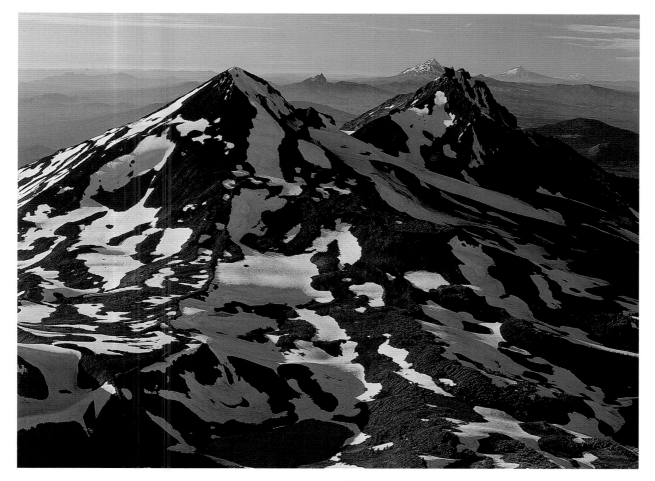

*View from top of South Sister. The Middle Sister at left (10,047ft/3,062m) and the North Sister at right (10,085ft/3,074m) are seen in this view from the summit of the South Sister in Oregon's Central Cascade Mountains. In the distance can be seen, from left to right: Three Fingered Jack, Mt. Jefferson, Mt. Hood, and Mt. Adams (in Washington State).*

ing, I hitchhiked up to Whitney Portal, at about 8,500 feet the starting point for the climb of Mt. Whitney, the highest point in the contiguous United States. There is a trail to the top that is free of snow late in the season. Wasting no time, I headed up the trail, and somewhere along the way I found someone who was willing to accompany me to the top. I remember leaving some equipment behind at about the 12,000-foot level.

We arrived at the summit at sunset. It didn't occur to me that we might have a problem descend-

ing. The little flashlight we had with us failed. Totally exhausted and unable to find our gear, we huddled together for warmth and endured a very long, frigid night. It occurred to me that from then on, it would be a good idea to pay a little more attention to the getting down part of a climb and to allow for unforeseen circumstances. I took this lesson to heart.

Cornell did have an outing club. I might point out that this was an era in which anyone who backpacked or climbed was looked on with suspicion and was considered out of the mainstream, unlike

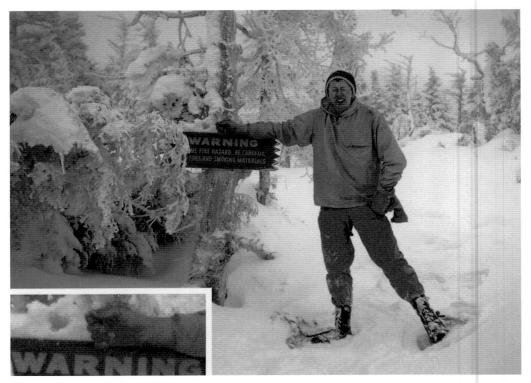

*Adirondack Mountains, Tim Bond on the trail. This was taken on the first day of the winter mountaineering trip into the Adirondacks in 1956. We used snowshoes on the trek into a base camp. Tim Bond was my partner on a number of early climbs, and later he became a popular climbing ranger in the Teton Mountains before his untimely death in a fall. The inset shows Tim, as a joke, holding a match over the warning sign.*

the present where even smaller cities may have a climbing gym and a shop with rock-climbing/mountaineering gear. Not surprisingly, the members of the outing club were a scruffy-looking lot, out of tune with the clean Ivy League look, crew cuts and all, usual to college students in the mid-1950s to the mid-1960s.

The outing club planned a winter climb of Mt. Marcy, the highest peak in the Adirondack Mountains of New York State. I jumped at the chance to go. It was in late January in my second year of college, between semesters. The temperature fell to 30 degrees below zero (Fahrenheit) one night. The day we ascended Mt. Marcy, the summit had about the same temperature, but a strong wind added greatly to the windchill factor.

We had to climb the last several hundred feet facing backward; otherwise, we would have received severe frostbite of our faces. We did not have face masks, and I am not sure that they were even available at this time unless they were homemade. This experience did temper my enthusiasm for winter mountaineering but did not totally end it. I was to have experiences in the years to come that would reinforce my feeling that winter climbing was really not what I wanted to do. The mountains look so beautiful and clean in the winter; it's a shame the temperature is sometimes so cold!

During that spring, I taught myself the dulfersitz body rappel, using a manila rope I had acquired. I practiced on a 15-foot cliff in back of my parents' house during spring break, using an instruction

*Mt. Haystack in the Adirondack Mountains. Though the peaks in the Adirondacks are not high, winter conditions in this area can be as fierce as any in the western mountains. I took this picture of Mt. Haystack (4,960ft/ 1,512m) on the way to climb Mt. Marcy, the highest peak in the Adirondack Mountains and New York State. This is a view seen through a windfall of trees that conveys the sense of cold that we felt. The temperature was way below zero (Fahrenheit).*

manual. This is a somewhat painful way to rappel (especially with the rough manila rope), and I felt much better about rappels when, two years later, I learned an easier method, employing a figure-eight nylon loop around the legs at crotch level. A carabiner was attached to this, and the rope then went through the carabiner and over one's back, eliminating the really painful friction in the crotch area.

Finally the summer rolled around, and I was off to another job in the West, this time at the Tacoma Smelter in Tacoma, Washington. Anyone who has been through Tacoma in the past can tell you about the "Tacoma aroma." It is a pervading smell (due to the pulp mills in the area) that makes you look suspiciously at the person sitting next to you, figuring he/she has laid a silent one. (Native Tacomans, who are accustomed to the odor, will tell you that the air just "doesn't smell right" in other places.)

Despite the "Tacoma aroma," I was in the Northwest again, very close to Mt. Rainier and the Cascade Mountains. This year I was keen for challenges at a higher level than before.

# CHAPTER FIVE

# A 200-FOOT FALL

By this time I looked at mountains as objets d'art. The Ansco Panda camera I had been using was no longer adequate for recording the beauty of the mountains. I looked around and purchased a used Voightlander Perkeo 2¼ x 2¼ folding camera. It would actually fit in a pocket when it was folded up. It now became a pattern to move slightly out of straight-line ascent routes in order to achieve better compositions for my pictures. I developed, on my own, the technique of blurring my eyes slightly out of focus to concentrate on the central elements of

the picture. It was not until many years later that I read of this as a technique employed by some photographers and artists when composing the scene to be rendered.

For one of the earlier climbs of the season, Tim Bond and I chose to attempt the east face of Mt. Jefferson in the Oregon Cascades. Tim was in the Cornell Outing Club and had gone on the same Adirondacks winter trip that I had been on. He also had a summer job in the Pacific Northwest. Tim was a very likeable and cheerful person. He also bubbled with enthusiasm, which made him a good

*Wet snow avalanche on Mt. Jefferson in 1956. This is the avalanche that fell down to our left, only moments after another one had shot tons of snow and ice over our heads while we crouched under the upper lip of the bergschrund. These events should have been signals to us to get out of there—fast. Instead, we continued upward. On the way down, Tim Bond took the fall described in the text.*

**The summit pyramid of Mt. Jefferson.** Even in early July 1956, the summit pyramid of this 10,497-foot (3,199m) volcano is encased in a winter-like coating of snow and ice, which made the final climb to the summit an adventure much like the climb of the east face of the peak recorded in the text. Seen here is Tim Bond. If you look carefully, you can see he is wearing what was then the standard Forest Service–issue silver hard hat with a brim. This was about the only type of hard hat available to climbers in that era.

climbing partner. Mt. Jefferson is a 10,497-foot (3,199m) volcano that is both more difficult and inaccessible than Mt. Hood. Further, the east face is not the standard route and has a 45-degree glacier slope of about 1,500 feet or more, with a run-out on rocks. Several people had been killed in falls on this route in the two or three years prior to our attempt.

Since it was early in the Cascade Mountain summer season (July 7), the approach road, still blocked by snow, added about 6 extra miles of hiking to the start of the trail to Jefferson Park, which is located below Mt. Jefferson on the north, where we camped. The next morning dawned bright, clear, and warm. In fact, it was far too warm.

By 9:00 a.m. we reached the large bergschrund at the base of the steep ice face. We heard a noise like an express train above us. Heavy wet snow, losing its cohesion with the ice layer below, was hissing rapidly toward us. We dived under the upper lip of the bergschrund as tons of snow shot over our heads. Tim was partially buried by snow that fell into the bergschrund, and I escaped with a mere pelting. I helped patch a deep wound in Tim's hand, and we watched another avalanche passing to our left, as we each thought about what might have happened if we had been 50 feet higher on the face.

Had we had any sense, we would have turned back at that point because the conditions were so obviously dangerous. We certainly had a lot to learn yet about the mountains. Lacking common sense, we continued on, encountering some of the most difficult mixed rotten rock and ice climbing either of us had experienced to that point.

The ascent of the last 300 feet over several vertical rock steps, covered with ice and snow, proved to be more difficult than anything we had yet encountered. We would have gladly tried to descend another route, but we couldn't see what was below

us in other directions, and there was no place we could safely anchor any pitons for a rappel. With dread, we concluded that we would have to descend the east face after all!

We made it without incident to the top of the steep portion of this face, then prepared to descend. I went first, with Tim a rope length behind me. I heard a sliding noise above me and looked up to see Tim hurtling toward me, then passing a few feet to one side of me. Instinct took over—I plunged my ice axe into the snow and took in as much slack as I could to give an ice axe belay. Tim actually bounced on the end of the nylon rope as my ice axe held the first, and then the second, great tug. The fall was over, and we hadn't fallen to the rocks a thousand feet below.

Since there were no rocks to hit on his rapid descent, Tim was unhurt after his 200-foot fall except for snow burns. I pulled my ice axe out of the snow and found that its wooden shaft, hitherto straight, now had a 2-inch bend to it. By all rights, the ice axe should have broken. We were very fortunate to have walked away from this climbing experience, having narrowly escaped with our lives—twice.

Tim was happiest in the mountains, but either he was accident-prone or just had very bad luck. A few years later I heard about a fall he took while climbing Mt. Rainier. He went on to become a popular and well-liked climbing ranger in Grand Teton National Park but died from asphyxiation while hanging on the end of a rope after a fall in the Tetons. This occurred before the use of climbing harnesses became commonplace, which might have prevented this type of death.

I think it was the Seattle Mountaineers who popularized the phrase "Mountains don't care." And they don't. People who say that climbing is safe if you have the proper equipment and training don't know what they are talking about. By the late 1960s

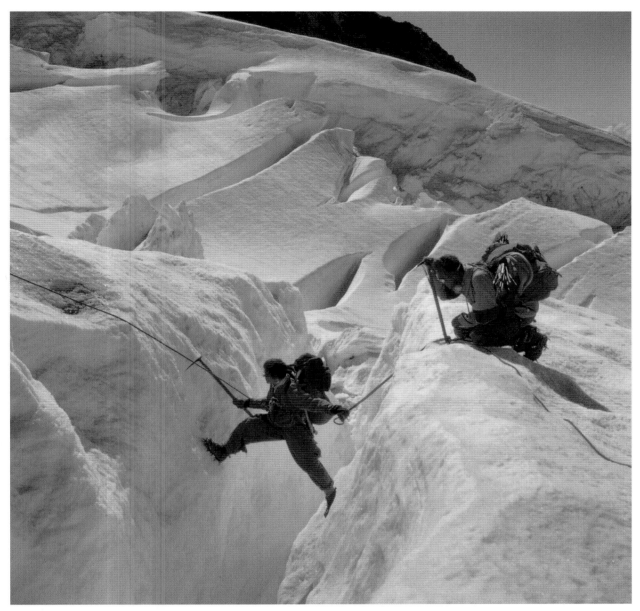

*Climbing on the Tahoma Glacier, Mt. Rainier, 1956. Mary Kay Pottinger crosses a crevasse on the Tahoma Glacier on Mt. Rainier in Washington State while Klindt Vielbig looks on. Right after I took this picture, Mary Kay fell upside down. She finally righted herself after a bit of struggle, made more difficult by the weight of her pack, and we continued with the climb.*

(after I had ceased technical climbing), I realized I had known about fifty climbers who had been killed in the mountains in just about every type of accident you can imagine. This group included many of my early climbing partners as well as simple climb-

ing acquaintances. At that point I stopped counting.

The remainder of that summer consisted of climbs of some large peaks, some small peaks, some ice climbing, and some rock climbing. The season ended with a September traverse of Mt. Rainier,

summiting via the Tahoma Glacier and descending via the standard Gibraltar Rock route to Paradise. That late in the season the Tahoma Glacier was very broken up and presented us with many puzzles in the form of interlocking crevasses through which our group of five had to work our way. It was a wonderful mountaineering experience, with two overnight camps on the mountain itself.

Oh yes, in my job at the Tacoma Smelter, I assayed for gold and silver (I still remember working in front of that furnace on hot summer days) and performed other, less relevant tasks for the company. We were given management hard hats and were allowed to wander around pretty much at will to learn the operations. It was like having a giant chemistry lab at my disposal, but I could only look (fortunately for them).

Among the products refined, besides gold, silver, and copper, were selenium, tellurium, arsenic, lead, sulfur compounds, and other good things like that. It is not surprising that for several miles downwind from the 500-foot foundry smokestack, only the hardiest weeds survived. I wondered about the health of the people who lived in that area. The hope of the smelter management was that after I graduated from college, I would go to work for them.

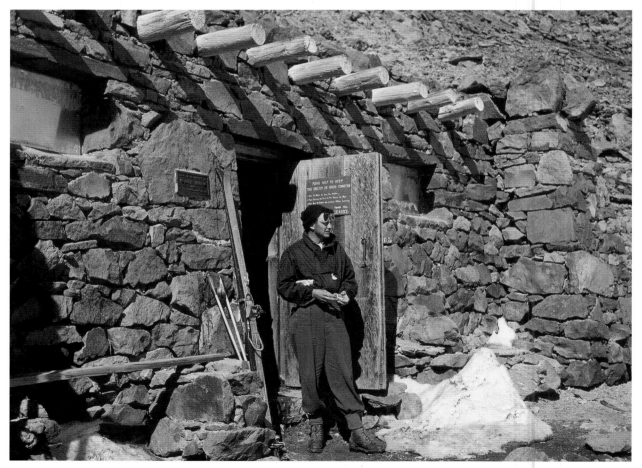

*Camp Muir on Mt. Rainier. This view of Camp Muir at the 10,000-foot (3,050m) level on Mt. Rainier was snapped in 1956. Walt "Buck" Sellers, with whom I made a number of early climbs, is standing in the doorway. On this particular occasion we spent the night here and climbed Little Tahoma, the satellite peak of Mt. Rainier, the next day.*

## CHAPTER SIX

# GOODBYE *to the* EAST COAST

hree months out of the year in the mountains was not enough. Accordingly, I applied my ingenuity to the process of transferring to the University of Washington Engineering School, where I could eat, sleep, and breathe the mountains. In this I was successful, and I left New York State in early March of 1957. Since Cornell had semesters and UW had quarters, I had a month-long break before starting UW

classes. I left New York in a snowstorm and arrived at Snoqualmie Pass, Washington, in a snowstorm. I was driving a 1947 Plymouth, the first in a line of klunkers I owned for about the next ten years. En route I had to have a costly repair made (a thrown rod), but this vehicle actually performed better than most I was to own, and it lasted through a year and a half of punishment.

A climbing journal that I kept at that time

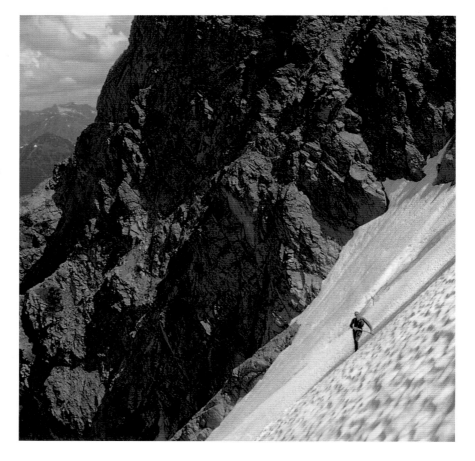

*Bob Working on the northwest couloir of Mt. Shuksan. This was taken on the first ascent of this route in 1957. Mt. Shuksan (9,131ft/2,783m) is located in the North Cascade Mountains of Washington State.*

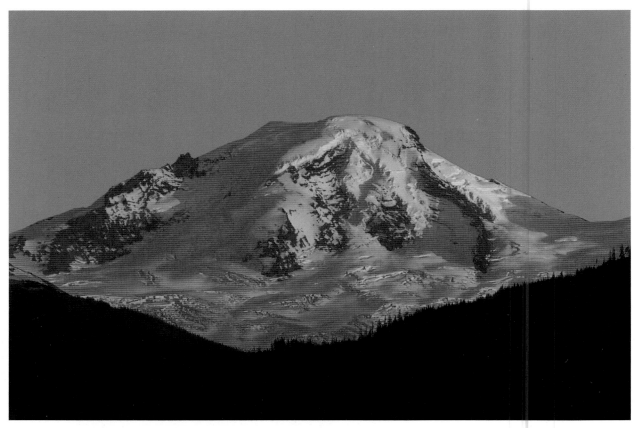

*The Coleman Glacier Headwall on Mt. Baker. Here the mountain is seen at sunset from the Mt. Baker Highway to the northwest. Mt. Baker (10,778ft/3,285m) is located in the North Cascade Mountains of Washington State. The central, sunlit portion of the face comprises the Coleman Glacier Headwall. Mt. Baker is the northernmost in the chain of Cascade volcanoes in the United States, and activity in steam vents in the mid-1970s caused concern among scientists.*

showed that I missed going to the mountains only two weekends from April 7 through November 16 of that year, and that was probably only because of extremely stormy weather.

As the season advanced, my skill at mountain craft improved. I was no longer content to climb the standard routes on peaks. I had observed what looked like a fine route of mixed rock, ice, and snow on the northwest side of Mt. Shuksan in the North Cascades (this route is now called the Northwest Couloir). The original edition of Fred Beckey's *Climber's Guide to the Cascade and Olympic Mountains of Washington* did not show a route in this

location, which provided an additional incentive.

I recruited a companion for the attempt—Bob Working—and on July 20 off we went. This new route on the peak proved to be what we had hoped for and really got our adrenaline pumping because it was exposed to rockfall and falling ice fragments from a small ice cliff near the top.

Four weeks later three other climbers and I found ourselves at the base of the Coleman Glacier Headwall on Mt. Baker in the North Cascade Mountains of Washington State. This is an expanse of fairly steep glacier ice rising in a series of ice cliffs and steep ice slopes, and at that time no route had

been climbed on it. I was somewhat more than apprehensive as we approached it on a cold morning, using an ice screw to get over one short vertical step.

There was really no good place to rest or relax on the climb, and as we climbed higher, the sun began to shine on the face, causing the snow to become soft and sloppy. The last 1,000 feet were very tiring because we had to kick steps in the snow. The climb left us all exhausted, so we spent another night in the tent on the Coleman Glacier, an event

that we had not anticipated. We had taken longer than expected, but that—as I was learning—is what one must continuously expect in the mountains: the unexpected.

Everyone missed a day of whatever they had to do on Monday. Tuesday I walked into my scientific Russian class (which I was taking in summer school), and the professor handed me an exam book. He had announced on Monday that there was to be an exam the next day. I had that terrible sinking feeling, as I

*Photographer's car at Snoqualmie Pass, March 1957. This 1947 Plymouth was the first car I ever owned—I paid $100 for it in 1956. When I crossed the country in 1957, I left New York in a snowstorm and arrived at Snoqualmie Pass, Washington, in a snowstorm. The prior night I had spent scrunched up in the backseat of the car.*

hadn't been working too hard at my studies, and because I'd had no notice, I wasn't even able to pull an all-nighter to cram, which was sometimes my mode of operation when exams were imminent.

For years thereafter I dreamed of walking into a classroom and being presented with an exam that I didn't know was going to take place. I told the professor my hard luck story about the climb, and he allowed me a makeup test a couple of days later, which I did manage to pass.

I was asked about this climb years later (in 2001) by some well-known Northwest climbers. Wherever did I get the idea for this climb? Had I heard about this headwall from Fred Beckey? I guess it is still considered somewhat of a breakthrough route in climbing standards for that time.

The fact is that I didn't know Fred at this time. I just saw this expanse of steep ice and felt that there should be a route up the center. I was influenced by the idea of "diretissimas," a concept made popular in the Dolomites of Italy that I had read about, where the climbers took the steepest and most direct route to the top.

An interesting thing happened a few weeks later. I told a climbing friend of mine, Klindt Vielbig, about this route. Klindt, in turn, told Fred, who scoffed at the idea that some unknown climbers would or could climb this headwall. Fred, famous for his first ascents, put together his own team, including Klindt, and went up to climb the headwall, where they found the steps we had kicked in the upper section. It was one of the few times that Fred made a second ascent of some route. The following year on a trip to the same area, I was admiring the face and observed a large section of ice cliff near the top of the headwall topple and sweep the 2,000-foot face directly over the route we had taken. The snow and ice particle cloud hid the view of the face for several minutes.

This year also saw an exploration of other mountain ranges. In a period of a little over a month before the start of a new school year, in what was a mad driving frenzy, I visited the summits of Mt. Jackson and Mt. Siyeh in Glacier National Park; made an attempt on Granite Peak, the highest in Montana; climbed the Grand Teton and several other peaks in Wyoming; climbed Longs Peak in Colorado; and visited the summit of Mt. Mitchell in North Carolina, the highest peak in the eastern United States.

In that same trip I also saw the Canadian Rockies for the first time. I drove the highway from Jasper to Banff. Shortly after leaving Jasper, I blew a tire, and it was not fixable (at that time the highway was unpaved). Now, I had no spare, and I had no money to buy a spare. Trusting in providence, I continued on the highway with three of my four remaining tires showing the cords. Fortunately, Lady Luck smiled upon me and I made it all the way back to Seattle with no spare tire.

# CHAPTER SEVEN

# A BAD RAPPEL *and* LOST *in a* SNOWSTORM

The new climbing season began on January 1, 1958, with an attempted climb of a new route on Grand Central Tower in the Peshastin Pinnacles of Washington State (with Fred Beckey and Don Claunch) and ended with a near disastrous ski mountaineering trip on Glory Mountain in British Columbia on December 28.

I had met Don Claunch in 1957. (His name is now Don Gordon; he changed it for personal reasons, and not—as the joke went—because he got married.) Don was a very strong climber and one of a very few at that time who were willing to try difficult (and sometimes risky) routes. Later in 1958 he was to participate in the first ascent of the Wishbone Arête on Mt. Robson in British Columbia. As was typical of climbers in that era, Don was considered very peculiar, and even a little peculiar by other climbers. He always seemed to be on a spiritual journey whose nature seemed to vary over time. I think he finally found his calling in the 1990s when he became a certified Reiki Master, specializing in energy healing and balancing.

Don had made a number of climbs with Fred over a period of several years, and that is how I connected with Fred. For some reason, which my journal did not record, this attempt on the first day of the year was unsuccessful.

No one has ever made, or will ever make, as many first ascents or new routes in alpine terrain as Fred Beckey. (*Note:* Harvey T. Carter, from Colorado, may have more new routes overall, but many of them are not strictly alpine.) Over the several years I climbed with Fred, I observed his genuine love of the mountains. In addition, his knowledge of the history, the geology, and the flora and fauna of the alpine regions was almost encyclopedic. Not many climbing partners saw or appreciated this side of Fred.

His nervous energy and almost total dedication to his next climbing objectives sometimes drove others, climbers and non-climbers alike, crazy. Who of his hundreds, perhaps thousands, of climbing partners cannot remember receiving phone calls at odd hours of the day or night, inquiring as to what the weather was like where they were, only to receive another phone call two hours later inquiring if the weather had changed? Who cannot remember the marathon trips in which he engaged, being in Wyoming for one climb, heading up to British Columbia for another climb two days afterward, and then to California for yet another climb two days later, making phone calls all along the way? Who cannot remember the persuasion he used to get you to go on a climb with him? Who cannot remember the almost continual monologue he would engage in when you were with him? And who, among his older climbing partners, cannot remember his 1957 pink Thunderbird sports car, a

most unlikely and impractical vehicle for a climber with a large amount of gear?

My wife and I recall one incident in the early 1970s when we were visiting Austin Post somewhere in the Olympic Peninsula (Austin is well known for his USGS photographs of glaciers). Fred was there, too, going through photographs looking for new routes to climb. He was also describing—in great detail—a route he had climbed recently. Austin Post's wife, attempting to be sociable, interrupted Fred with some small talk about the weather, the garden, etc. Fred's expression remained more or less frozen while she talked. She then stopped, expecting some sort of reply, and Fred immediately continued

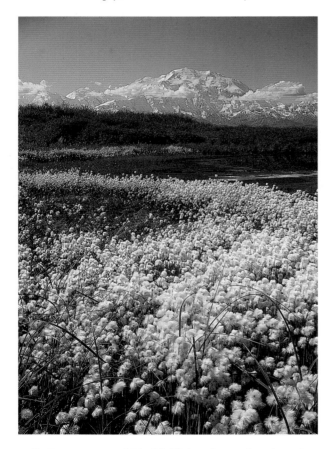

*Cotton grass and Mt. McKinley. At an elevation of 20,320 feet (6,194m), Mt. McKinley is the highest peak in North America. Here it is viewed from the north amidst a setting of tundra and taiga forest. In the foreground is cotton grass, common in the north country.*

describing the climbing route as though he had never been interrupted.

Fred did once make a startling admission to Don Gordon and me while we were making the first ascent of the northwest face of Slesse Mountain, just over the Canadian border from Washington State in the North Cascade Mountains. He allowed as how he might be one of the most disliked personalities in mountaineering.

Regarding Slesse Mountain, it was the site of a famous plane crash in December 1956. Sixty-two people died when the plane failed to clear a notch by 100 feet. This plane was rumored to have had a large cache of gold aboard. One story that circulated among climbers was that Fred tried to recruit one or two trusted people to go up and search for the gold. They couldn't go in from the Canadian side because the Royal Canadian Mounted Police (RCMP) placed guards to prevent anyone from going up there. So a much longer approach would have had to be made from the American side.

I don't believe there was any truth to the rumor. Still, if anyone could have reached that cache of gold through some of the most difficult terrain in the North Cascades (involving not only climbing but also river crossings and dreadful brush fighting), it would have been Fred.

Almost everyone who has climbed with him has a Fred Beckey story to tell. All these stories, complimentary or not, simply add to his legend.

Fred has been criticized at times in the past for not keeping up with the current standard of climbing. I don't believe this is valid. He was the standard setter in an era when very few people climbed, and as standards rose with new generations, he continued his exploratory mountaineering at a pace no one else could match. He remains to this day, in my mind, truly the grand old man of North American mountaineering.

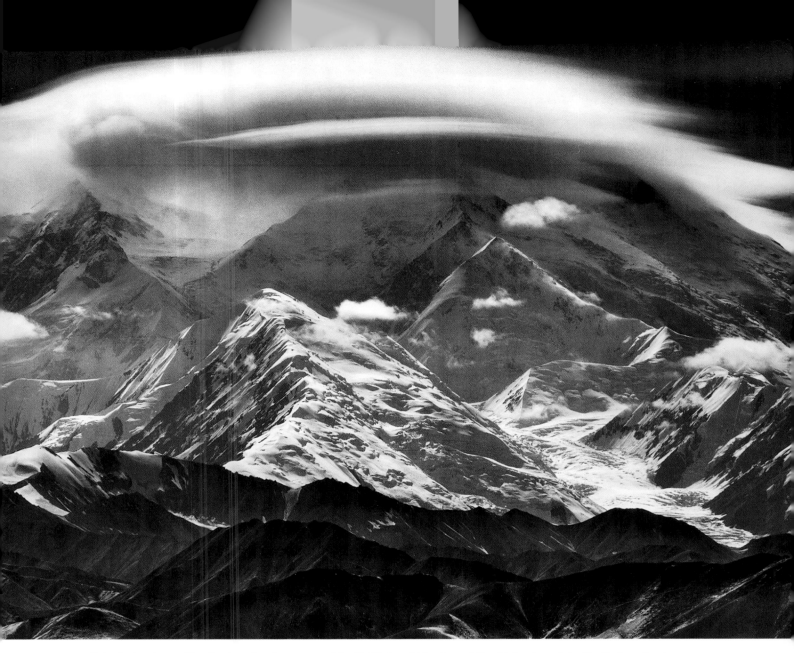

*Telephoto view of lenticular cloud cap over Mt. McKinley. This view of the highest peak in North America is from the Eielson Visitor Center in Denali National Park, some 32 miles distant from the summit. These cloud caps are often a sign of deteriorating weather and are almost always accompanied by very high winds. What started out as a clear morning developed by the end of the day into a storm that lasted several days.*

You could always count on attempting to climb a new route or unclimbed peak or pinnacle when Fred recruited you for a climb. He was sometimes deliberately vague about exactly where the climb or route was located, a practice that did not go unnoticed by me. I adopted the same tactic.

One area where we sometimes differed was in trip objectives. Fred would sometimes have as an objective a new route on a major peak, but just as often it would be some small unclimbed pinnacle that involved a long approach march. After a few of the latter trips, I declined climbing invitations from Fred unless it was for some major objective.

On May 18 of that year, Ron Niccoli and I were rappelling off the North Peak of Mt. Index in Washington's Central Cascade Mountains after an unsuc-

cessful attempt. Many things can go wrong on a rappel in the mountains, and I nearly bought the farm on that one. While I was in an overhanging section, the cord to my piton hammer jammed in my rappel sling, and I came to a stop in midair. Slowly I was losing consciousness as the strength drained out of me while I made futile attempts to untangle things.

I finally decided that even falling to my death would be better than what I was undergoing. I reached for a knife that I carried (no, not a belay knife—that's a climber's joke!) and began to slash at the mess. Something finally gave, and I completed the rappel to a ledge. I was too weak to utter a sound for ten minutes, much to the concern of Ron, who was above me out of sight and could only guess at what might have happened to me. This is another example (see chapter 5) of the usefulness of a climbing harness, an item not developed until years later. With a harness, I could have hung comfortably while untangling the rope.

I have known several climbers who have been killed in rappelling accidents, including Jim Baldwin, who was my climbing partner on the 1961 climb of the Grand Wall of the Chief near Squamish, British Columbia (see chapter 11), and also on Yosemite's El Capitan in 1962 (see chapter 15). Jim died in 1964 in Yosemite on Washington Column. Since that experience on Mt. Index, I have always approached rappelling with the utmost respect.

During the previous season a climbing partner of mine, Ken Carpenter, had planned an ascent of Alaska's Mt. McKinley via the Muldrow Glacier. He had obtained some information and black-and-white aerial photographs from Brad Washburn, the leading expert on Mt. McKinley. I had the good fortune to view the photographs, which were stunning.

I had no idea photographs could be so sharp; the lighting and contrast control seemed perfect. These images evoked in me the same kind of awe and admiration that I felt when viewing the unforgettable and famous image of Mustagh Tower in the Karakorum in Pakistan, taken by pioneer mountain photographer Vittorio Sella (1859–1943) about a century ago. I began to awaken to the possibilities of photography.

As it turned out, Ken was unsuccessful in his attempt on Mt. McKinley. There had been a surge in the Muldrow Glacier, as could be seen from comparing Ken's expedition photos with those aerial photographs Brad had taken several years earlier. The glacier had become so broken up as to make it an impractical route. The beauty of the mountain as revealed in Brad's photos prompted me to make plans for an attempt by a different route the following year.

In June and July, five other climbers and I made the second ascent of the West Buttress of Mt. McKinley, at 20,320 feet (6,194m), the highest peak in North America (pioneered by Brad Washburn and his eight-man team in 1951).

We were flown into the Kahiltna Glacier by legendary bush pilot Don Sheldon. Don was an amazing person. I observed him flying his clients for almost thirty-six straight hours nonstop, one by one, from the mountain back to the Talkeetna landing strip. He would refuel his plane between flights. I remember noticing all the fumes of aviation fuel while he refueled and the fact that he was breathing them as he did this work by himself. Years later, I wondered if this had anything to do with his premature death from cancer.

It's a wonder we didn't have some sort of disaster on the mountain, considering that most of us didn't know each other until we met in Alaska before the climb and the different skill levels of the

*Climbers at the 14,000-foot (4,267m) level on the West Buttress route on Mt. McKinley, 1958. Mt. Foraker (17,400ft/5,304m) rises in the distance above a sea of clouds.*

group members. It was left to me to do all the organizing in Seattle; other members were from the northeast United States, Canada, and Alaska.

Climbing up the West Buttress (whose top is at 16,000ft/4,877m) from a camp at Windy Corner (about 13,000ft/3,962m), we decided to climb up rocks to the left of a smooth, steep snow/ice slope.

The rocks looked easier—that is, until we got there. (Difficult terrain often looks easy when viewed from just below, which gets many inexperienced climbers in serious trouble in a hurry.) We had unroped, having expected easier terrain.

I found myself climbing up a steep chimney of rock and ice, wearing crampons and carrying a

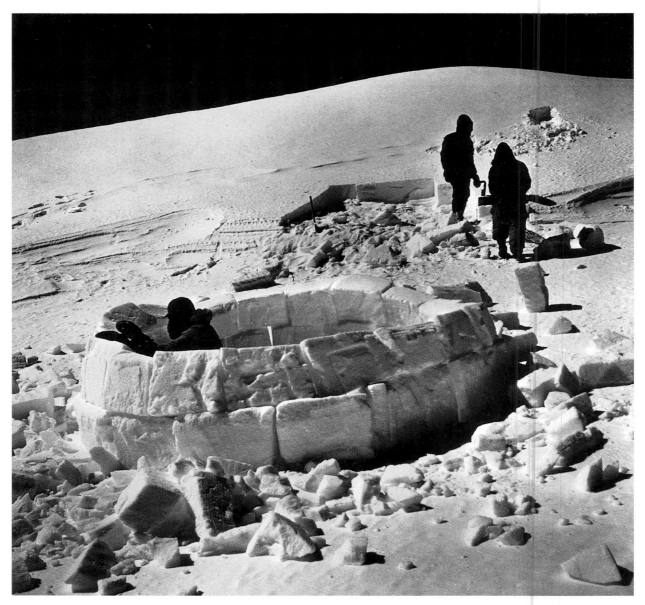

*Building an igloo at the 17,100-foot (5,212m) level on Mt. McKinley, 1958. The snow "quarry" can be seen in the background together with one of the climbers holding a snow saw. We built igloos at two camps and used a combination of snow caves and tents at other camps on this second ascent of the West Buttress route.*

heavy pack. At the top I found a very steep ice ridge, which I followed up for another 200 feet. When I called for the others, they all decided they were too tired, announced they were retreating to the glacier at about 14,500 feet (4,420m) to camp, and urged me to come down. As there was no way I could climb down that ridge and chimney safely,

I continued up to the top of the West Buttress, where I dug a partial snow cave to protect myself in the deteriorating weather.

The next day, in a snowstorm, the other five expedition members arrived at my campsite. That was fortunate because I couldn't have lasted much longer with virtually nothing to eat or drink. The

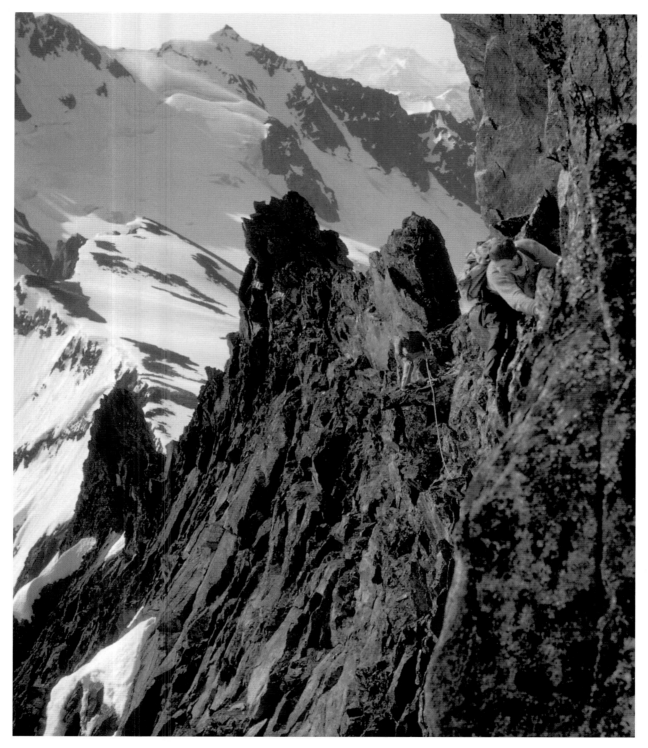

*Climbing on the East Ridge of Forbidden Peak, 1958. This is one of my all-time favorite peaks in the North Cascades, since I climbed three new routes on it, as well as completing the first traverse from Mt. Torment. Seen here is Don (Claunch) Gordon belaying Fred Beckey on the first ascent of the direct East Ridge of Forbidden Peak. My climbing partner was Joe Hieb (not seen here). In the background you can see Boston Peak (at extreme upper left edge) and Sahale Peak to the right.*

next day one of them set down his sleeping bag on the snow, and the wind blew it off the West Buttress into the depths. The rest of the trip we had to provide him with our down jackets and pants to sleep in. Many people have died on Mt. McKinley for mistakes far smaller than the ones we made.

To make a long story short, on July 2, 1958, only a couple of days before Alaska officially became a state, four of us reached the summit, with the members from the northeastern United States remaining behind at the high camp due to altitude sickness. A bamboo pole placed there in 1947 was still standing. The weather was beautiful, with no wind. Despite a temperature of -8 degrees Fahrenheit (-22 degrees Celsius), the radiant energy of the sun at this altitude made it possible to take off our gloves, unzip our parkas, and enjoy the summit at our leisure.

There was one touch of levity on the trip. While we were on the mountain, one of our members, Bruce Gilbert (from the agricultural community of Yakima, Washington), performed a nightly ritual of stripping down to his bare skin and then putting on his pajamas before crawling into his sleeping bag. When I went to sleep, I often wore every article of clothing I had, which kept me warm and therefore made it much easier to get out of the sleeping bag when it was time to get up.

I discovered a couple of things about myself as a result of this experience: (1) I didn't like the responsibility of organizing a major expedition, and (2) I missed the color green (we were on the mountain in the midst of snow and ice for almost three weeks). Vanished were any aspirations I may have had about organizing trips to the high peaks of the Himalayas.

There were many climbs and new routes that season, but only one really stands out in my mind. In 2002 Peter Potterfield, noted climber, journalist, and author, asked me to write down any thoughts I

might have about the Mt. Torment–Forbidden Peak traverse near Cascade Pass in the North Cascade Mountains of Washington State. I'll just quote my reply to him here:

I consider it one of the three peak (pun intended!) experiences in my mountaineering phase. I had seen this long ridge in three previous trips to Cascade Pass that same year (1958). I thought it would be a great mountaineering adventure, and it was. We experienced some of the best scenery and alpine climbing to be had in the North Cascades. I made the climb with Walt Sellers, with whom I had made one or two other climbs. (Walt is now an attorney and still plans a yearly multiday trip in the North Cascades.)

Our gear was primitive; we didn't take sleeping bags to save weight (we knew that we would spend the night up there and actually looked forward to the experience), but we had some sort of sack that we huddled in together for warmth (it didn't provide much). Despite that, it was a splendid trip. It would provide a total North Cascade experience to anyone doing the traverse.

And get this—it was the last weekend of July in absolutely clear weather. We camped Friday night in about the last campground before the trail. We didn't see a single soul all that weekend, not in the campground, not on the peaks! Try that now.

On the last trip of the season, December 28, a group of three or four of us planned to ski to a hut on Glory Mountain in British Columbia where we would spend the night. The next day we would tour around and possibly climb to the summit.

We should have paid more careful attention to the weather forecast. A storm was predicted, and it hit with full fury before we reached the hut. We were struck by one of those blizzards in which the wind was blowing so hard that snow entered every opening in your clothing and visibility was reduced to a matter of feet. One member of our group

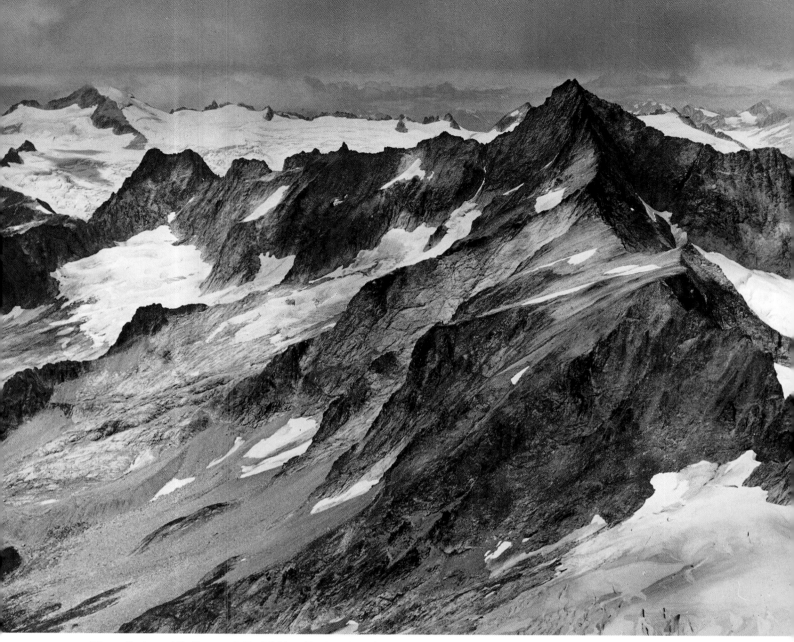

*The mile-long Mt. Torment–Forbidden Peak ridge. On the left is Mt. Torment (8,120ft/2,475m); Forbidden Peak (8,815ft/2,687m) is at right center. Eldorado Peak (8,868ft/2,703m) appears at upper left with its summit just covered by a cloud. This is in the North Cascade Mountains of Washington State near Cascade Pass.*

assured us he knew where the hut was.

As darkness fell, we still hadn't found it, and we started to prepare for surviving a night out in the open in a full-blown storm. We occupied ourselves digging a snow cave with our hands or whatever other tools we had on hand. We were already losing feeling in our fingers and toes. As luck would have it, one of the group went on one final, probably fruitless, search. He found the hut, at last light, within 100 feet of our location.

Finding the hut probably saved some of our fingers and toes. Feeling the heat of the fire we built in the stove was both wonderful and extremely painful, as feeling slowly came back into our extremities. It was a lesson on the importance of carrying sufficient emergency gear to survive a situation such as this.

# CHAPTER EIGHT

# A GRISLY DISCOVERY
## *and* "AVALANCHE!"

As 1959 rolled in, no dream seemed impossible. I let my imagination run loose on climbing objectives, an attitude that led to several great failures as well as some spectacular successes.

I also made the transition from being a student to being a full-time climbing bum when I graduated from the University of Washington in June with a bachelor of science degree in metallurgical engineering. I was now totally on my own. Horror of horrors—I was faced with the prospect of gainful employment. I considered this option seriously—for maybe ten minutes.

And then I was off for a summer of adventure, with no mind as to what would happen in the autumn when I ran out of the meager funds I did have. Truthfully, I became somewhat fatalistic. What was the point of planning beyond the next climb if I didn't know whether I would be around for another climb after that?

For the first grandiose project of the season, I chose one of the most beautiful and aesthetic climbs I could think of. This was the incredibly smooth and steep north ice face of Mt. Robson, the highest peak in the Canadian Rockies. No matter that it was only March and that I had never set foot on this mountain.

I had a plan. We would climb the north face and then descend by the Conrad Kain route on the east face, about the same steepness as the north face but shorter. I bought 600 feet of ⁵⁄₁₆-inch nylon rope on a spool. When we arrived at the steep section of the Conrad Kain route (on the descent), we would simply anchor the rope at the top and let the spool run out. We would use it as a guide rope to aid in the descent of unfamiliar and ice-covered rocks.

Ron Priebe and Irv Dunn were willing to accompany me on this mad project during our spring break from studies. We took the train to Mt. Robson. Once we got off the train we were on our own. Nobody was there at this time of the year (this was before the Yellowhead Highway was completed). We set off on skis with very heavy packs. Three days later we found ourselves at a high camp at about 9,000 feet (2,743m) on the Berg Glacier, right below the face we planned to climb.

The weather, which had been perfect for two days, now turned against us; very high winds and gathering clouds greeted us the morning we were to start on the face. We had no choice but to turn back. As if to taunt us, the weather turned very warm on the way back to the train station, and we sank deep into the snow at almost every step.

Later in the season, in July, I recruited Fred Beckey (it was usually the other way around) as a partner for this climb. This time we reached a point probably 800 feet below the top (or about 1,300 feet up the face). Fred didn't like the conditions (soften-

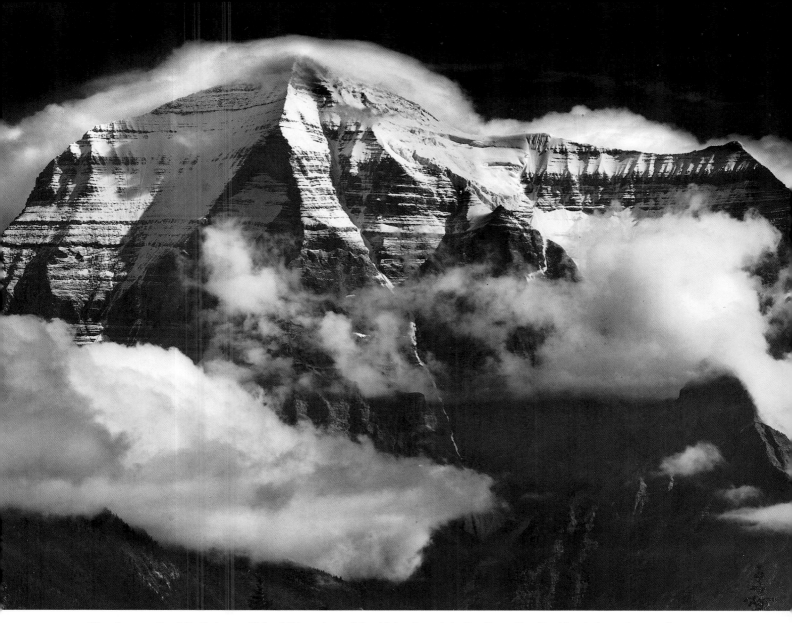

*Clouds wreathe Mt. Robson. This striking view of the highest peak in the Canadian Rockies is from the south-west. This is an example of the waiting game involved in photography. You set up the camera and then wait and hope for the clouds not only to part, but also to form into a pattern that is pleasing to the eye, which they did in this case. There have been countless times I have set up a camera and waited more than an hour for a scene to unfold, only to finally give up and pack up the photo gear without taking a single picture.*

ing snow about 2 feet deep on top of blue ice), so we turned back. I disagreed with the decision to turn back, but in retrospect, he was correct.

After we descended, some wet snow avalanches swept the face. If I had been with someone else, we probably would have continued going up, and we would likely have wound up as one more statistic in the climbing accident reports. I was to have one

more unsuccessful try at this route, which will be related in a later chapter.

Another failure that season was the north face of Mt. Baring in the Central Cascade Mountains of Washington State. Part of the vertical profile of this face can be seen from the Stevens Pass Highway; for that reason, it became a magnet for the top climbers of the day. This face was the then-current "last

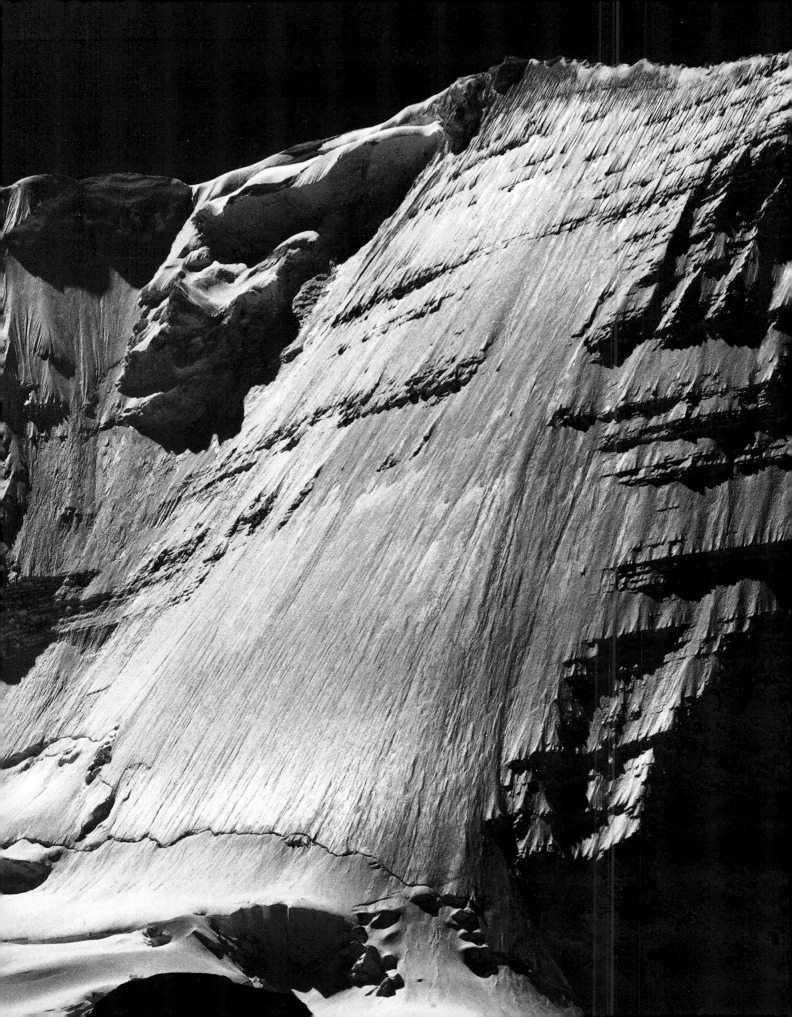

unsolved problem." There had been six previous attempts, starting in 1951. One climber had been killed in a descent from one of the attempts, while he was with Fred Beckey and Tom Miller.

I thank God that I was never on a climb where anyone was killed. The worst accident that ever occurred to anyone on a climb in which I participated was a broken foot. This happened twice: One was on the ski descent after a winter climb, where my partner fell wearing the old-style "bear trap" ski bindings, in the days before safety bindings became common; the other was on a rock climb when my partner fell while jamming a crack. That I never suffered a major injury on a climb amazes me to this day, when I think of the routes I did and the chances I sometimes took.

So there was a little sense of foreboding when Don Gordon, Fred Beckey, and I headed up to Mt. Baring for yet another attempt on the face. We reached the high point from the previous attempt, and then the puzzle began. The extremely thin cracks in the rock would not accept the pitons that were available at that time. Further, bolts were almost impossible to place. The rock was extremely hard and brittle and, after the hole for a bolt was drilled, the rock would shatter when you tried to drive in the bolt.

Nevertheless, we did manage to place one $\frac{3}{16}$-inch bolt for an anchor. Don free-climbed about 15 feet above the bolt and then announced that he was going to fall. Fred and I held our breath and shouted encouragement. One bolt of that size for an

*The north ice face of Mt. Robson. At 12,972 feet (3,954m), this is the highest peak in the Canadian Rockies, which straddle the Alberta–British Columbia border throughout much of their length. Mt. Robson itself is located wholly within British Columbia. This is the view as seen from the shore of Berg Lake.*

anchor does not inspire confidence. Fortunately, Don managed to down-climb to the bolt.

We psyched ourselves up for another try, with either Fred or me leading. At this point, Don—who had a job to return to—announced that he needed to return to Seattle, because it was Sunday and it was obvious that we were going to have to spend another night up there. Fred tried to persuade Don to stay up there, promising that he would talk to Don's boss on Tuesday and that everything would be all right. Fred started promising the moon to Don, if only he would stay up there to continue the attempt. (Fred can be extremely persuasive; there are legends about the way he has convinced people to go on climbs—or continue on climbs—even after they have said no several times.)

In this case Fred's persuasiveness did not work. Picture this: We were all in a very precarious spot, standing in slings, and Fred and Don got into an argument that became increasingly loud and abusive. Since they were right next to each other, I actually thought they were going to get into a fistfight.

In the end, we all went down. All the way back to Seattle, Fred and Don would not speak to each other. Anytime Fred had something to say to Don, he would address me and tell me to tell Don (in the backseat) whatever it was he had to say. And Don did the same thing in reverse.

Interestingly, the next time Fred called me or Don, he didn't mention this confrontation, pretending it had never happened. All parties involved seemed to go along with this charade, more or less. The three of us were to have another go at this same climb the following year.

This year I pretty much stopped keeping my journal. I have only a few pencil notes about some of the climbs. Over the years, I lost a whole page that had some notes on climbs made that summer.

Also, since I was so busy going from climb to climb and didn't really have a home base, it was more difficult to stay organized and keep notes. The very last notes I have date from early 1960. At the time, I was probably the first Northwest climber to devote himself full-time to the sport.

I discovered the Bugaboos of British Columbia that year. The smooth granite forms and clean lines of the peaks immediately attracted me when I first saw them. The Bugaboos became a playground as I settled in for several weeks, camping under a huge boulder at the appropriately named Boulder Camp (this was before the construction of the Conrad Kain hut).

The thing I remember about this boulder is that when the sun rose (if the sun were visible, that is), it would shine directly into the sleeping spot for about twenty minutes until the angle of the sun rose above horizontal. Some years ago someone told me that this camp was called Cooper's Cave.

Since I was there by myself, I set my own pace. Solo climbs included Pigeon Spire, Bugaboo Spire, and Snowpatch Spire; likely this was the first solo of Bugaboo and certainly the first solo of Snowpatch. On the top of the latter, I encountered Canadian guide Willy Pfisterer (and party), who inquired where my partner was. When I told him I was it, he shook my hand.

Snowpatch proved to be a little easier than its reputation at the time, and the adrenaline was really flowing in me, so I got up with no trouble, self-belaying with my own arrangement at the crux of the climb.

An interesting thing happened on the top of Bugaboo Spire. I was looking at an attractive snow-clad peak maybe 10 to 20 miles to the west. As I watched in amazement, a dark curtain seemed to descend from the summit area and envelop most of the snow on the mountain. A cloud started to rise up from below and maybe a minute or more later, I heard a loud, low rumble. I had been perhaps the sole witness to a landslide of gigantic proportions.

I wandered around on the glaciers by myself, just taking in the beauty of the area. One day I completely circled Bugaboo Spire. En route I reconnoitered possible new routes up the west face. I sat down to rest and eat something on a talus slope immediately below the face, and as I was eating, I happened to glance between the rocks and melting snow, where I noticed a bone.

Had someone else stopped at this same spot years ago to eat some chicken or something else with bones in it? Given the remoteness of this spot, it didn't seem likely. On further inspection I found a few more bones, a piece or two of tattered clothing, and part of a boot. Maybe someone had left the boots, changing into more comfortable rock climbing shoes? This find troubled me a bit, but I had to move on, so I thought no more about it at the time.

Several days later I climbed a new route on the west face of Bugaboo Spire with Elfrida Pigou, along a line I had picked out. Like me, she was another independent soul and had one time been asked to leave one of the climbing camps of the Alpine Club of Canada for not following standard procedures and rules.

It wasn't until I was on my way back to Seattle in the klunker I then owned that the truth of what I had found hit me. I remembered an article that had been featured in the *Reader's Digest* about a party of three struck by lightning on the summit of Bugaboo Spire in 1948. Two people had recovered sufficiently to be able to go down for help, but they had to tie the third person, burned and in shock, to a rock close to the summit, to prevent him from falling. When rescuers returned to the spot, all they found was the untied rope. The remains of this climber were what I had encountered.

Back in Seattle I cast about for some climb that would test my abilities and be good training for a really big wall. Snow Creek Wall near Leavenworth was an excellent candidate. It is about 700 feet high, extremely steep, good rock, and had no route up the central portion of the wall. In late August I approached the wall with Galen McBee. It was afternoon when we started, but that was all right.

We planned to spend the night on the wall just to get the feel of spending the night on a face where there was no ledge to sleep on. At the relatively low elevation of the wall (between 3,000 and 4,000 feet), it was not too cold but still was quite uncomfortable. Despite the fact that we were more or less hanging from slings, the whole experience was exhilarating. The climbing was both challenging and continuous.

We felt at the time that it had been a "breakthrough" route in standards and objectives—choosing a route simply because it was longer and more direct. It was excellent practice for things to come.

That September I drove back to New York to visit my parents, pork up, and get my stamp collection. I sold it in Seattle early the next spring for about $1,000. I felt bad about doing this, since I had put so much effort into it. No doubt this collection would now be worth many times that figure, but that money kept me going through much of the 1960 climbing season.

On the way back to the Pacific Northwest, I detoured to the Southwest, where together with John Ohrenschall I climbed the North Tower of Shiprock in New Mexico (we made a mistake in

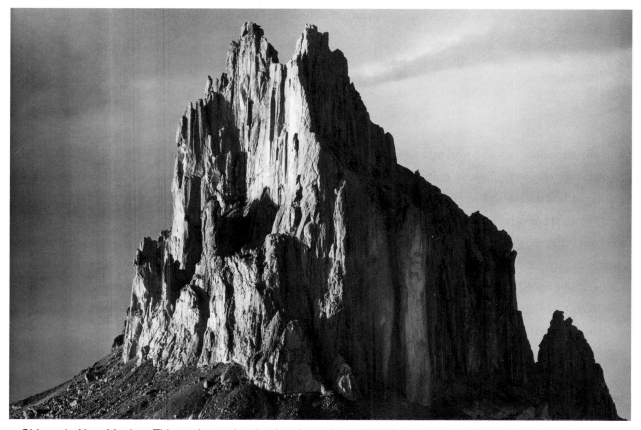

*Shiprock, New Mexico. This ancient volcanic plug rises about 1,700 feet above the floor of the desert in north-western New Mexico to an altitude of 7,178 feet (2,188m). Shiprock is located on the Navajo Indian Reservation, and climbers must obtain permission from local Navajo land-use permit holders to climb the rock.*

*Rappelling on Lizard Head, 1959. John Ohrenschall makes a long rappel on this 13,113-foot (3,997m) peak in the San Miguel Range in southwest Colorado. The rotten rock on this peak reminded me of the crumbling volcanic rock on the Cascade volcanoes. This rock is, in fact, volcanic in origin, and the peak is an ancient volcanic neck.*

route finding that led us to the lower, but more difficult, North Tower) and Lizard Head in Colorado.

We were drawn to the latter peak by a description in Robert Ormes's *Guide to the Colorado Mountains* (1955 edition), which described the approach route and then stated: "Take photograph and go away." What climber can resist a challenge like that? In any case there was a lot of truth to that statement. The rock was about as rotten as it is possible for rock to be and still remain standing.

One further incident took place that year that nearly ended this story. In the second half of November, six of us decided to climb up to Camp Muir at the 10,000-foot level on Mt. Rainier (with climbing skins on our skis) and then ski down.

Leaving from Paradise at about the 5,500-foot level, we broke above the clouds at about 6,000 feet. As we climbed higher above the clouds, we noticed they had an unusual "boiling" feature to them. The wind was also very strong, so strong, in fact, that bits of ice were being picked up by the wind and hurled into our faces, giving the sensation of bee stings. Since it would only get worse as we gained altitude, we decided to abort the effort at the 7,500-foot to 8,000-foot level and ski down.

We each picked our own route down, although we remained in sight of each other and fairly close together. Several others and I were crossing at mid-level in a bowl-shaped basin while the last of the party to start down was traversing the upper portion of this same basin. I heard someone yell, "Avalanche!" and looked up to see a wall of snow taller than I was rushing at me. I really thought my last moments on earth had arrived.

Before I could react, I was tumbling head over heels, enveloped in snow. I sensed the avalanche slowing and the last thing I did before it stopped

was to put my hands in front of my face to create what I hoped would be an air pocket. Once the snow stopped, I was totally buried and immobilized. The same snow that can be so soft and fluffy when it is falling and fresh turns into something more like concrete when you are buried in it. Fortunately, I had managed to create a tiny air pocket.

After some time, I did hear some muffled sounds. I could even make some of my own, which I hoped would be heard. Meanwhile, the cold was seeping into every pore and cell of my body as I tried to resist thinking about the possible finality of it all. After what seemed an eternity, but was probably more like half an hour, I heard digging action going on above me.

My head was soon exposed to daylight, and daylight had never seemed sweeter. It probably took the better part of an hour to completely free me from the snow. Several others had been partially buried but had managed to free themselves with the help of two others who hadn't been caught in the avalanche at all. Luckily, there were no fatalities or serious injuries.

We all went down the mountain and rented a cabin where we could warm up. I spent probably forty-five minutes in a very hot shower trying to counteract the shock my body had received. I had inhaled a lot of snow during the avalanche, and there was a quantity of water in my lungs that took several days for my body to absorb.

The very next day a once-in-a-decade warm rainstorm moved into the Cascade Mountains and melted all the fresh snow up to a fairly high elevation. Among other damages caused by this rainstorm was the destruction of the major east-west highway through the Cascade Mountains, the Snoqualmie Pass Highway. It was almost a week before even an emergency bypass could be constructed.

# CHAPTER NINE

# A SOLO EXPERIENCE
## *and a* LARGE ROCKFALL

In the spring of 1960, Castle Rock, a popular practice climbing rock in Tumwater Canyon near Leavenworth (within driving range of Seattle), was the premier gathering place for climbers to socialize and find climbing partners. It became a giant jungle gym for aspiring climbers—there weren't that many of us—as we started to get into shape for the season. It was here in the spring of 1960 that I made my first climbs with Jim Baldwin, with whom I made some major ascents later (see chapters 11, 13, and 15).

In Seattle itself, there was the water tower in Volunteer Park, the "climbing gym" of its time. The water tank was enclosed in a brick facade where it was possible to gain tiny handholds and footholds. Climbers could try to circle it a few feet above the ground to get their fingers in shape.

On Castle Rock I would solo the Midway or Saber routes to get warmed up for tackling more difficult routes with partners. (I think my best time on the Midway was a little more than five minutes.) The first part of the Angel route (called the Angel Crack) became a boulder problem for me, and I frequently climbed this portion unroped. I note with surprise that it is now rated at 5.10. We rated it at 5.7 at the time, reserving 5.8 and 5.9 for harder moves, believing that 5.9 was at the top of the scale.

The current scale of difficulty on the Yosemite Decimal System runs to 5.14, with further subdivisions 5.14a through 5.14d. For those of you not familiar with this rating system, 5.9 is rated easier than 5.10. Think of it as "five point nine," then "five point ten," not "five point one zero," which mathematically would be less than five point nine.

The competition to put up new routes heated up. It was open season on anything by anybody. All this undoubtedly raised the climbing standards rapidly for everyone involved. These higher standards trickled down to new wannabe climbers just entering the scene. It would be this new generation of climbers that helped to turn climbing into more of a mainstream activity, instead of what appeared to many as a refuge for kooks.

Among the major items on my hit list for the 1960 season were (1) the "final solution" to the north face of Mt. Baring; (2) the east face of Bugaboo Spire in the Bugaboos (an attempt the previous season by Art Gran and me had fallen about 700 feet short); (3) various new routes on volcanoes; and (4) one other objective I dreamed up, which is described below.

The three peaks of Mt. Index are a familiar landmark to anyone traveling the Stevens Pass Highway in Washington, the more northerly of the two main routes that cross the Washington Cascades. The Main Peak is an easy climb by most routes, but the Middle and North Peaks are difficult climbing objectives, and all serious climbers in the Cascade Mountains sooner or later turn their attention to

*Climbing the Angel Crack. Photo of photographer/author climbing the Angel Crack on Castle Rock, in Tumwater Canyon near Leavenworth, in 1960. At the time we rated it 5.7, as we considered 5.9 the top of the scale. It is now rated 5.10, with the scale going to 5.14.*

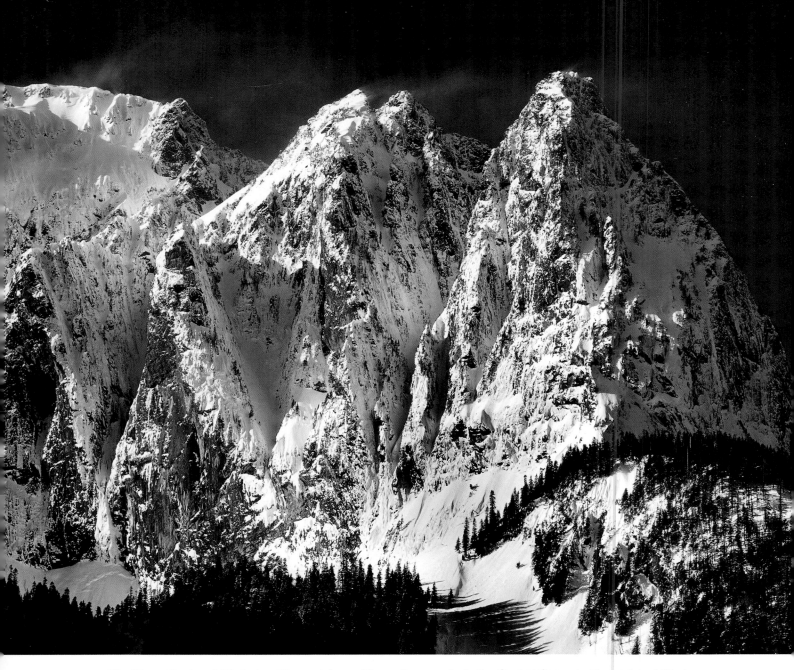

*The Three Peaks of Mt. Index. The east face of these three peaks in the Central Cascade Mountains of Washington State is seen here from the Stevens Pass Highway, U.S. Highway 2. This is a familiar sight to skiers in the winter. Left to right: Main Peak (5,979ft/1,822m); Middle Peak (5,450ft/1,661m); North Peak (5,357ft/1,633m).*

them. At that time, the Middle Peak had been climbed only once, on a north-to-south traverse of the three peaks.

My mind conceived an audacious plan. Without telling anybody where I was going, I left Seattle and drove up to the Mt. Index area. Please note: *This is NOT a recommended course of action for any-*

*body heading out for a mountain trip.* I had a burning idealism for climbing that overpowered rational judgment.

This was to be the second of my three "peak" mountaineering experiences (the first one is described in chapter 7). My plan was to make the first traverse of the three peaks of Mt. Index from

south to north, from the Main Peak to the North Peak. This traverse would involve the first climb of the Middle Peak from the south (and its second ascent) and the first climb of the North Peak from the south. Further, I had never climbed the North Peak. My experience with it had been limited to an attempt only about 40 percent complete, and the near disastrous rappel described in chapter 7.

Route finding going down a peak can be considerably more difficult than route finding going up a peak. If you come to an impasse in an ascent, you can always retreat. If you are descending and rappel into unknown territory, pull the rope down, and then reach an impasse, you are in very serious trouble.

Realizing that speed and ease of movement in difficult spots were of paramount importance, I left behind almost everything that one normally takes along on a climb of this sort. Everything I needed to make this attempt weighed about 25 pounds, and it all fit into a daypack with the exception of a 300-foot length of 5/16-inch nylon goldline, which I alternately tied to the pack or wore around my neck. (This is thinner than normal rappel rope, but I felt confident it would hold my relatively light weight in the long rappels that I knew I would have to make.) I had maybe a dozen assorted pitons and sling rope to make rappel points.

I proceeded to climb the Main Peak and then started the descent to the notch in between the Main Peak and the Middle Peak. Night overtook me on the descent. It was a beautiful night. The stars shone brilliantly, and from my comfortable bivouac spot, I watched the cars travel on the Stevens Pass Highway far below. I truly felt "one with the mountain." (*Note:* This is an expression borrowed from the famous French mountaineer Gaston Rebuffat, but it is appropriate.)

The next day I completed the descent to the notch between the Main Peak and the Middle Peak. My body was on a natural high as I climbed class 4 and 5 pitches to reach the summit of the Middle Peak, and then approach the notch between the Middle and North Peak. I discovered I was a rope length away from the notch, separated by a wall that dropped off several thousand feet. I couldn't climb back up; I had rappelled over an overhang and had already pulled the rope down after me. As I was traversing this wall unprotected, a handhold came out and I nearly plummeted down with it. When I reached the notch, I started shaking visibly and had to wait until my body calmed down.

Attempting to ascend the North Peak, I reached one dead end, then another. Finally, on the third try, I reached a point where there was a very short overhanging pitch over a 3,000-foot drop. It was this or nothing. I pretended that the drop wasn't there and that I was only climbing a difficult boulder problem right above the ground. This was the only frame of mind that would allow me to do this pitch. The rest of the way to the summit of the North Peak was a breeze.

I had not carried any water, counting on finding snow, but I had encountered the last snow before reaching the summit of the Middle Peak. These were the hottest two days of the year so far in Seattle, and when I encountered the one and only snow-patch below the summit of the North Peak, I spent an hour eating snow. My senses, on heightened alert, guided me as I placed the necessary rappels to descend the North Peak. By now I was glad to get down but sorry the experience had come to an end. It was one of those adventures that you wish could have continued indefinitely. Living on the edge, I felt freer than I had ever felt before.

That spring I met a remarkable young man— Mike Swayne. He matched me for enthusiasm of

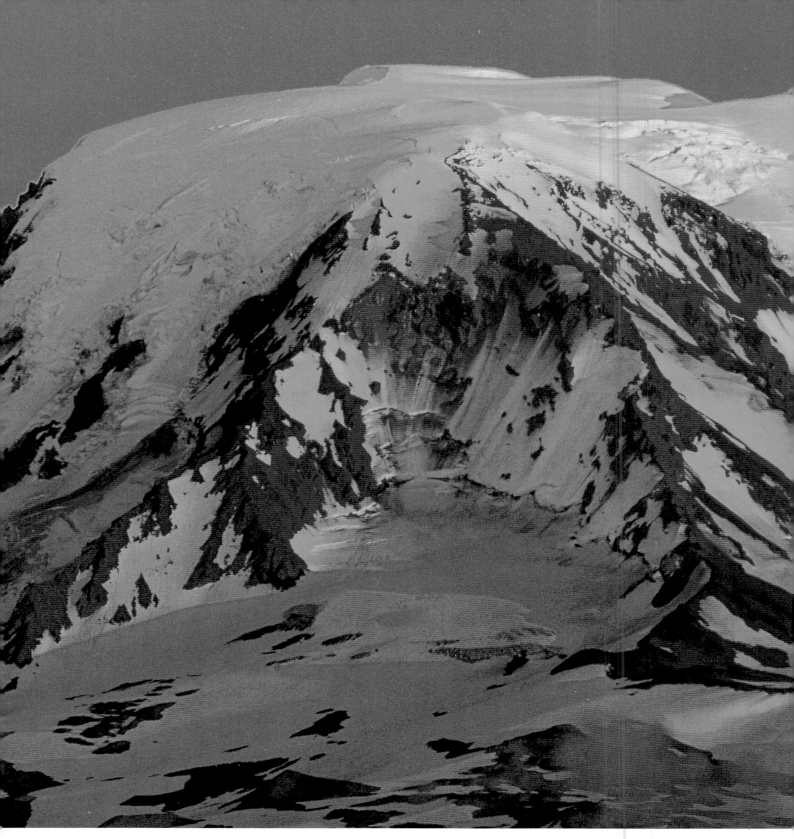

*Mt. Adams viewed from the north. At 12,276 feet (3,742m), this is a member of the chain of Cascade volcanoes and is located in southern Washington State. The Lava Glacier Headwall is in the center, partly in the sun and partly shaded. The Adams Glacier is at upper right, and part of the east face is seen in the shaded area on the left.*

the unknown and was even more than a match in his endurance. He was a member of the Trail Blazers, a group that stocked backcountry lakes with fish, and some of the lakes are just as hard to reach as the more remote summits of the North Cascades. I could match him step for step, but his legs (and therefore his stride) were longer than mine were. As a result, when we hiked together, I would start to fall behind slightly, and every so often I would have to run a little to catch up with him.

After Mike and I, in the company of two other climbers, had climbed a new route on Mt. Baker in late June (the Roman Nose), we headed down to Mt. Adams to tackle another route I had picked out—the steep north-facing Lava Glacier Headwall.

I have memories of this climb, but whatever I had written down about it at the time I have lost. Fortunately, Mike kept very detailed journals of all his mountain experiences, something I didn't know until 2001. Following is an excerpt from his description of that climb:

> At 2:00 a.m. we were up, ate, put on crampons, and headed up. We dropped onto the Lava Glacier and started up the slope to the bottom of the headwall. The headwall is very imposing. The morning sun was casting an orange glow on 3,000 feet of ice and rock bands at what looked to be a near perpendicular slope. We crossed three crevasses at the bottom to get onto the headwall, and then we started up.
>
> There was constant rockfall so we climbed roped together without belaying for the first thousand feet. The ice was firm but steep, averaging about 50–55 degrees. I didn't want to think what would happen if someone slipped. There was no way you could have stopped before hitting the bottom.
>
> About 2,000 feet up there was a loud boom on the cliffs above, and a large avalanche of rocks came thundering down on us. Rocks hit the slope above and then flew hundreds of feet before hitting

again. We only had a few seconds to move but there was no place to go. One large rock was zigzagging right at us, so Ed went right and I went left and it went between us.

> Behind rocks as large as cars were scores of smaller ones. We just leaned in to the slope hoping they would go by or over our heads and not hit the rope. There were rocks going over us, between us, around us, and hitting us. We were shaken up, but we were wearing hard hats and by some miracle nothing of any size hit us.
>
> When the activity subsided, we extended ourselves and finished the next thousand feet without stopping. At about 11,000 feet, above a steep chute through a rock band, the slope began to ease so we stopped to rest. Ed built a cairn on a rock projection at the top of the headwall to show that we had been there.
>
> The route soon merged with the upper part of the North Ridge. From here we contoured around the head of the Adams Glacier to the summit, arriving about 9:15 a.m. The climb had covered about 6,000 feet in five hours.
>
> The weather was good so we could see for miles in all directions. Coming down, we met a party from Yakima headed by Les Maxwell, who had come up the Salmon Glacier. We descended the North Ridge, where we met the Everett Mountaineers coming up. They had seen us on the headwall, had seen the rocks come down, and thought we were goners. We hurriedly finished the rest of the ridge, picked up our gear, and hiked out.
>
> Note: The Mountaineers wrote an article in *Summit* magazine about watching our miraculous escape on the Lava Headwall. They thought it was impossible for us to have survived.

Were the mountains trying to send me a message? If so, I wasn't listening. In late May I went with Ron Niccoli to take a look at the north face of Mt. Baring. There is some fierce brush fighting in the lower portion, even before setting foot on rock. We fought our way through a thicket of slide alder

to a 10-foot clearing in the middle of the brush patch. As we rested, we heard someone else approach the brush patch. The only other person we could think of who could possibly be interested in reaching that spot would be Fred Beckey and a partner he had recruited. Had he followed us?

Finally, from the other side of the clearing emerged—a bear. We both stood up with our ice axes—the only weapons at hand—at the ready. The bear, as surprised as we were, stared at us and at our ice axes poised in the air. There were two of us and one of him. After fifteen tense seconds, the bear turned tail and quickly exited the scene.

Were we being paranoid in thinking that Fred might have followed us? No. I later learned that when I disappeared to go to Mt. Index for my solo climb, Fred had actually sent someone to the parking area that is the jump-off place for Mt. Baring to see if my car was there. I have no idea what he would have done if he had learned that I was up on the North Face of Mt. Baring. In any case, Ron and I turned back before reaching the rock because there were poor snow conditions at this early-season date.

In the end, I went up to Mt. Baring with Don Gordon (his fourth time up there) and Fred Beckey (his third time up there). We spent several days cutting a trail through the worst of the brush and cedar branches that seemed to cling in even vertical places, and stocked a high camp (named Dolomite Camp because of its breathtaking view of the adjacent "Dolomite Tower") with provisions.

As we reached the high point that had given us so much trouble the previous year, Fred made an astounding announcement. He was going back to Seattle because he had work to do. So this year it was Fred who wanted to leave, and there was no quibble about it from either Don or myself. It is the only time I had ever observed Fred letting work (or any-

thing else for that matter) interfere with his climbing plans. He was able to descend safely because we had put fixed ropes in the difficult spots in order to aid in stocking the high camp with provisions.

Almost all attempts to place more bolts failed, and the few more that we did place were suspect. The chrome molly knife blade pitons, made by Yvon Chouinard and just newly available to us, proved to be the key to utilizing miniscule cracks in the rock. Don and I had only a few of these pitons, and we had to keep reusing them, which slowed us down considerably. The principal barrier at this point was mental; the climb had an aura about it that slowed us down physically as well as mentally.

The climbing in the last section, which should have taken only one day, took three. We started late each day with a feeling of dread and came down early to the safety of camp. On the way down after completing the climb, we met a search and rescue party heading up to us. Fred had assumed that we had met with an accident because there had been no word from us. While Don and I felt a sense of elation at having finally done the climb, there was more of a feeling of relief that it was over.

In July I returned to the Bugaboos to meet Art Gran for another attempt on the east face of Bugaboo Spire. To me the east face of Bugaboo Spire is to rock what the north face of Mt. Robson is to ice—an incredibly beautiful and aesthetic form to view. Bugaboo Spire takes on a symmetrical and graceful shape when viewed from the northeast near Crescent Spire. In very early afternoon the face takes on a glow as the sun slants across the central portion of the face and reflects toward the viewer, as can be seen on the dust jacket of this book.

It was on this trip that I met Eric Bjørnstad (see chapter 12). I had posted a notice on a Seattle Mountaineer bulletin board looking for someone to

*Eric Bjørnstad on the north face of Howser Peak, Bugaboos, B.C., 1960. This dramatic view epitomizes what mountaineering is all about. There is rock, snow, great scenery, and the feeling of being in the right place at the right time (from the viewpoint of a climber). Eric Bjørnstad is a noted climber, as well as author of a series of rock climbing guides to the desert rocks of the American Southwest.*

share expenses going up to the Bugaboos, and he quickly responded. His description of me from his as yet unfinished autobiography, *Remembrance of Mountains Past: A Memoir* (a copy of which he sent to me in 2002), is interesting and reads as follows:

> He was a scrawny little fellow without any semblance of athletic build. I wondered how he managed to make all the arduous ascents he was famous for.

Note to reader—I'm still a "scrawny little fellow"! But I am paid a compliment shortly thereafter:

> It was a pleasure to watch Ed approach a seemingly blank wall, rub the palm of his hand over its crystalline surface, then pinch an invisible grain of granite and move up on it. Suspended on its surface like a fly, he again caressingly explored the smooth surface above, found an excrescence, a wrinkle invisible to my eye, and gingerly levitated an inch or two higher.
>
> It was the poetry I felt from ballet, but more—it was the strength and delicacy I sensed in nature and the vibrant music of life I experienced while alone in the wilds. That one was able to waft gracefully upward over smooth surfaces of rock was a dimension of existence I likened to the marvel of the flight of birds. It seemed a metaphysical oneness with the essence of the physical world and one's spiritual being.

Whatever truth there was in this, Eric was very poetic in his descriptions, and 1960 was the year that I most enjoyed free face climbing. We did make one alpine climb together while there, the first ascent of the north face of Howser Peak. Again, quoting Eric:

> As we picked our way back to Boulder Camp from our frightening but successful climb, I felt honored to have been Ed's partner on such a valorous first ascent. I thought of the many friends back in Seattle who would have exchanged their most treasured possession to have been in my place.

Since I had a reputation for being a little crazy, other climbers being willing to exchange treasured possessions to be my climbing partner seems highly unlikely to me.

Back to the east face of Bugaboo Spire, where I was awaiting Art Gran: I set up a small camp on a large ledge about 200 feet up the face, where I brought supplies. I went back and forth from this camp to Boulder Camp waiting for Art to arrive. Meanwhile, I made other climbs in the area with various climbers who arrived and then left. I spent time at the Ledge Camp reading books on philosophy. With my scientific background, I have reflected more than once on a quote I read during this period by the Spanish-American philosopher George Santayana: "Science is superstition intensely believed in."

One of the climbers who showed up while I was waiting was Layton Kor. We teamed up to put up a very enjoyable new route on the east face of Pigeon Spire on a very cold, overcast day with occasional snowflakes falling. On this and a few other climbs I did subsequently with Layton elsewhere, I was impressed with the boundless energy and the ferocity with which he tackled any pitch he climbed. One had the feeling that all you had to do was to aim him at a pitch on a climb, and no matter how horrible it was, he would somehow—flailing and scraping—make his way up it.

It did not surprise me when I heard several years later that he participated in the first ascent of the Eiger North Face Direct Route (the John Harlin Route)—done in winter yet—and that he led some of the worst nightmarish pitches. Also not surprising was a comment about Layton made by Chris Bonington. Layton was at Death Bivouac on the Eiger, and upon hearing that the weather forecast was not good for the next day, he decided he would slip down to Kleine Scheidegg for the evening, reportedly to party,

*Layton Kor on the east face of Pigeon Spire. This unusual picture was taken on the first ascent of the east face of Pigeon Spire in the Bugaboos, B.C., in August 1960. There is a large crack inside the face that we were able to climb.*

and return the next day. Chris said: "Only Layton could have had energy even to contemplate this." This cost him his chance to finish the climb—and may have saved his life. It was the next day that the fixed rope broke when John Harlin was ascending it, sending him to his death. The result was that none of the climbers who were below John could join the summit team. The last I heard of Layton he had converted to the Jehovah's Witness religion and was applying all his enormous energy to that arena.

My activities in the Bugaboos were interrupted for almost a week by what must have been food poisoning. I think it resulted from eating some old Logan bread that had been around for some time. In any case, I started to feel so sick that I returned to my car and the small shelter that was at the end of the road. (*Note:* This was before the new road came farther up the valley and the Bugaboo Lodge had been built.)

Things got so bad that I actually decided it would be preferable to die than to go on with that acute agony. There was nobody around there at the time who could have transported me to medical aid, and I couldn't move in the slightest without feeling even worse, if that were possible. Somehow I endured, passing a crisis, and spent about three days simply recovering my strength.

Finally, since July had become August, I stopped waiting for Art and started up the climb myself and completed about 65 percent of it, using a self-belay system of my own making. I placed a few bolts in a blank section, the point at which Art and I had been stopped the previous year, to reach the continuation of crack systems.

Art finally showed up in mid-August. Art was a climber from New York, known for climbing in the "Gunks" (the Shawangunk Mountains near New Paltz), and was also associated with the "Vulgari-

ans." This group put up many fine new routes in the western United States, Canada, and Alaska, but they were better known for their outrageous antisocial and anarchistic behavior, which is legendary. I have a copy of the first *Vulgarian Digest* published in 1970. Joe Kelsey, one of the Vulgarians, who had had a run-in with the Canadian guide Hans Gmoser in the Bugaboos, wrote:

> F**k Gmoser and his guides and guns. I will go to the Wind Rivers and make love to a sheep. If you want to climb in a wilderness area, go to the Logans or Alaska or Patagonia. If you want to go to the Bugaboos anyway, treat Boulder Camp like Camp 4, or Climbers' Camp in the Tetons, and take beer (Calgary Stock Ale is highly recommended), musical instruments, and a chick. Walk naked around camp, piss publicly, and have an orgy on Snowpatch.

Art Gran was a fascinating person to watch. He talked as much with his hands as with his mouth, and he loved to talk. His descriptions of difficult moves on climbs he had done were very visual, and he became known as Art "The Move" Gran. At times, his New York accent became somewhat wearing. He was a competent climber, however, and the two of us were sure we could finish the climb of the east face of Bugaboo Spire in one day, so we traveled extremely light with no emergency gear. Nightfall found us with one pitch to go to reach the ridge just slightly east of the summit. We had not brought a flashlight, and Art climbed the last pitch in darkness, feeling the rock to find cracks in which to put pitons. It was overcast, windy, and very cold, and a few snowflakes were falling when we reached the ridge.

Far off to the west we could see lightning underneath the clouds. Since it was impossible to go anywhere, we spent one of the most bone-chilling

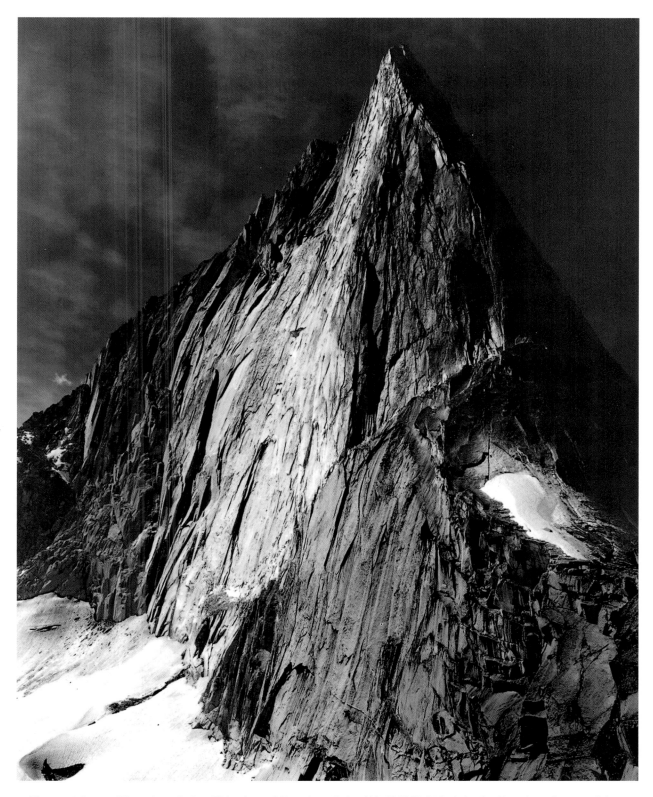

*The east face of Bugaboo Spire. This view of Bugaboo Spire (10,420ft/3,176m), in the Bugaboo Group of the Purcell Mountains of British Columbia, is from Crescent Spire, to the northeast. I carried a 5x7 view camera and related equipment to this spot in order to capture this image. It is one of my favorite mountain portraits.*

nights I have ever spent on a peak. We knew the past history of Bugaboo Spire and lightning, and since storms almost always travel from west to east in the western mountains, that knowledge added to our mental discomfort.

Fortunately, the lightning never reached us, but the next morning it was still overcast and spitting snow. I don't think I have ever had such a difficult time trying to get started, with the feeling almost gone in my fingers and toes, and the rest of my body's muscles protesting at every attempt to get moving. We had to descend the hard frozen snow below the Snowpatch-Bugaboo col without ice axes or crampons (we had figured we would be descending this the day before in the late afternoon when the snow would have been softer). The only tools we had to help were piton hammers, but it was extremely difficult trying to cut steps below our stance using only a piton hammer. As the climbing season drew to a close, my finances—which were nonexistent—took center stage. I had to do some hard thinking about where I was headed from there.

*Castle Rock in Washington, 1969. One of the popular sites for rock climbing on firm granite in Washington State is Castle Rock, located in Tumwater Canyon near Leavenworth, the town with a Bavarian theme. Two climbers are barely visible near the right edge part way up the rock. This area is often dry (being on the eastern side of the Cascade Mountains) when it is raining in Seattle.*

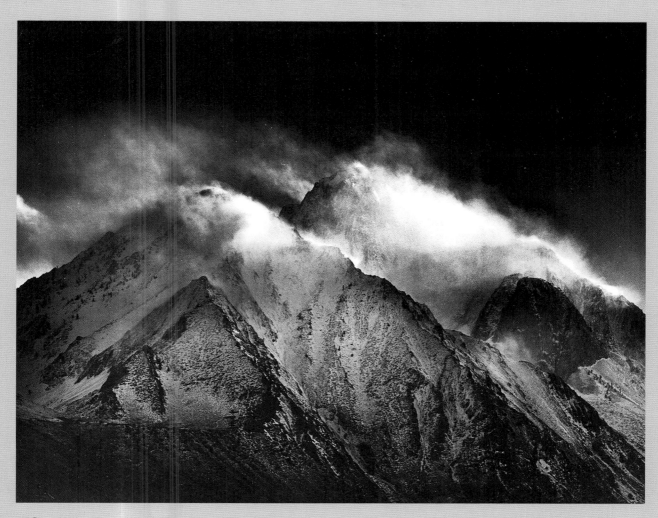

*Storm clearing over Mt. Morrison. This peak along the eastern front of the Sierra Nevada south of Mammoth Lakes, California, is a familiar landmark to the hordes of skiers commuting back and forth to Mammoth Mountain from the Los Angeles Basin. Mt. Morrison is 12,268 feet (3,739m) in elevation and towers over Convict Lake, a popular camping area, at its base. It is hard to resist the temptation to capture this peak on film every time I pass by it, and over the years I have amassed a small collection of Mt. Morrison views.*

*Sunset on peak, head of Rock Creek Canyon. This was taken on a day hike up the Rock Creek Canyon Trail, approached via U.S. Highway 395 from Toms Place on the eastern side of California's Sierra Nevada. This area is also known as the Little Lakes Valley.*

*Post-sunset at Mt. Shasta. In early evening, Mt. Shasta (14,162ft/4,317m) seems to float above the city of Mt. Shasta (lights below the peak) like a mirage. This view is from the Castle Lake Road to the southwest of the peak. Mt. Shasta is the second-highest in the chain of Cascade volcanoes (only Mt. Rainier in Washington is higher) and has been identified by volcanologists as one of the four to five sites in the contiguous United States that is most likely to see renewed volcanic activity in the geological "near term," which could be anywhere from tomorrow to several hundred years from now. Not only the city of Mt. Shasta would be at risk in such a case, but also nearby communities like Weed, Dunsmuir, and McCloud, all of which are within the shadow of Mt. Shasta.*

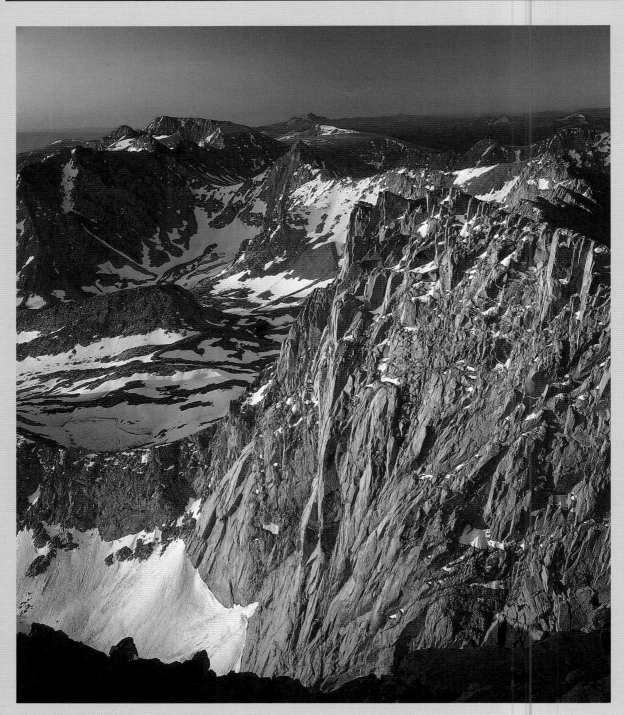

*The east face of Keeler Needle, seen from the top of Mt. Whitney. These golden colors await those who are dedicated enough to spend the night on top of Mt. Whitney in order to see the first rays of the sun strike the precipitous eastern front of the Sierra Nevada. Mt. Langley, the southernmost of the 14,000-foot peaks in the Sierra Nevada, appears on the left skyline.*

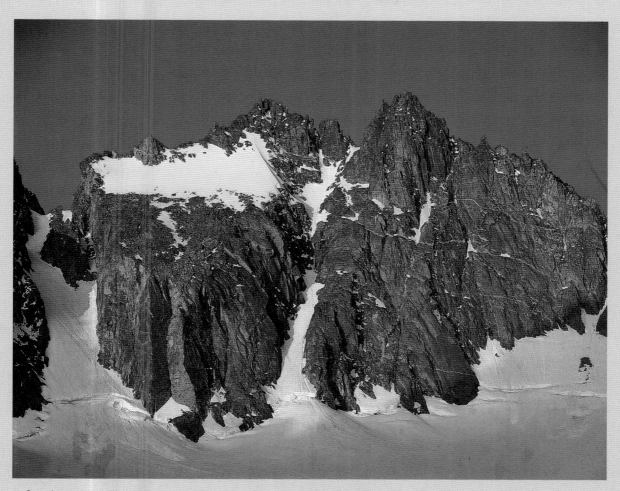

*Sunrise on the North Palisade. At 14,242 feet (4,341m), the North Palisade (the left of the two peaks) is the third-highest summit in the Sierra Nevada of California and also lies in the heart of the most alpine region of the range. The bergschrund (crevasse in the snow between the rock of the peaks and the main body of the Palisade Glacier) can be clearly seen. The northwest peak of the North Palisade, on the right, is also referred to as Starlight Peak and is slightly lower.*

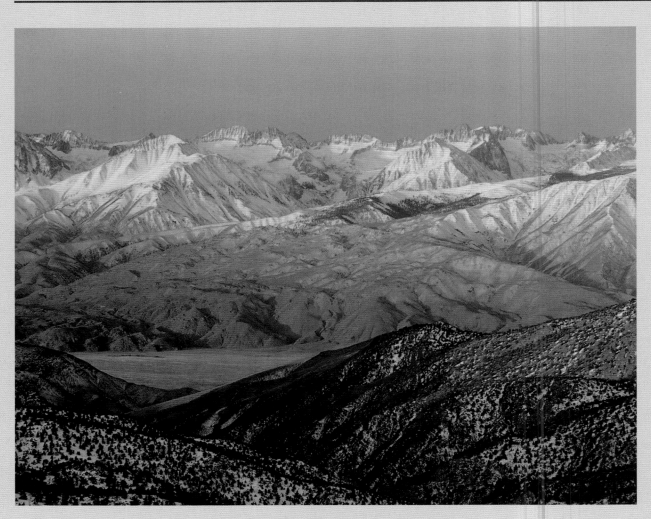

*The Palisades seen from Sierra Point, White Mountains. This are perhaps the premier view of the eastern escarpment of the Sierra Nevada in California. There are over 10,000 feet of relief from the floor of Owens Valley (about 4,000 feet at the point seen) to the summit of the North Palisade (14,242ft/4,341m) at right center (just above and slightly to the right of Temple Crag, the large shaded cliff). The immensity of the Owens Valley trench may best be appreciated when one realizes that it is one of the few geological features on earth that would be visible from the moon with the unaided eye, given the cross lighting conditions of early morning or early evening.*

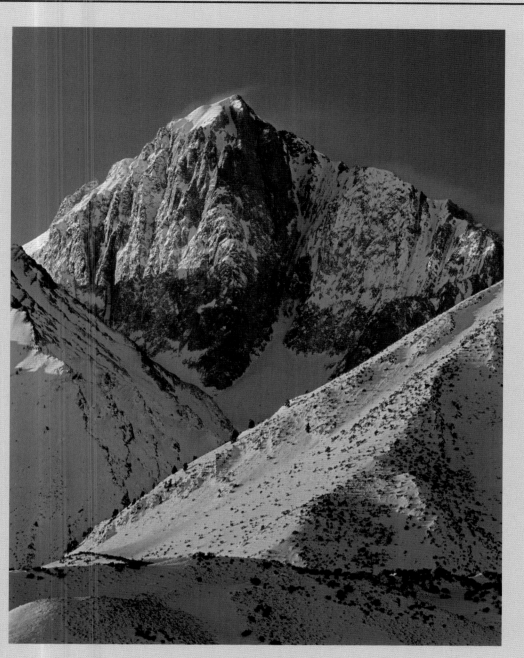

*Winter sunrise on Mt. Morrison. This photo, so different from the one of this peak on page 69, is no less exciting. You must be up and in place early to capture this portrait of the sun's first rays striking this beautifully formed peak.*

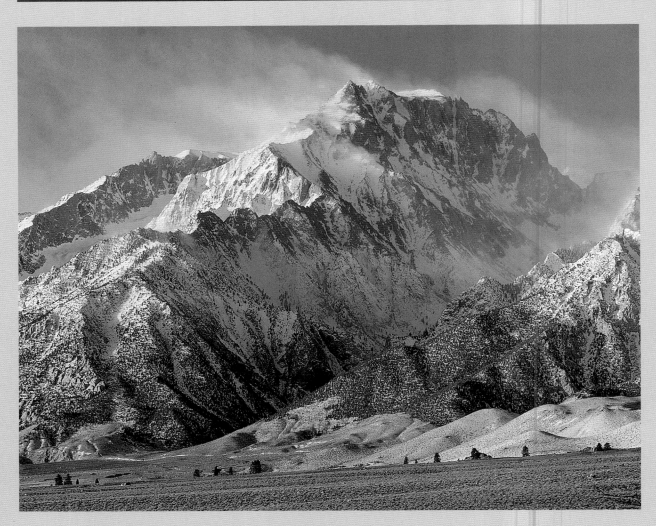

*Winter winds over Mt. Williamson. One has to know right where to look to see Mt. Whitney from Owens Valley, and many people no doubt believe they have sighted Mt. Whitney when in fact they are looking at Lone Pine Peak. There is, however, no mistake in spotting Mt. Williamson, Whitney's neighbor to the north. At 14,375 feet (4,382m) in elevation, it is the second-highest peak in California's Sierra Nevada. Because Mt. Williamson is east of the main crest of the range, it appears to loom over Owens Valley at this point.*

*Judging from my experience in the mountains, the winds at upper elevations (which can be seen here in the form of plumes of blowing snow) were probably in excess of 60 mph. Under these conditions fine spindrift snow will force entry into the tiniest of cracks and holes (as might be found in a tent or clothing) and accumulate, greatly increasing one's discomfort. All available energy is channeled into just surviving. It was well below freezing where I took this picture at about 4,000 feet in elevation; the windchill factor at the summit, 10,000 feet higher than my present location, would have been equivalent to 70 to 80 degrees below zero Fahrenheit (the Centigrade equivalent is approximately 57 to 62 degrees below zero). This was one occasion when, despite the awesome beauty of the mountains, I was glad I was not up there, but close to the comfort of my vehicle.*

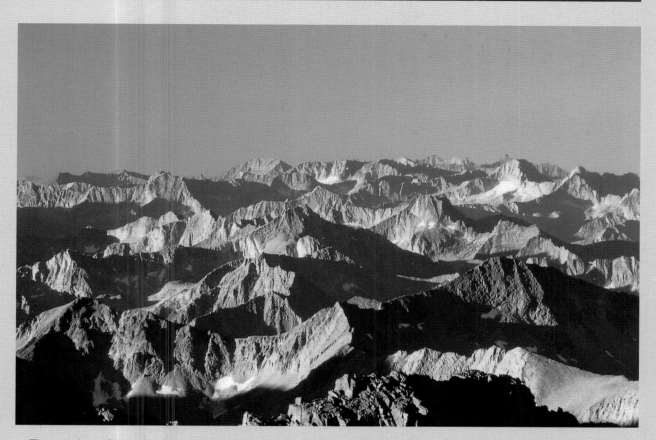

The southern Sierra Nevada seen from Split Mountain summit. This image is truly the mountaineer's dream. A convoluted landscape of peaks and ridges presents itself to the eye as far as you can see. The distance is not that great—a little more than 30 miles—but nowhere in my files do I have a picture that better represents the word "mountains." Split Mountain (once referred to as the Southeast Palisade) is 14,058 feet (4,285m) in altitude. This photo was taken during my hike of the John Muir Trail. Parts of three major Sierra features are visible: the main Sierra Crest, the Kings-Kern Divide, and the Great Western Divide. There are too many peaks to identify them separately, but one prominent peak seen on the right skyline, with a snowfield beneath a sunlit face, is Mt. Brewer (13,570ft/4,136m), which dominates the northern part of the Great Western Divide.

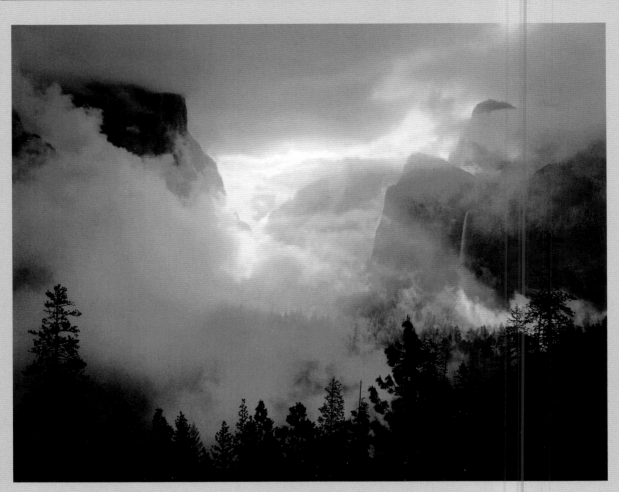

*Brief storm clearing over Yosemite Valley. After two days of rain that had cleared out the campgrounds in Yosemite Valley, I awoke about 4:30 a.m. and saw a patch of clear sky amid several cloud layers. On the chance that I might find an unusual picture opportunity at Inspiration Point, I rousted myself out of bed and drove up there. This is the most meaningful image I have of the Valley as a whole.*

*Words cannot describe what I felt as this scene unfolded. It was as if I had a privileged position to witness creation itself taking place. El Capitan can be seen on the left, rising out of, and back into, the clouds. Bridalveil Falls can be made out in the shaded area on the right, and Lower and Middle Cathedral Rocks form the profile seen to the left of, and above, Bridalveil Falls.*

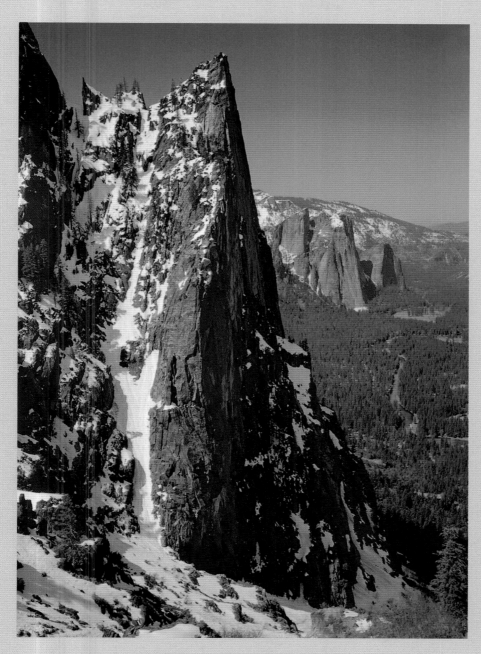

*Sentinel Rock seen from Union Point. This near perfect rock form rises proudly and resolutely as it stands watch over Yosemite Valley. To the public, this is one of the lesser stones in the rock diadem surrounding the valley, yet to the discerning eye, this is a gem as precious as its better known brothers. This view never fails to stir my imagination. In the background are Upper, Middle, and Lower Cathedral Rocks, and the Merced River is seen on the valley floor.*

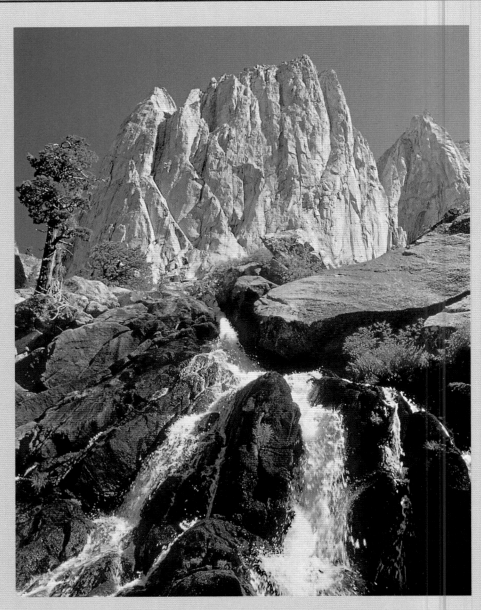

*The Angel Wings and Hamilton Creek. One of the most delightful surprises along the High Sierra Trail (which crosses the southern Sierra Nevada in an east-west direction) is the place where the trail passes by and underneath the formation called Angel Wings. At 10,252 feet (3,125m) in elevation, it is located in Sequoia National Park about 13 miles from the western end of the trail. This rock formation is not readily visible from the western approach until you are within 2 miles. From this point on, it becomes more and more dominant until your neck becomes sore from trying to encompass the view to the top. The point where Hamilton Creek crosses the trail makes a superb lunch or rest stop (if you can catch it without insects—see the technical data) and affords this spectacular view.*

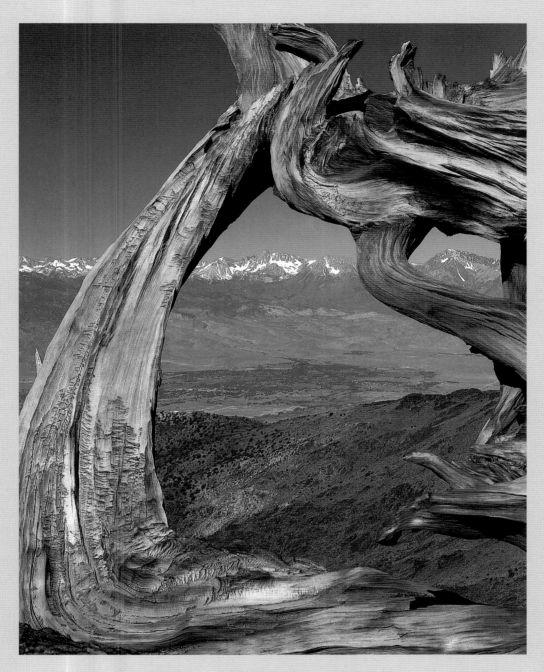

*Bristlecone pine wood in the White Mountains frames Mt. Humphreys. No one who sees these ancient bristlecone pine trees can fail to be impressed by these hardy inhabitants of the upper elevations in the White Mountains of California. Here the wood frames Mt. Humphreys (13,986ft/4,263m) in the Sierra Nevada. The town of Bishop in Owens Valley, almost 10,000 feet below Mt. Humphreys, can also be seen.*

# CHAPTER TEN

# GETTING BY *on* PRACTICALLY NOTHING

had kept myself going for about a year by conserving funds—really conserving. I made a little bit of money go a long way. It was October, I think, that my entire expenses for the month amounted to about $7.00, and most of that represented gas expense for the klunker I was driving. During late spring, summer, and early autumn of 1960, I was out in the mountains most of the time, so there were no lodging expenses. Between mountain trips, I would stay at the houses of various friends for a day or two to get cleaned up and have a few good meals.

I did have occasional income—I got a job as a photo lab assistant that lasted about a week. The University of Washington Medical School was conducting some physiology experiments, and they were looking for volunteers, especially climbers. They offered to pay, so I signed up. For $50 I walked on a treadmill that was set at an uphill angle and going about 3 miles per hour. Tubes were attached to my wrist and my upper arm, and all the time I was walking, blood samples were being taken. There was a rotating wheel in front of me with a large number of vials filling up with my blood one by one. The people doing the testing kept emphasizing that I could stop anytime I got too tired to continue.

After an hour passed they stopped the treadmill. At that point, I asked the testers if they wanted me to do another hour. Nobody had ever asked them that question before! (They declined.) It seems they were comparing the endurance of the U of W

Huskies football team members with that of climbers. The climbers won hands down. Very few of the football players could last an hour on the treadmill, but most of the climbers could.

This experiment went better than another experiment on Steve Miller, a climber from back East. The people doing the test wanted to take tissue samples from somewhere inside the lower body. This involved inserting some instrument up the climber's rectum; of course he had to bend over for them to do this. Something didn't go quite right and he started bleeding from the rectum. He had to spend some time bent over in this position while the doctors debated about how to stop the bleeding (they eventually succeeded). Steve was paid $75 for his trouble, and I don't believe he was overpaid!

I discovered the government surplus foods distribution program. The food was being given away to anyone who asked for it. There seemed to be no other qualification, and it didn't seem to matter if you were capable of working or not. (Government programs seem not to have changed much since 1960 in this respect. That's why the taxes on productive people are so high.) Several other climbers and I signed up.

This program kept me fed on some basic foods for a year and a half or more. Among the food items we received were cornmeal, oatmeal, butter, powdered milk, wheat germ, and sugar, as well as some other things I can't remember. I would use some of

these items as a basis for an all-purpose general food that I could take backpacking and climbing. My meals were very simple. I would carry a plastic bag with a mixture of these ingredients, pour the mixture into a cup, mix it with water, and eat the result with a spoon.

In this manner, I would have a complete meal. I would repeat the procedure any time I got hungry. This meal saved a great deal of time and weight, and I had no need to build a fire or carry a stove and cooking utensils.

Early in 1980, I received a letter from Yvonne Prater. She asked me about my favorite mountain menus to include in a book she was writing together with Ruth Dyar Mendenhall, which was published in 1982 under the title *Gorp, Glop, & Glue Stew.* I responded saying, "My interest in outdoor cooking might be termed negative—I want to spend as little time as possible on it."

Then I described the type of meal I describe above. In my letter I also added, "That was in the early 1960s, but I still do the same sort of thing." (This remains true even as I write this. My wife, Debby, verifies that I still have a minimalist approach to food preparation!) I sent this response off to Yvonne and thought no more about it, but to

*Photographer's portable home. I am standing next to the tent that was my home for well over a year during my period of trying to get by on practically nothing. Sometimes I would sleep in the backseat of whatever klunker car I owned at the time or stay with friends for varying amounts of time.*

my surprise she published my description under the heading of COLD FOOD.

Those climbers among us who were destitute also discovered that supermarkets would put outdated food near the back entrance prior to having it carted away. On more than one occasion we could be seen making late-night visits to the loading docks of supermarkets.

My serious interest in photography bloomed during that autumn of 1960. I acquired a small enlarger, and Eric Bjørnstad supplied me with a small room where I could eat, sleep, and make prints from black-and-white negatives I had taken that year.

These first results were primitive, now that I look back on them. Besides the prints being 5x7s for the most part (I couldn't afford 8x10 paper), they lacked contrast and displayed lots of dust and pinhole marks. But it was a start, and I was determined to improve my photography on all levels.

For the first time, I began to think, "What if I *don't* get killed climbing?" How could I continue to remain close to a mountain environment in the years to come? Slowly the germ of an idea began to develop. I started to refer vaguely to a "master plan" to other climbing friends, without ever really defining to them what that plan was.

# FREE ROOM *and* BOARD

That spring of 1961 I was to undertake a climbing adventure with Jim Baldwin that is certainly one of the most bizarre in mountaineering history. I had met Jim the previous year either on a skiing trip or while climbing at Castle Rock (see chapter 9), a practice rock in Washington State. He was from Prince Rupert, British Columbia, where the principal activities were logging, fishing, mining, and drinking. He developed an interest in climbing totally on his own, just from looking at some of the spectacular peaks that can be seen from the highway alongside the Skeena River east of Prince Rupert. Climbing as it refers to the mountains just did not appear in the local lexicon.

Meanwhile, with my growing interest in photography, I purchased a Super Ikonta IV 2¼ x 2¼ folding camera to replace the Voightlander Perkeo (it cost about $90, a sizeable purchase on which I made monthly payments). The new camera had a built-in light meter, which took the guesswork out of exposures. I would alternately shoot color transparency film and then black-and-white, in order to have a mix of both.

Jim Baldwin and I had gotten along well the previous year, and often we would exchange "war stories" at the end of a climbing day over a brew or two or more. On one of those occasions, Jim told me about a great rock formation at the head of Howe Sound in British Columbia called the Chief, and told tales of all sorts of granite practice cliffs. He urged me to come up and take a look. (In 1958 a highway had been completed from Vancouver to Squamish, a distance of about 40 miles, which opened up the area to easy access.) I had been up there very briefly in 1958 and recalled this rock formation, the face of which had looked unclimbable at the time.

In the autumn of 1960, I joined Jim in Vancouver, British Columbia, and we went up to the Squamish area to spend a week or two. We climbed some routes on cliffs in the area, but the big attraction was the Chief. It rises in one 1,700-foot vertical sweep of granite, right above the highway. At that time, there were few climbers about and only a few routes had been climbed on the periphery of the main wall. Interestingly, we envisioned that some day this area would become a major center for rock climbing. It was a natural, being close to the major population center of Vancouver. (We turned out to be correct in this prediction—see the postscript at the end of this chapter.)

The central portion of the south section of the Chief (the section right above the highway) appeared smooth and unclimbable, with few cracks. We decided that this central portion of the face, starting at the lowest point and climbing the steepest portion, would make a suitable objective for the following spring.

The following May (1961), we showed up in Squamish prepared to stay for as long as necessary to make the climb. We set up base camp in an abandoned dynamite shack near the base of the Chief,

*The Chief and Mt. Garibaldi. View from the top of the Papoose toward the Grand Wall of the Chief (on right) and Mt. Garibaldi (8,787ft/2,678m) in center, British Columbia. Mt. Garibaldi is considered the northernmost in the chain of Cascade mountain volcanoes. Part of Howe Sound and one of the many popular smaller rock-climbing cliffs in the area (the Malamute) can be seen at the lower left.*

and in damp and rainy weather (typical at that time of year) we cut a trail by machete, axe, and saw up to the base of the wall. Because of its location at the head of Howe Sound, the Chief, surrounded by mountains on almost three sides, is subjected to more than its share of Pacific Northwest rainfall. This same trail is still in use and maintained and sees heavy traffic in any spell of good weather.

At that time there was no such thing as big wall equipment; we had to improvise almost everything as we went along. Early on, Jim Baldwin mentioned to Jim Sinclair (now the leading authority on the history of climbing on the Chief) that it was a "grand wall," a name that stuck.

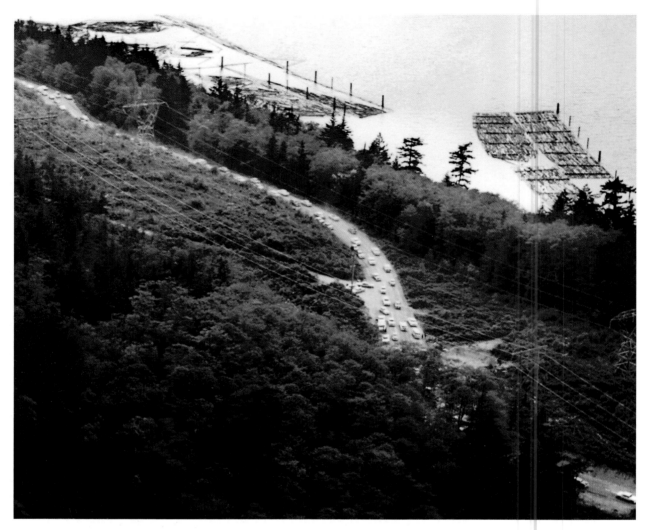

*View of traffic jam from the Chief. This is a view from the Split Pillar on the Grand Wall of the Chief, near Squamish, B.C. It shows part of the traffic backup caused one weekend by the thousands of motorists trying to get views of the climb of the Grand Wall. The Royal Canadian Mounted Police estimate was 12,000 cars.*

Our first objective was what appeared to be a detached pillar in the center of the wall that we had picked out with the help of binoculars. Our progress was slow because we had to place bolts in the smooth granite to reach this pillar. While we were climbing in this area, we were spotted by some townspeople. Word spread rapidly, and soon the local school bus would stop after school and let the students out to cheer us on as we worked on the bolt ladder on the wall above them.

I believe that it was the mayor of Squamish at that time, Pat Brennan, who called the two Vancouver newspapers. They wasted no time in filling the front pages of the papers with photographs. TV stations sent reporters, and one May weekend the highway to Squamish filled with 12,000 cars as people drove up to take a look. From up on the face, we could see traffic backed up as far as the eye could see. Enterprising youngsters set up telescopes and charged a dime for a view. One person, obviously

displeased with the circus atmosphere, yelled up to us, "Fall! *Fall!*"

The RCMP was having a terrible time trying to manage traffic, and we could hear the bullhorn going continuously as the police moved motorists along who were trying to stop in the middle of the road. Whenever Jim and I came down from the face, we would be surrounded by a crowd of motorists asking for our autographs. A young aspiring climber (at least, I assumed so) asked us, "If you get killed up there [on the wall], can I have permission to go up your ropes and finish the climb?" He appeared to be very serious. I don't remember our reply.

Dick Culbert, himself a mountaineer and explorer of some note, and later to be author of the *Alpine Guide to Southwestern British Columbia*, showed up. He was an acquaintance of Jim's. He talked about how all the climbers who had died trying to make the first ascent of the north face of the Eiger had helped to build up the reputation of this wall as the most notorious in the Alps. I remember his suggesting distinctly, in a tone of voice that was not entirely joking, that such a thing might be good for the reputation of the Chief! We were not about to sacrifice ourselves for a cause of this sort.

Pat Brennan was a real booster for the town of

Climbing the Split Pillar on the Chief. Seen here are the large iron pitons made locally by the blacksmith in Squamish, B.C., that were placed behind the Split Pillar on the 1961 climb of the Grand Wall of the Chief. Jim Baldwin is standing at a hanging belay station.

Squamish, and he treated us royally. He set us up with a hotel room, our choice of restaurants, free food in the supermarket, and some badly needed new equipment. If we went into a bar, everybody was buying for us. What more could two virtually penniless climbers ask for? Early on, when we weren't too high up on the wall, runners would bring food up to the base of the wall.

Among the items to which we fell heir was a large quantity of ⅛-inch yachting nylon, at least 1,000 feet, which we used for fixed ropes. This rope was very strong, but it had two disadvantages: It was quite slippery, and it stretched to a much greater degree than standard climbing rope. The rope's slick nature led to a serious incident on El Capitan the following year (see chapter 15). Its stretchy nature meant that we had to prussik (a method of ascending fixed ropes) 10 to 15 feet before even getting off the ground (or leaving a belay station) on a section of rope 150 to 200 feet long. Gradually the rope, once a clean white, turned a dirty gray. Also, the roughness of the rock we were ascending tore tiny fibers loose from the rope, giving it a "hairy" appearance that made it look a bit scary to continue to use.

When we reached the pillar, it was obvious that it was more or less detached from the face, and we christened it the "Split Pillar." The wind would actually flow through behind it. The size of this crack stopped us temporarily, as we didn't have pitons large enough to insert behind it. We went back to town and described our problem.

The local blacksmith solved our dilemma by making some giant iron pitons for us. These pitons were "bombproof" (they would stay there forever), but they were also very heavy. They did work well, except for one thing. As we climbed higher up the pillar, the solid pitons we had hammered in would actually push the pillar away from the face slightly, causing lower pitons to fall out. We placed a bolt in the granite next to the Split Pillar as an anchor in case all the pitons ripped out like a zipper unzipping.

One other chilling experience occurred here. While placing a piton, I was suddenly conscious of something moving at my waist. I looked down just in time to see the rope, my very lifeline, falling through the line of pitons and carabiners below. The rope, a perlon rope of German manufacture, was an exceptionally strong rope, but knots tied in it have a tendency to work loose if not carefully watched. I had never felt more isolated than at that moment. There was nothing for me to do but to work my way, unprotected, down a row of pitons (some of them not well placed) until I could retrieve the rope. One of the very pitons that I'd used to climb down on later worked loose just from the motion of the rope moving against it.

During this time, one of the climbers who had made the first ascent of Shiprock in New Mexico, John Dyer, showed up at the base of the climb to talk to us and give us encouragement. Shiprock was one of the very early technical climbs made in North America, in 1939, and it received much publicity at the time. Fred Beckey also showed up, perhaps attracted by all the publicity, and wanted to know if we "needed any help." We thanked him but politely declined.

However, all the hoopla grew old fast. Even adulation gets tiresome after a while, and you wish for some anonymity again. Soon we tried to avoid even appearing in town, and we moved out of the hotel into a small cabin that Pat Brennan had provided for us in lieu of the hotel room. The strain showed up on the climb, and we started to get on each other's nerves. Jim was a real extrovert and wore his emotions on his sleeve. I, on the other hand, was more of an introvert and held my emotions inside. On a couple of occasions, Jim physically attacked inanimate objects (like beating the rock with a piton hammer) during the climb, which was somewhat scary, but it relieved the tension for him. I just withdrew inward and displayed a dark and somber mood for longer periods of time.

The climb proceeded with several delays. One was for the "Sword of Damocles," a 200-foot

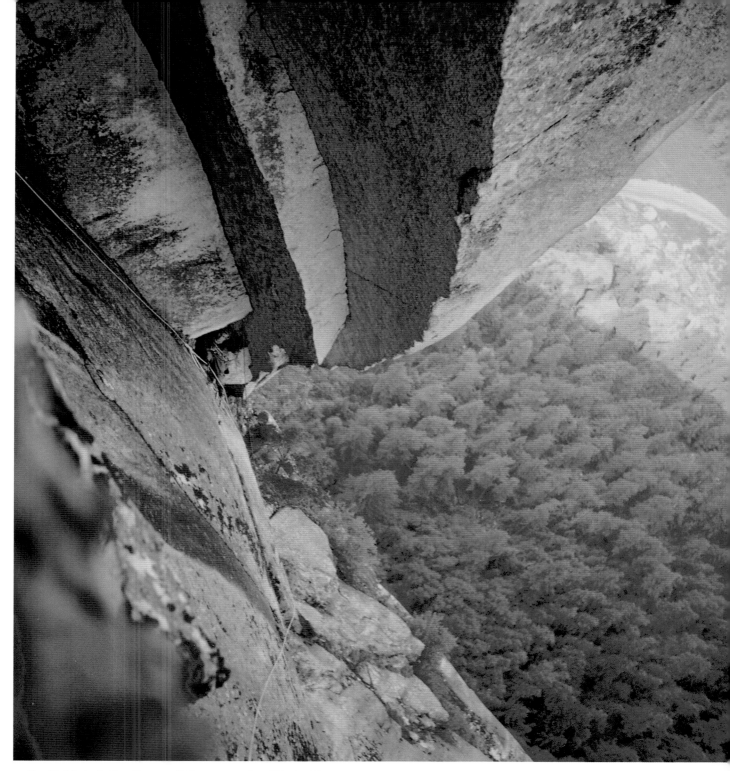

*Jim Baldwin in the Roman Chimney on the Chief, 1961. In terms of geometry, this is certainly one of the most unusual and wildly spectacular spots I have ever been privileged to witness. I took this picture from the edge of an overhang where the vertical exposure to the trees is about 1,400 feet. The highway can be seen at the upper right edge.*

detached flake pointing down. When I reached it and tapped it with a piton hammer, it vibrated like a giant gong. The Split Pillar was detached, and so was this. It was only 3 or 4 inches thick at the bottom, and in order to progress with the climb, we had to go over it. Rocks *do* fall off mountains, and

we descended in order to reassess whether we would continue with the climb. We did decide to continue, and upon reascending a day or two later, I more or less held my breath while I placed a bolt in this detached flake. Obviously, the giant gong behaved, or I would not be writing this!

We also had periods of bad weather, and on the final push to the top in June, we were roasted by record-breaking heat for the area. We ran out of water on the fourth of five days and actually sucked damp moss that was behind various rock flakes to get moisture into our parched throats. The newspapers reported that we sucked "moths" for moisture. It made us realize how much erroneous reporting probably gets into the news all the time.

On the very last pitch, which Jim led, at the top of the Roman Chimney, there was a 50-foot crack of a uniform size. There were only a few pitons available that fit this crack, which Jim climbed using three pitons, removing the lower one and placing it higher while still anchored to the center piton. The last piton, the one supporting Jim's weight, fell out as he chinned on a bush that overhung the top of the wall!

We were glad the whole thing was over, and after a day of interviews, we left the area to go our separate ways. We had left behind our old boots at the base of the wall (the town had financed a new pair for each of us) and all of the pitons that had been made for us, most of them on the large ledge called the Dance Platform. Jim Sinclair collected all these items later, and I believe they are now in storage somewhere awaiting placement in a climbing museum that may open in Squamish, dedicated to local climbing history.

I managed to sell an article and photos to a magazine; this represented the first income I had ever made from photography. It wasn't much, but it allowed me to stay afloat on my very tight budget for a summer in the mountains.

*Postscript:* I was invited to Squamish for a July 2001 celebration of the fortieth anniversary of the first ascent of the Grand Wall of the Chief. I brought some of my original 2¼ slides, which I showed to a capacity audience at the Brew Pub, the local gathering place for all the climbers in the area. Jim's and my prediction in 1961 that Squamish would become a major rock-climbing center had come true in spades. There were climbers everywhere, on big cliffs and small. On a nice spring weekend day, there may be between 500 and 1,000 climbers active in the area.

In June of 2002, two filmmakers from Vancouver visited me at my home in Sonoma, working on a film of this adventure titled *In the Shadow of the Chief.* They made use of archival film footage by the Canadian Broadcasting Corporation, my original photos of the climb, interviews of me and a few other early climbers on the Chief, and created some film footage of contemporary climbers on the original route. This film debuted at the Whistler Mountain Film Festival in December of 2003, winning the People's Choice Award for best film of the festival.

When I looked at the CBC archival film footage from 1961, I saw something that I had completely forgotten. An interviewer asked me what I planned to do next, and I replied, "Look for a job." My having said that really surprised me. That resolve hadn't lasted long: I had resumed my climbing activities immediately upon my return to Washington after the climb of the Chief. After all, there is nothing that cramps the lifestyle of a climbing bum more than a job, especially in the summer!

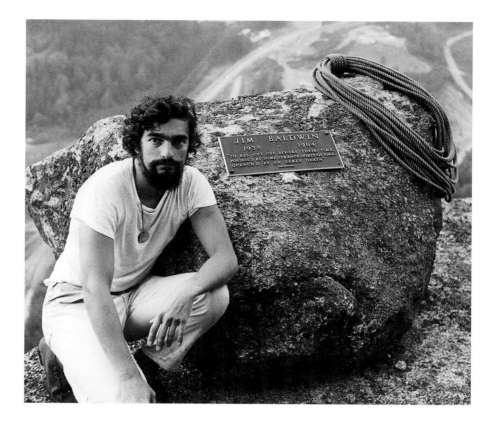

*Photographer/author at Memorial Ledge on the Chief. Seen here is the memorial plaque to Jim Baldwin on that ledge, near Squamish, B.C. This photo was taken in August 1968.*

*Jim Baldwin. This image captures the spirit of Jim Baldwin, my partner on the Grand Wall of the Chief near Squamish, B.C., and the Dihedral Wall on El Capitan. This particular view was taken in 1962 on the top of El Capitan in Yosemite Valley.*

# CHAPTER TWELVE

# MT. TERROR, THOR'S VISIT, *and a* BROKEN HARD HAT

In the spring of 1961, *Summit* magazine ran an article by Dee Molenaar about the great unclimbed east face of Washington State's Mt. Adams. What better invitation could a climber have than that?

Accordingly, Mike Swayne and I headed there at the end of June to test our skills once again against Mt. Adams. We did something on this climb that is never a good idea. After arriving at the base of the east face, we made the decision to continue our attempt even though a lenticular cloud cap was forming and growing over the top of the peak. This is often a sign of worsening weather, and almost always there are high winds and whiteout conditions when this kind of cloud cap occurs. Perhaps we felt that it would keep things cool (which it certainly did) and minimize any rockfall.

On the latter score, while we were in an ice-coated rock chimney, the mountain sent down a boulder about a foot in diameter toward us, ricocheting down the chimney. (Foolish mortals, challenging me again!) It missed both of us by maybe a foot. We reached the summit area (the top of Mt. Adams occupies a very large area) and were extremely lucky to find our way safely down the mountain in whiteout conditions that could only be described as sub-survival. A week or two later, Fred Beckey and Herb Staley established a second, separate route on the east face.

In an e-mail from Charlie Bell in May of 2002, he stated in reference to the Mt. Adams climb:

> Fred [Beckey] asked me to join him on a trip to the Tetons. He mentioned something about an ice climb but gave no further details, as was his wont (and yours too; you didn't tell us which Picket we were to climb until you had us safely in your car).
>
> Fred even suggested that I tell my friends we were going to the east side of Mount Adams where Dee Molenaar had outlined several unclimbed routes in an article in *Summit*. Fred hoped to dissuade other climbers from attempting the routes until he had a chance to turn his attention to them.

That ploy didn't work in this particular case, but it does illustrate how intense the state of competition for new routes was during that era of climbing.

The third and final of my "peak" mountaineering experiences (I describe the first in chapter 7, the

*The northern cirque wall of the Southern Picket Range. This spectacular group of peaks is located in the North Cascade Mountains of Washington State. This view is from Luna Ridge; McMillan Creek Valley lies below at the left. Mt. Terror (8,151ft/2,484m) is just right of center. These are sometimes called the "American Alps" and represent (to me) the most spectacular grouping of glaciated peaks in the contiguous United States.*

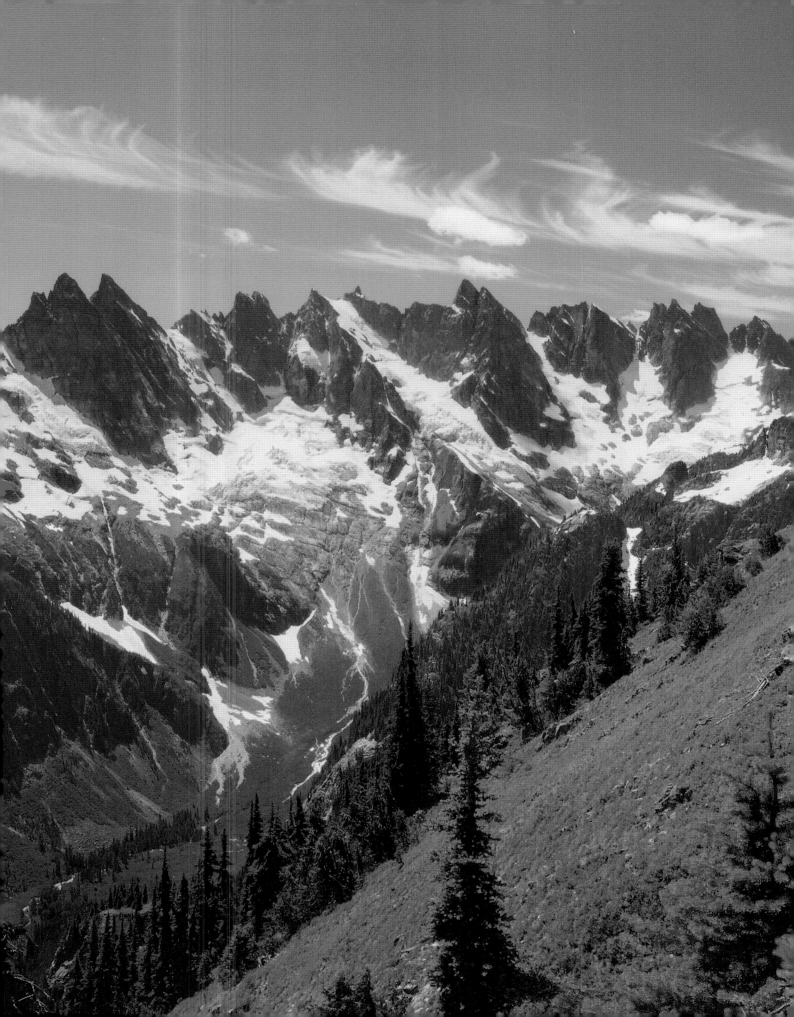

second in chapter 9) occurred in early July, together with David Hiser, Mike Swayne, and Charlie Bell. This involved the first ascent of the north face of Mt. Terror (North Buttress of Mt. Terror route) in the Southern Picket Range of the North Cascade Mountains, in the northern part of Washington State.

How fortunate that many of the finest peaks in the North Cascades aren't named after surveyors or deceased personalities. You have to love some of these colorful and graphic names, such as Triumph, Damnation, Despair, Forbidden, Torment, Formidable, Fury, Terror, Challenger, Redoubt, Ghost, Phantom, Sinister, and Cutthroat.

The northern side of the Southern Picket Range is located at the head of McMillan Creek. No one had ever been up to this cirque headwall with its steep glaciers and peaks soaring above. One attempt had been made to march up the McMillan Creek Valley, but the party gave up early on. When viewed from above, this valley appears to be lined with pleasant green meadows.

In actual fact, each of these "meadows" is almost one continuous patch of slide alder interlocked with vine maple and devil's club. This last plant, for those of you who are not familiar with it, comes armored with needles and is therefore an unpleasant plant to grab hold of when you are slipping on, say, a damp, moss-covered rock. Unfortunately for hikers and climbers, there are many damp, moss-covered rocks in the North Cascades and a lot of devil's club.

McMillan Creek Valley is about 5½ miles in length, with its start from the Big Beaver Trail. There are very few large trees to provide a break in the brush because winter avalanches fall from both sides of this U-shaped valley. To my knowledge, no one has yet marched up this valley to its end, and frankly, I don't know why anyone would want to.

When viewed from the north, the Southern Picket Range in the North Cascade Mountains presents the most alpine appearance of any group of peaks in the United States outside of Alaska. To make a long story short, this climb in the Pickets presented a combined challenge of exploratory mountaineering and technical climbing. We set off in early July, in a long stretch of perfect weather, which was rare for that "early" in the summer season in the North Cascades.

We basically traversed the range from north to south via the north face of Mt. Terror. Route finding was a challenge both going in and out. Like the earlier "peak" experiences, it was one that all of us wished could continue indefinitely, or at least be repeated at some point in the future. More basic needs brought us back to reality because we were about out of food the day before the end of this trip.

David Hiser, like me, turned to photography and has gone on to become well known as a member of Photographers Aspen. He has done many *National Geographic* assignments and gives workshops in photography. Mike Swayne continues expanding his knowledge of fish in backcountry lakes, is the Trail Blazers librarian for all their records of fish stocking and surveys, and is also a member of the State of Washington Inland Fisheries Policy Advisory Group and the U.S. Forest Service Resource Advisory Committee. (In 2001 I made a six-day east-to-west traverse of the North Cascades with Mike and Jim Nelson—more about that in chapter 22.)

Charlie Bell was (and still is) a puzzle to all the climbers who encountered him. If I could be considered crazy for some of my climbs, lifestyle, and ideas, Charlie was simply bizarre. During a rest stop on one climb, he pulled out a book of Chinese poetry, *in Chinese,* and began to read it. He seemed to arrive at the climbing scene from out of nowhere,

determined to make a name for himself. He didn't do a lot of the smaller climbs that most climbers start with, but went for the big ones. He certainly had courage in doing the climbs he did, but other climbers were a bit wary of being his rope mate.

Perhaps the following passage from Mike Swayne's climbing journal about the north face of Mt. Terror might explain some of Charlie's bizarre behavior. (Mike refers to Charlie as "Chuck" in this narrative, although he is commonly called "Charlie.")

The face is about 2,500 feet high, but looked endless. At first we roped up, but all the pitches were going class 4 so we unroped to save time. Though it was late afternoon, and I was a little tired from the effort expended to reach the wall, I found myself enjoying each pitch. There was a terrific feeling of freedom and exhilaration climbing free, hold after hold on good solid granite, looking down hundreds and then over a thousand feet.

I measured our progress against the Flanks of Fury to the right and McMillan to the left. One false move and it would have been impossible to recover, but I was oblivious. What kind of drug the body makes to get into this state, I don't know. Chuck made no bones about the drugs he was on and popped pep pills several times.

Then, regarding some difficult and frankly scary rappels, Mike's journal has this to say:

We set up a two-piton rappel anchor just below the top. Ed went down on a single rope using the other as a belay to look for the next anchor. He found a good ledge and signaled for the rest of us to come down. Dave and Chuck went down on a belay and then I came down.

Since the East Face overhung near the top, the first rappel went over the NE face. I must say it was a little lonely, this was the most exposed rappel I had ever made, at least 2,000 feet down, and I hoped those pitons held. From the first ledge we could free-climb a short way. Then the fun began.

[A description of the next rappel omitted here.]

The next landing was even worse, there was only room for two people on a thin ledge. The others had to land above and below and tie themselves down. On Chuck's turn to come down last, he decided to emulate a Swiss guide and came down in great bounds.

The rest of us were not too happy, fearing that the extra tension could pull out the anchor. This would not only kill him but also leave the rest of us stranded with no rope. The next rappel took us to a leaning tower against the face. From here we free-climbed down to the col.

At the time I was personally unaware of any drug use on Charlie's part; it wasn't until I first read Mike's journal in 2001 that this possibility came to my attention. I have no idea to what extent (if any) the use of drugs may have altered his behavior on this (or future) climbs, but the rappelling incident did not seem entirely rational to the rest of us.

Interestingly, all three of my "peak" climbing experiences in the mountains involved a grand traverse route of some sort. And what better way to meld one's mind with the mountains! This kind of experience provides, to my mind, "Compleat Alpinism" (apologies to Izaak Walton).

That summer I also managed to climb that most beautiful of mountains—Mt. Robson, the highest peak in the Canadian Rockies. (*Note:* I frequently consider whatever mountain peak I am closest to at the moment as "the most beautiful," but Mt. Robson truly is exceptional.) Accompanying me were David Hiser and Charlie Bell, and several other climbers we encountered on the mountain itself. Mt. Robson has the distinction of having no easy route up the peak, nor a route without risks from objective dangers.

It's amazing how the memory recalls some minor incidents clearly while at the same time for-

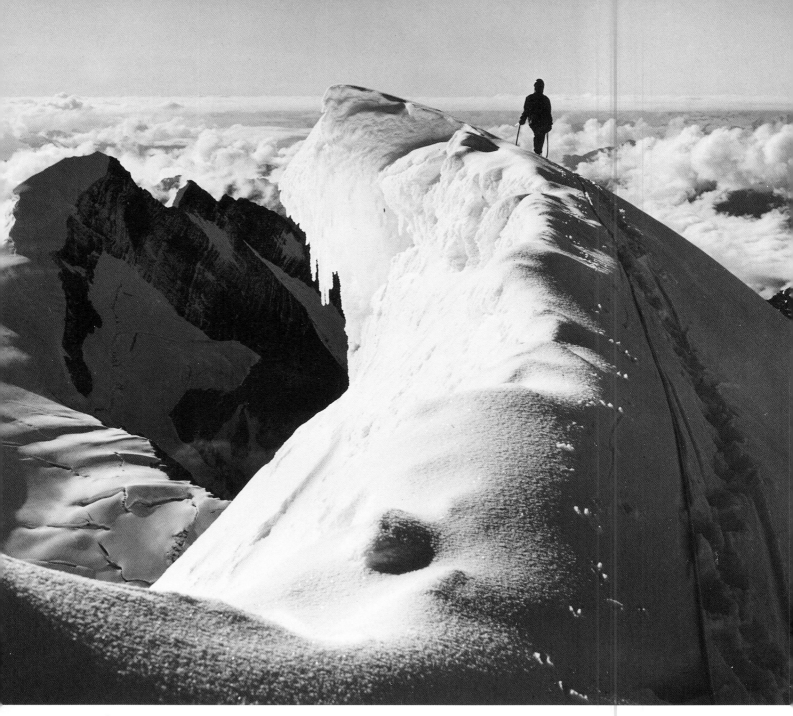

*Climber on cornice, Mt. Robson, 1961. Here John Neal is seen on a cornice formation on the southeast shoulder of Mt. Robson, about 1,000 feet below the summit. Mt. Resplendent (11,240ft/3,426m) appears in the left background.*

getting the details of much more important occurrences. Sometimes little competitive "trail games" are played between climbers. David and I became involved in one such "game" that seemed important at the moment but which had no ultimate meaning in terms of reaching the summit.

The trail to Berg Lake (which is the base starting point for the Mt. Robson climb) alternates between forest and open areas along a river about halfway up the trail. David was about 100 yards

behind me on the trail. When we were in the open areas, I would walk as fast as I could, trying to get farther ahead.

Since I couldn't seem to get any farther ahead in an open area, when we entered the woods, I would run with my pack on, figuring that I would get ahead in that manner. When I reached an open area, I would resume my fast walking pace so that it would not look as though I was intentionally trying to gain distance.

Imagine my surprise to see that when he entered each clear area, he would still be about the same distance behind me. I hadn't gained on him at all. This went on for some time, and I was mystified as to why I couldn't pull ahead. Some time later I learned he had been doing the same thing I had been doing—running with his pack on when he was in the wooded areas where neither of us could see the other!

When we arrived at Berg Lake, the weather was marginal, so we decided to camp there for the night—except, that is, for Charlie. He decided to wander up the Robson Glacier by himself to who knows where. We caught up with him later the next day on the upper part of the glacier. He said he had spent the night near the top of one of the lesser peaks that rise above the glacier, in weather of light mixed rain and snow.

We all continued on to a camp spot on top of the Dome at about 10,100 feet (Mt. Robson itself is 12,972 feet, 3,954 meters). This is a very prominent snow dome below the east face and the Conrad Kain route up the peak. It is also the highest point for about half a mile until you reach the start of the technical climbing on the Conrad Kain route. That evening we were entertained (I use the word advisedly) by a lightning storm.

Each time the energy was building for a flash of lightning nearby, we could hear a low hum and see a dim glow on our metal tent pole. Once the flash of lightning occurred, it was like someone had flipped a switch, and the sound and glow would cease until the next buildup of charge. There was no place to escape to. It was pitch black, hailing and snowing, and any attempt to descend in that type of weather would have been riskier than staying where we were. All we could do was grit our teeth and endure in a state of terror.

The weather cleared late the next morning, but we stayed in our camp, giving time for small avalanches to clear the face of loose snow. We climbed the peak the following day. Besides the fine snow and ice climbing, there were splendid photo opportunities, and I managed to get some of the best snow and ice climbing pictures I've ever had the opportunity to take.

The day after the climb, David Hiser descended from our high camp on the Dome, but Charlie and I stayed on. I was going to make one more try on the north ice face (see chapter 8), this time solo, and Charlie agreed to be my backup in case of trouble. About all he could have done, actually, was seek help or report me missing.

My plan was to start in the afternoon, anchor myself to the ice face for the night partway up, and then complete the climb the next morning. This way I would avoid climbing on the portion of the ice face below the rock bands, which could be subject to snow avalanches in the morning sun because of its slight eastern orientation. The descent would be relatively easy since the route down was fresh in my memory.

Early the next afternoon, per schedule, Charlie and I climbed up to the col between the Helmet and the north ridge of Mt. Robson. There is an awesome view of the north ice face from there.

We dropped down to the Berg Glacier, where

*Photographer/author with 4x5 gear on top of Lynx Mountain, 1962. This peak is in the Canadian Rockies near Mt. Robson. It is located on the border between British Columbia and Alberta and also between Mt. Robson Provincial Park and Jasper National Park. Its elevation is 10,417 feet (3,175m), and it affords great views of Mt. Robson and the Robson Glacier. This was my first 4x5 camera, one of the old 4x5 Speed Graphic press cameras. I can't remember for sure who took the picture of me with one of my cameras, but I think it was George Whitmore (who some years earlier had participated in the first ascent of the Nose of El Capitan).*

we unroped. From here I made the short climb up to the bergschrund below the face. Clouds had been collecting as the day went on. I probably spent half an hour at this bergschrund trying to decide whether to commit myself to the wall. In the end,

mindful of the night of terror on top of the Dome and imagining how many times worse it would be anchored to an ice face, I turned back.

I felt regret about that because it was such a beautiful place to be and I sensed I would never

again be in a position to climb it. To this day, it's the one climb in my life that I regret not making.

Another climb stands out in my mind from 1961—the first ascent of the east face of the Middle Peak of Mt. Index. Of the faces on the North and Middle Peaks, this was at that time the only unclimbed one. I made the climb in August with Eric Bjørnstad (see chapter 9), who was famous for his collections of unconventional items. Among the items I remember were a 4-foot-high wooden camel and a large condom collection.

At that time, Eric was the manager of the Pizza Haven in the University District of Seattle, and this soon became an unofficial gathering place for climbers in that era. Most visiting climbers could count on a free pizza that was "mistakenly" prepared. Currently, Eric makes handcrafted items, writes climbing guidebooks, and guides people in the backcountry areas near the trendy community of Moab, Utah. In every corner of his small quarters are priceless items of mountaineering memorabilia gathered in more than forty years of collecting.

One very serious problem about doing a climb this late in the season (a little past the middle of August) on the North or Middle Peak of Mt. Index is the utter lack of water. You have to carry all your water along, and no easy exit exists from the summit of either peak. I used a technique of water supersaturation before starting the climb. At breakfast, after I felt sated with liquids, I forced two more quarts of water down my throat. I urged Eric to do the same, but he was unable to drink that much liquid.

En route to a bivouac high on the face, Eric was leading. Somehow a boulder dislodged and landed squarely on my head. Fortunately I was wearing a hard hat, but the boulder broke the straps on my hard hat and cracked it. The blow knocked me to the belay ledge, which luckily was wide enough to accommodate my sprawling fall onto it.

Actually, I was fortunate. If the boulder had been a few inches to either side, it might have broken one of my limbs. Rescue from this location would have been one of the most difficult rescues ever attempted in the Cascade Mountains, and a helicopter rescue would have been impossible because of the steepness of the face.

By the end of that day I hadn't touched my water, while Eric had run out and was becoming extremely thirsty. (I didn't feel a need to drink water until the next morning.) I shared my water with Eric until we reached some water on the Main Peak of Mt. Index after a second bivouac.

In a phone conversation with Eric in May 2002, I mentioned his thirst on this climb and he responded, "Blueberries!" I had completely forgotten about this. There were patches of blueberries on ledges on the upper face, and they provided much needed moisture (as well as nutrition) and helped us conserve what water we still had left.

That year I managed to sell a second article to a magazine, this one about the climb of the north face of Mt. Terror. Slowly the "master plan," mentioned at the end of chapter 10, was taking shape.

# CHAPTER THIRTEEN

# A NEW DIRECTION . . . AGAIN

During the fall and winter of 1961–62, I devoted myself almost wholly to photography. More specifically, I worked in a makeshift darkroom. I started to make some decent prints—not great, but decent. I sold a third article on climbing to a magazine and then a fourth (to *Pageant*, then a popular magazine). Having color transparencies seemed to make sales more likely, but the creative process in making black-and-white prints was what captured my attention and interest. More specifically, the relatively quick feedback on black-and-white test strips produced in the darkroom was much faster than the long, cumbersome process involved in making color test strips. Further, there was a greater degree of contrast control in black-and-white, by using different grades of paper.

The 8x10 print became my standard, replacing the 5x7 from the previous year. I liked the mountain images crisp and sharp. It was at that point I realized I wanted to move up in negative format from the 2¼x2¼ to the 4x5 size. Somewhere in that time period, I first saw some reproduced images by Ansel Adams. I particularly noted the sharpness and full range of tones in each image.

Early in 1962, I acquired a used 4x5 Speed Graphic, which had a 6½-inch Kodak Anastigmat lens, and a tripod to go along with it (all my shooting to this point had been handheld exposures). I couldn't have been happier with my new toy. Now I could really "go to town" with my photography. My big problem was being able to afford the film to use with this large format camera.

Somewhat appropriately, I first used this new format in Yosemite Valley in late March of 1962, only a day or two after arriving there for my first visit. One of my very first stops in the Valley was Virginia Best's Studio, where Ansel Adams prints were on display. Even before I walked in there, I knew what the result would be. I walked out with a new mission in life.

Having been inspired initially by Brad Washburn (see chapter 7) and now again by Ansel Adams, I became resolute in my new course. Capturing the image and spirit of the mountains on film—their soul, if you will—became my passion. Hence the name *Soul of the Heights* is used as the title of this book. The "master plan" was coming into being. However, very few life plans proceed smoothly, and there were and are pitfalls, detours, and back-steps along the way.

The stated reason I was in Yosemite was to climb a new route on El Capitan. In the autumn of 1961, I linked up with Jim Baldwin again. After a few beers, we had forgotten the stress we had undergone on the Grand Wall of the Chief (described in chapter 11). I had a picture of El Capitan I had cut out of a magazine, and from the photo we enthusiastically picked out a line more or less in the center

of the nearly 3,000-foot granite southwest face, almost the exact route we picked out with binoculars upon arriving in Yosemite Valley.

Before Jim and I left the Seattle area to take up residence in Yosemite Valley, we solicited donations of climbing equipment from friends and acquaintances, and compiled an impressive array of gear. Projects often take on a life of their own, and while I would have been happy wandering around Yosemite Valley making photographic discoveries, at that time I was still locked into the climbing scene.

While some people have associated me with Yosemite climbing, in truth I was never really part of that climbing scene. Some of the climbers there were offended by what they considered aloofness on my part, as I did only a few climbs with the local climbers. In addition, I guess it was my total disregard for the Yosemite Valley climbing hierarchy (the first such "pecking system" I had encountered in the climbing world) that further enraged some locals. I marched to the beat of my own drummer. Perhaps the title of a book published by the Mountaineers, *Freedom of*

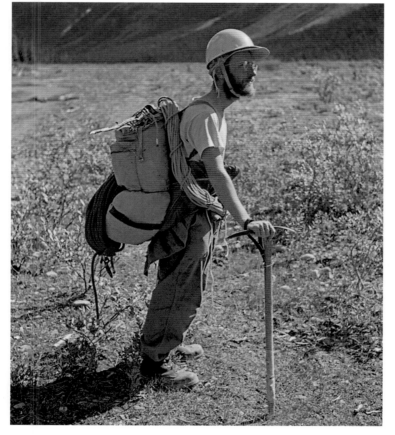

The enigmatic Charlie Bell, seen here in July 1961.

*the Hills,* best expressed my philosophy. The locals were right in sensing aloofness but attributed it to the wrong reasons. It was not my unwillingness to climb with them that caused the standoffishness on my part as much as it was the fact that I now devoted much of my spare time to going around the Valley with my 4x5 camera, looking for images. I was not, like them, wholly devoted to high-angle rock climbing.

In the same way that going to school was what I did when I wasn't climbing, now technical climbing became what I did when I was not engaged in photography. *Reaching a summit or climbing a rock route was becoming less important to me than searching out and capturing great views of those very same landforms.*

This was a bifurcated year. The spring and fall were spent in Yosemite, and in the summer I returned to the Pacific Northwest and Canada, pursuing photography when finances permitted the purchase of 4x5 film. In between my search for those "perfect" images, I was to do one more climb while in the Northwest.

One last climbing objective attracted my attention in the Pacific Northwest—the vast expanse of the 4,000-foot-high Willis Wall on the north side of Mt. Rainier, at 14,410 feet (4,392m) the highest peak in Washington State. For the most part, Willis Wall is a horrible place, composed of rotten volcanic rock. In the summer months it is continuously disintegrating under the action of thawing and freezing. In addition, this wall is intermixed with steep ice gullies that become bowling alleys for rocks and boulders headed toward the Carbon Glacier at the bottom of the wall.

This glacier is littered with volcanic rubble debris all the way to the snout of the glacier, and it is speculated that an especially large rockfall in the 1920s rode on a cushion of air all the way to the snout and beyond. In addition, a line of ice cliffs up to 250 feet high overhangs most sections of the wall and discharges tons of ice at irregular and unpredictable intervals, further exacerbating the disintegration of rock as the ice cascades down the wall.

The National Park Service had banned all climbing on Willis Wall, giving the reason of "protecting the public." Also, climbing any summit route on Mt. Rainier was forbidden between Labor Day and Memorial Day, and there was a party minimum of three persons required for any climb. This didn't deter climbers, however. Bob Baker and Don Gordon made a winter ascent of Mt. Rainier on January 22, 1961, reaching the summit at dark and coming down in moonlight. Mike Borghoff and Eric Bjørnstad, also in the party, turned back a little beyond Camp Muir, at the 10,000-foot level. In that same year the first climbers approached Willis Wall to climb it.

In early June, a party of Eric Bjørnstad, Gene Prater, Bob Baker, Dave Mahre, and Barry Prather climbed to the base of the wall before turning back. One of the three "backup" members was Charlie Bell, who was supposed to observe and go for help in case the party ran into serious trouble. All the members returned to their vehicles except Charlie Bell. Two days later, on June 11 and 12, the story goes that Charlie Bell (see the reference, chapter 12) approached the wall alone and managed to climb the West Rib.

He announced his ascent to the climbing world in the following manner. I quote here from the detailed journals kept at that time by Mike Swayne. This particular entry was made June 14, 1961, when Mike was traveling with Fred Beckey in Oregon:

About 8:00 a.m., [Eric] Bjørnstad, Herb Staley, Bob Baker, and Charles Bell arrived with a fantastic tale about Bell having soloed the right side of the Willis Wall two days earlier. He said he climbed Monday to about 12,000 feet where he bivouacked and then finished the climb to Liberty Cap, descending via Liberty Ridge. He said that he built three cairns on the way.

Fred was beside himself. He hotly disputed that Bell had made the climb. This caused plenty of dissension and hard feelings. Bell felt that few people believed him, and Fred was equally adamant that Bell was a lunatic.

Fred Beckey sent me an e-mail in May 2002, in which he stated:

My own thoughts were that I questioned his climb. He [Bell] ran into us a short time later, and it seemed that there was insufficient time to do the climb and show up where we were. Also he did not seem to have much of a tan or burn, given the good weather. . . . He kept to himself a lot (like the Unabomber). Actually he might have made a good Unabomber.

Bell responded to the above statement by e-mail to me in May 2002:

[Regarding the Unabomber], I learned recently that he was a college classmate of mine (Harvard

class of 1952). With the lab skills I showed at prep school, any bomb I tried to make would have blown up in my face.

As a response to Charlie Bell's announcement of having made this ascent, a party was organized to go up there ten days later to repeat and confirm the ascent. This group consisted of Barry Prather, Dave Mahre, Bob Baker, Herb Staley, Fred Beckey, Eric Bjørnstad (all seasoned mountaineers), and Charlie Bell himself.

They were unable to either repeat the climb or confirm where Bell had gone on his ascent. In all fairness to Bell, it should be pointed out that an intervening warm spell could have changed the snow and ice conditions.

Bell was not totally without mountaineering experience, as he had been a member of the Harvard Mountaineering Club and had done some standard climbs in the Tetons and in the Canadian Rockies, and had made a guided ascent of the Matterhorn in Europe. Regarding this contested climb, Bell did not have a camera along, and he stated that he could not find the Mt. Rainier summit register, so exactly where he went on that climb in 1961 will forever remain a mystery. This is how the situation stood when the climbing season began in 1962.

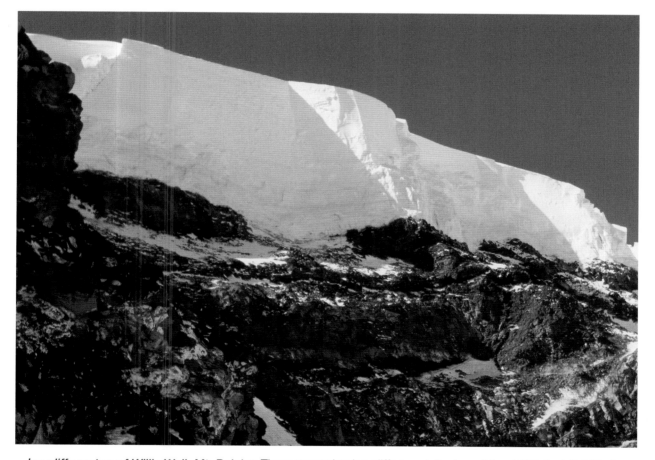

*Ice cliffs on top of Willis Wall, Mt. Rainier. These menacing ice cliffs are at the top of the 4,000-foot (1,200m) Willis Wall. Climbers who consider ascending this wall should look at this picture of the 200-foot (60m) ice cliffs to determine for themselves if they really want to attempt this climb. These ice cliffs, at irregular intervals, discharge thousands of tons of ice, creating huge avalanches that sweep clean everything in their path. This photo was taken on the climb in 1962.*

# CHAPTER FOURTEEN

# SHOELESS *on a* GLACIER

By the latter part of June 1962, two parties had already been up to the base of the Willis Wall and had turned back (Fred Beckey and Eric Bjørnstad, and separately another party composed of Fred Dunham, Jim Wickwire, Gene Prater, Barry Prather, and several others). On June 19 I left Seattle with Mike Swayne, and we headed up to the end of the Carbon River Road after notifying the Mountain Rescue Council and giving them a return time (no call to them by the return time would have automatically initiated a search and rescue effort).

Little did we know that we were being observed very closely by Charlie Bell, who had heard about our departure from Eric Bjørnstad at the Pizza Haven (see chapter 12). I felt comfortable being a climbing partner with Mike Swayne (and he with me) on a climb as demanding as this, where speed and climbing ability might mean the difference between life and death. Neither of us had felt this kind of confidence in connection with Charlie Bell. Further, the line we had picked out appeared—unlike the route Charlie was said to have climbed—to have technical difficulties. Charlie apparently followed us by car up to the Carbon River and even observed us at the end of the road, as I was to learn later.

Early on the hike to the base of the wall, we passed a closed ranger station with a register for parties to sign out. I remember (though Mike does not recall this) signing the register to make us "legal" in case there were any problems later with the Park

Service authorities. (Registration was required of all parties.)

By early evening we reached a spot on the Carbon Glacier about 200 yards from the bottom of Willis Wall. The plan was to rest for several hours there and then try a line up what is now referred to as the East Rib. It looked a little more protected from objective dangers than the route Charlie was to climb (and said he had climbed the previous year), now known as the West Rib. At about 11:00 p.m. of that long June day, we heard a loud rumble from above. We looked up to see a white cloud descending the face heading in our direction. Not even waiting to put boots on, we raced across the Carbon Glacier in stocking feet, unroped, in a direction away from the cloud.

It took several minutes for the ice crystals in the air to settle before we could tell if all our equipment, including our boots, had been buried or not. The avalanche had reached and passed the level of our rest spot but had passed 100 or so feet to one side of it. We were happy about that, as it would have been an interesting proposition trying to descend the Carbon Glacier and a rocky trail in our stocking feet! That avalanche was a sort of swan song for me. It was forcibly impressed on me that I had probably exhausted my "nine lives" in the mountains, and after this climb I never again challenged fate in such a confrontational manner.

We looked at the course of the avalanche; it had barreled down part of the very route we had

planned to attempt, the one we thought was the most "protected" and "safest" route on the Willis Wall. It just didn't seem possible that an avalanche could have left the prescribed avalanche courses so completely, but it had happened. Had it occurred a few hours later, Mike and I would have disappeared entirely, perhaps to reappear 500 years later when the snout of the Carbon Glacier disgorged us.

Very shaken, we regrouped, and after a few fitful hours at our bivouac spot, we started up at 3:00 a.m. on a different course from the one we had planned. We moved to the left of the East Rib, where we crossed the bergschrund and then made an ascending traverse to the top of the major buttress on the East Rib. From there we climbed steep ice and "Boulderfield Cliff" to the left edge of the line of ice cliffs at the top of Willis Wall. We did the entire climb unroped, since speed was of the essence, and rope drag itself could have dislodged rocks and boulders. Mike had the following to say about one point of our climb on the wall:

I almost lost it at one point on the traverse. I was using an ice hammer in one hand and ice piton in the other, and the tips of my crampons to

*Mt. Rainier, Willis Wall the day before the climb, 1962.* This photograph of Willis Wall on Mt. Rainier (14,410ft/4,392m) was taken on the way up to, and the day before, the author/photographer climbed a route on the left side of the wall with Mike Swayne. It shows the conditions at that time. Mt. Rainier in Washington State is the highest peak in the long chain of Cascade volcanoes stretching from southern British Columbia to northern California.

keep three-point suspension. The ice crusted on a rock gave way under my foot as I made a move, and for a moment left me hanging onto the ice hammer and piton. I looked down about 3,000 feet and quickly recovered my footing.

"Boulderfield Cliff" is like a boulder field set at about a 55-degree angle. To climb this section, you have to not only use the boulders as handholds and footholds but hold them in place at the same time.

Once at the top, we signed the summit register, descended by an easier route, and managed to get out and notify the Mountain Rescue Council with only ten minutes to spare before a rescue would have been automatically initiated. We were not completely satisfied with our "solution" to Willis Wall, but neither of us ever wanted to go back up there again!

Meanwhile, early on in the climb, we had spotted a lone figure approaching the wall near Liberty Ridge. Occupied with our own problems, we didn't see the climber again. It was Charlie Bell, as we later learned. He had apparently followed Mike's and my steps up the Carbon Glacier and diverged from them at the point where we headed toward the East Rib. This time he had a camera with him. It was verified that he reached the summit of Mt. Rainier, as he signed the summit register the day after we signed it.

Charlie took some photographs that were the subject of speculation on the part of experienced climbers for some years. Many felt that they were taken either from Liberty Ridge or by traversing a short distance off Liberty Ridge to the east. The issue wasn't settled until 1972 after Jim Wickwire and Alex Bertulis climbed the West Rib, which they did in 1970.

Jim Wickwire, who has climbed more routes on Willis Wall than anybody else and is one of the leading historians (besides Dee Molenaar) on the Willis Wall, examined photographs taken by Charlie Bell and reported, after correspondence with Charlie Bell:

I was able to establish that he had indeed climbed major portions of the West Rib on his second climb. But it was marred somewhat by the fact that he made an ascending traverse from just above the toe of Liberty Ridge and only reached the West Rib about two-thirds the way up from the bergschrund (at roughly 11,500–12,000 feet). He then climbed the rib for some distance before traversing back to Liberty Ridge just below the prominent sickle-shaped ice cliff that Bertulis and I avoided as well.

Charlie Bell stated to me in a September 2000 e-mail that the negatives from his photos of the Willis Wall had been lost in the theft of a file cabinet from his van in 1970. Jim Wickwire says that he has some poor copies made from original prints, which apparently were lost by the American Alpine Club.

In retrospect, after studying all the material on the subject, it would appear that Bell's 1962 ascent was, in a very rough manner, a mirror image of our ascent. Substitute the words Curtis Ridge for Liberty Ridge, and right for left, and it is almost a description of our ascent. Even more amazing, most of it was done on the same day as our climb (he bivouacked near the top of the West Rib).

The accompanying photograph (see page 105) was taken on the way to the base of Willis Wall the day before both climbs and shows the conditions that existed at the time. One can almost trace out a route where it would have been possible to avoid most of the rock areas following Bell's 1962 route as described by Jim Wickwire (with the exception of the upper portion). Jim also stated, regarding the

*"Boulderfield Cliff" on Willis Wall, Mt. Rainier, in 1962. Photo of Mike Swayne on "Boulderfield Cliff," a loose conglomeration of rotten volcanic rock set at a 55-degree angle, high up on Willis Wall of Mt. Rainier. The only way to describe this location is as a "climber's nightmare."*

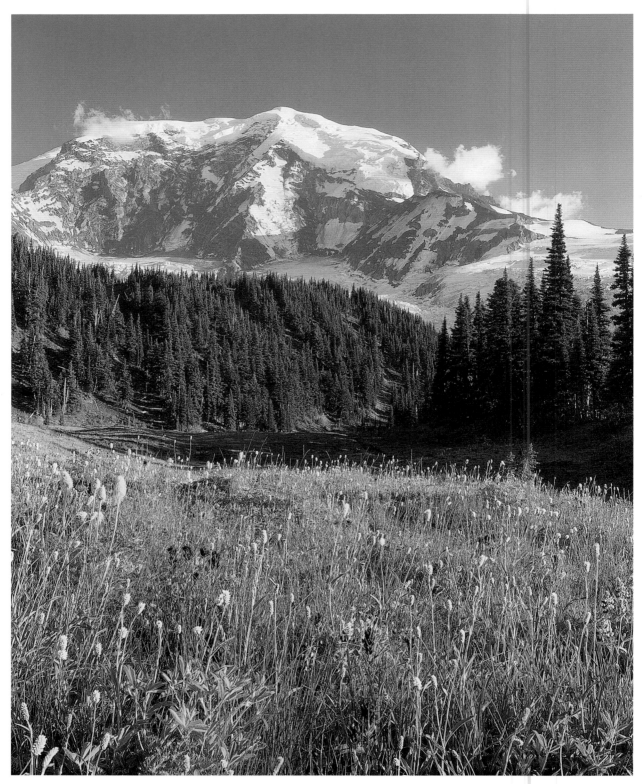

*Willis Wall on Mt. Rainier: a kinder, gentler appearance. Beautiful flowering alpine meadows and forestlands are found along the Mystic Lake Trail, on the approach to the base of the mountain. Willis Wall provides a dramatic backdrop to this fairyland.*

upper portion of the route, that the traverse immediately beneath the ice cliffs to the top of Curtis Ridge did not present great technical difficulties.

It was ironic that for all our trouble, all three of us received fines from the Park Service for climbing in a prohibited area. But as a result of these climbs, the Park Service changed its rules to allow climbing on Willis Wall and to allow climbing in all seasons, and dropped its requirement that there had to be three in a party. (*Note:* I never did contest the legality of our registration; I was in another state at the time and it was cheaper in terms of time and dollars to pay the fine rather than travel back to Mt. Rainier to contest the charge.)

*Postscript:* In an e-mail in May 2002, Charlie Bell stated to me:

> When I reached it [the bergschrund] I saw I could not cross as I had the previous year so I backed off, sat down on the glacier, and took a nap. When I awoke, you [Ed Cooper and Mike Swayne] were no longer in sight. I walked west almost to the bottom of Liberty Ridge where the bergschrund ended, scrambled onto the lowermost diagonal ledge, and followed it back to the gully west of my Rib. A quick dash brought me back onto the Rib only a few dozen feet above the bergschrund.

This contradicts both earlier statements of Charlie Bell and the conclusion of Jim Wickwire after considerable correspondence with Charlie Bell in 1971 and 1972, about where Bell reached the West Rib. Jim stated:

> Above Point X [the point where Charlie Bell joined the West Rib Route], your [Charlie's] '62 route coincides in almost every particular with our '70 route.

Jim's placement of Point X was the only area of dispute with Charlie, and Charlie did eventually concede to Jim that

> . . . you must be right [about the higher location of Point X], in a fit of absentmindedness unusual even for me, I apparently wandered diagonally halfway up the wall and never realized that instead of making the lowest possible traverse onto the Rib, I seem to have made almost the highest. Oh well, I suppose I should be happy to have played the parts of both Lindbergh and Wrong-Way Corrigan.

Jim Wickwire further stated to me in an e-mail in May 2002:

> Reading through everything again, I must admit that I am still troubled by Charlie's initial confusion about where he went in 1962, which could affect—if one chose to view it that way—his credibility about the 1961 climb. In his own mind, he seemed to think he had duplicated the 1961 climb with his 1962 ascent, which, of course, his own photographs proved he hadn't.
>
> I eventually came to the conclusion that this was simply a guy who was completely oblivious to the objective danger on Willis Wall, probably due mostly to the fact he was an outsider to the Northwest climbing community. But I also think he may not be the type of person who remembers precisely something he has done (a climbing route on a big, complex mountain face).

Each reader will have to draw his/her own conclusion about this matter. But one thing is certain. Charlie Bell had a proprietary feeling about the two climbs that he did on Mt. Rainier (notice his reference to "my" rib above), and it became his mission in the years after the climbs to "redeem" himself to the climbing community regarding the validity of his climbs.

*Note:* I have one photograph in my collection that could—possibly—solve the riddle of exactly where Charlie Bell went on the lower part of the

wall on his second climb, if it were subjected to scientific analysis. This photo was taken high on Willis Wall looking down at Liberty Ridge and is a fairly sharp 2¼ transparency. There should be a line of Bell's footprints in the snow, something that is not readily apparent when inspecting the transparency, even with a jeweler's loupe. Possibly microvariations of density in the snow when seen under extremely high magnification might reconstruct a line of footprints. They would not be seen as footprints, but rather as a continuous line of irregular density that is otherwise "out of place" in its location.

Jim Wickwire himself has some remarkable mountain stories. They are told skillfully in the book *Addicted to Danger*, published in 1998 (coauthored with Dorothy Bullitt). In this gripping narrative he tells the story of his many adventures (both successful and unsuccessful) and the deaths of four of his climbing companions in three separate incidents. The following saying began circulating in the climbing community: "Don't go climbing with Wickwire 'cause you'll never come back."

More recently, in September of 2002, Jim was leading a party of four on Mt. Rainier. Among the team members was Ed Hommer, the noted double amputee, who was training for an attempt on Mt. Everest the following year. They were at the 11,700-foot level when Jim heard the whizzing sound of a rock falling off Disappointment Cleaver, a rock ridge directly above them. The rock struck Ed Hommer, who was killed instantly.

# FALL ON EL CAPITAN *and a* CIGARETTE COMMERCIAL

n the autumn of 1962, I returned to Yosemite Valley after having spent my first summer in search of great landscape images. Jim Baldwin and I had been forced to discontinue our attempt on El Capitan the prior spring because of both heat and a serious rope burn to Jim's hands. In addition, there was a climbing ban on El Capitan during the summer months because of the problem of traffic and crowd management, which had occurred during the first ascent of the Nose of El Capitan, in 1957 and 1958.

Jim's rope burn had occurred while we were using—on the lower part of the climb—the same slippery yachting nylon for fixed rope that we had used on the Chief. There was one overhanging pitch

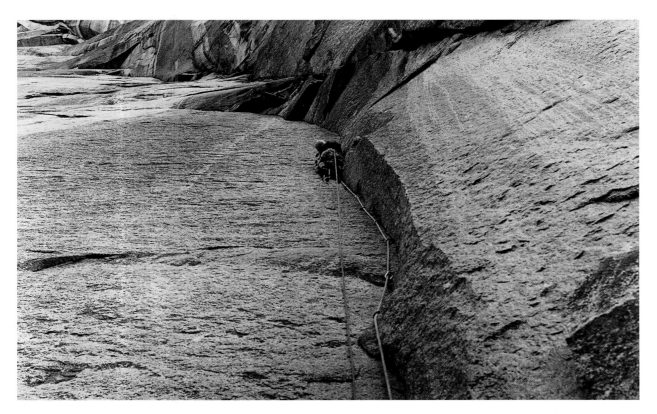

*Jim Baldwin on El Capitan, 1962. The vast expanse of rock dwarfs a human in this view looking almost straight up. There are acres and acres of exposed rock on the face of El Capitan, and many portions are smooth enough that if this formation were tipped on its side, it would be possible for a vehicle to drive the approximately 3,000-foot distance by choosing the proper route. This picture was taken on the second pitch of the Dihedral Wall route on El Capitan.*

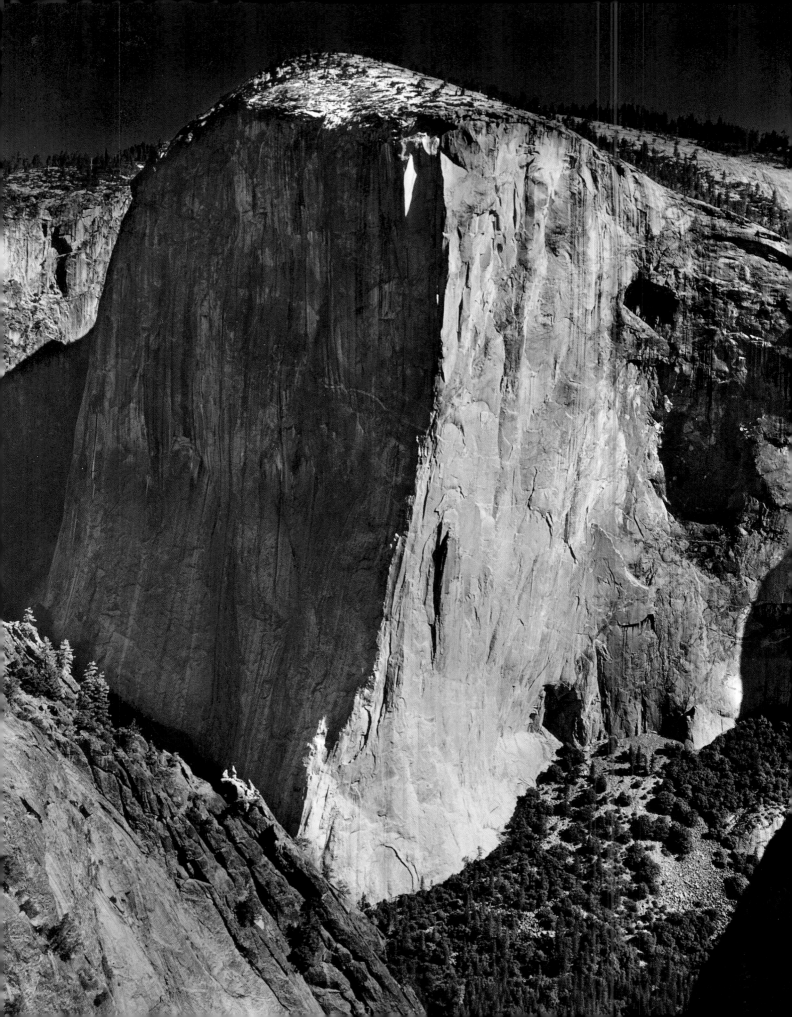

at about the 700-foot level, and it was necessary to prussik *down* this rope when descending, as a rappel would have left one hanging in space. (Prussiking down was also necessary on many other pitches that either overhung or went too far sideways to reach by rappel.) Jim's prussik knots had failed to grip the slippery nylon yachting rope properly at the top of the overhang, and he had slid at almost free fall speed all the way down to a belay point, where he was stopped by the end of the rope being fixed to the wall. Jim had grabbed the main climbing rope to try to stop his slide, burning his hands badly in the process, and the prussik knots had almost burned through. (See the note later in this chapter on prussik knots.) After that experience we used triple loops on our prussik knots.

We continued in the autumn, adding Glen Denny—from Livingston, California—to our climbing team. He was a quiet but very strong and determined person and made a great addition to the team. Jim and I now did not have to rely on each other all the time, which greatly relieved the pressure and strain that we both felt with just the two of us.

Going up the fixed ropes in the autumn to the previous high point of about 900 feet was, frankly, quite scary. The ropes had been there throughout the summer heat, and by this time the once pristine white nylon yachting rope now looked absolutely dreadful. It was dark gray to black in some places

*El Capitan, Yosemite Valley. I have so many favorite views of El Capitan that it was hard to pick just one, but when reviewing them I kept coming back to this image. Here the bold lines are shown to best advantage: the prow of a mighty landform thrusting forward. This is not a standard view, nor one you are likely to find on a postcard. I will leave it to the determined photographer to find this viewpoint. Hints: Some rock climbing is involved, and the best time to photograph it is in the morning.*

and looked puffed up to almost twice its original volume in locations where the rope had been blown across abrasive sections of granite. I went up first, trying not to think about the unthinkable, but if the unthinkable did happen, it would probably be over so fast that I wouldn't realize what had happened. Lest the reader be totally misled about the state of our ropes, we did have several new perlon ropes for the actual climbing and belaying.

At the resumption of the effort, before Jim was able to rejoin us, Glen and I were caught in a once-in-a-decade lightning storm while hanging in seat slings. (It was not until the next year that bivouac hammocks became available.) I quote from an article that I wrote at the time:

> This lightning storm was more intense than either of us had ever seen before, which (for me) included some real shockers in the Bugaboos and the Canadian Rockies. It was in fact the worst electrical storm to hit central California in a dozen years. Hundreds of forest fires were started, some of which we could see. Even the valley floor received strikes during the nine continuous hours of lightning. Concerned friends reported seeing bolts actually strike the sides of El Capitan and bounce off.

Hailstones up to $\frac{1}{2}$ inch in diameter pelted us, and at times the volume of hail was so great that we had to shovel it away between the vertical rock wall and us. We retreated the next morning, thankful for just having survived, at which time Jim joined us, thankful that he had missed this unique experience.

The only fall I ever took while engaging in roped climbing occurred on this climb. At about 1,500 feet I was leading a pitch, placing some insecure pitons. As I swung my piton hammer back, the piton I was hanging on popped out. My momentum carried me in a backward swan dive, another piton or two popped, and I was left hanging upside

*Collection of climbing gear for El Capitan. Before Jim Baldwin and I left for California in late March of 1962, we held a party in Seattle and asked everybody who came to bring a contribution of climbing gear for us to be able to climb a new route on El Capitan in Yosemite Valley. This gear was added to what we already had. We wound up with a total of more than 3,000 feet of nylon rope plus lots of iron (pitons). The result is shown in this photo.*

down in the air in a slightly overhanging section. After a short time I extricated myself from this position and, using prussik knots, ascended back up to the last piton that had held and completed the lead. (*Note:* It was not until the following year that mechanical rope ascenders—"Jumars"—became available; we used the laborious prussik knot method of ascending ropes, and descending them where necessary, throughout the climb.) Jim and Glen also took falls when pitons popped out.

Because of the prominence of long inside corners on the climb (often leaning), it was christened the "Dihedral Wall." One memory that remains of

this climb is its repetitive and at times monotonous nature, if living in a vertical world for days and days at a time can be said to be monotonous. The last pitch, the top of which overhung, was definitely not boring and is worth describing. Again, quoting from my article:

Three overhanging flared cracks of 15 to 20 feet followed one another. Pitons could be placed only deeply within them. A short section of mixed aid and free climbing led to an overhanging corner, which in turn led to a seemingly impassable ceiling, through which a way would have to be found. This was done the next morning by nailing 15 feet

straight out over one of the ceilings in a crack formed by the juncture of the ceiling and an overhanging wall. The crux piton was a knife blade placed at the outer edge. And there it was for the first time possible to see the end of the difficulties, a scant 20 feet away. The friction of the rope going through all the overhangs became so great on this last pitch that it was necessary to untie from one climbing rope and tie into a second, unclipping from most of the pitons placed.

The route we climbed is vertical for most of its length, with only one ledge in the first 2,000 feet, other than a ledge at the top of the first pitch. Seventeen of the next nineteen belays were hanging. The route consisted mostly of "nailing," putting in one piton after another (this was before other advanced rock-climbing hardware became available). The new route was the fifth ascent of the face of El Capitan, the first ascent of the Dihedral Wall, and the first climb on the face by "Valley outsiders" (Jim and me). We finished the climb November 25, 1962, a few days after Thanksgiving.

Glen went on to make many difficult climbs and first ascents in subsequent years. Jim moved from Canada to California the following year (1963) to become Canada's first full-time climbing bum before his tragic accident in 1964 (see chapter 7). I will always miss Jim. Despite the exchange of an occasional harsh word or two on climbs, he was the most jovial person I have ever known with whom to share "war stories" over a beer or two.

In that same autumn (before finishing the climb), I auditioned for an ad for Camel cigarettes. This was the era when athletes endorsed cigarettes, which is hard to believe now. A friend of mine, Bob Bhyre, of the Mountain Rescue Council in Seattle, had also done a Camel ad and he recommended me. I was chosen to appear in the ad, and the fact that

shortly after my acceptance I had successfully climbed the face of El Capitan was an additional feature that was incorporated into the ad.

The thing I remember about the filming of the commercial was that I felt sick from all the inhaling of cigarette smoke I had to do. I smoked only moderately (in those days almost all adults smoked), but I didn't need a surgeon general to tell me that it was bad for my health. Even at that time cigarettes were called "cancer sticks." Less than a year later, I gave up smoking of my own free will. The only problem I had then was to dispose of the two cartons of Camels that continued to arrive weekly for many months afterward. My wife tells me I still had cartons of Camels when we met in 1967.

The climb also led to my appearance on the TV program "To Tell the Truth," in which three contestants, including me, all claimed to be Ed Cooper. The impostors were good ones, apparently, as only one of the four panelists picked me as the real Ed Cooper. The panelists didn't know much about mountain climbing, apparently. At one point, one of them asked one of the impostors, "How long does it take to climb Mt. Hood?" The improbable response of "fifteen days" apparently went unnoticed by three of the panelists!

The income from the residuals from the ad allowed me to devote one full year to learning the art of photography, free from financial worry. I rented a small house in Berkeley and set up a darkroom with some pretty good equipment, including a Beseler enlarger and three Schneider Componon enlarging lenses. Many a night I burned the midnight oil in the darkroom while listening to the radio show "Music 'Til Dawn," with host Ken Ackerman, sponsored by American Airlines. I also used some of the income from the cigarette ad residuals to add two new camera lenses: (1) a Schneider

150mm Symmar—a sharper lens than the Kodak Anastigmat, and (2) a Schneider 90mm Angulon wide angle. In between darkroom times, I would travel to Yosemite or other points of interest in California to exercise my 4x5 camera.

One *always* has to be careful in the mountains, even when doing something seemingly safe like taking pictures from a viewpoint. One such place I visited that summer overlooked Rainbow Falls near Devils Postpile in the Sierra Nevada of California. This was before an elaborate viewpoint had been constructed; one just chose a point along the edge of a cliff to view the falls. With my tripod set right at the edge, I became so engaged in bending around to the front of the camera making lens and shutter adjustments that I lost track of where I was. I slipped on some gravel and for an instant I balanced on the edge of eternity, between the safety of the ledge and the sharp volcanic rocks 100 feet below. Once again the mountains had given me a lesson to take to heart.

During this time frame, I acquired a set of four books by Ansel Adams: *Camera & Lens—Basic Photo 1; The Negative—Basic Photo 2; The Print—Basic Photo 3; Natural Light Photography—Basic Photo 4.* This is his classic series. Looking at these books at the time of this writing, I noticed that each book of the set is autographed by Ansel Adams. If I had ever known this, I had forgotten, and I can't remember if I bought them that way or if at some point I asked him to sign them.

Studying Book 2, I soon realized that I would have to make some modification to his "zone" system of exposing and developing negatives. I knew I would be taking photo trips lasting weeks or even months, and would be collecting numerous 4x5 (and in a few years 5x7 and 8x10) black-and-white negatives. It would be impossible to keep all these straight as to which negative should be developed for what period of time.

Adams's system does yield the best negatives, but over a period of the next several years—by necessity—I evolved my own system. I kept on hand photographic paper from Grade 1 through Grade 6 contrast, and then chose the paper to fit what I wanted to derive as a print from each negative.

Old habits die hard. I made plans, somewhat unenthusiastically, for another climb—a new route on the northwest face of Half Dome, which I planned to do with Galen Rowell in the early summer of 1963. We actually went up there, climbed two pitches, and left some gear there, planning to return and complete the climb later.

Another team made the climb before we had a chance to return. My feeling about this was simply one of relief. I didn't have to go back up there and make another difficult climb. I now felt free from the compulsion of having to do any particular climb and free to roam around the mountains at will, seeking those special wild places to photograph.

A climbing journal used two of my photos to illustrate this face climbed by the other team. One of the photos was taken from the "Diving Board," a hard-to-reach viewpoint made famous by Ansel Adams when he climbed to that spot in 1926 to take one of his classic landscapes. Other climbers puzzled over the fact that I was willing to supply photos to be used with an article about a climb Galen and I had started that other climbers had finished.

*Northwest face of Half Dome seen from the Diving Board. Half Dome (8,836ft/2,693m) stands guard over the eastern end of Yosemite Valley. The northwest face is over 2,000 vertical feet and appears almost as if it had been sliced by a sharp knife. This spot is my choice for the single point in the entire Sierra Nevada where one can be the most infused with the power of rock.*

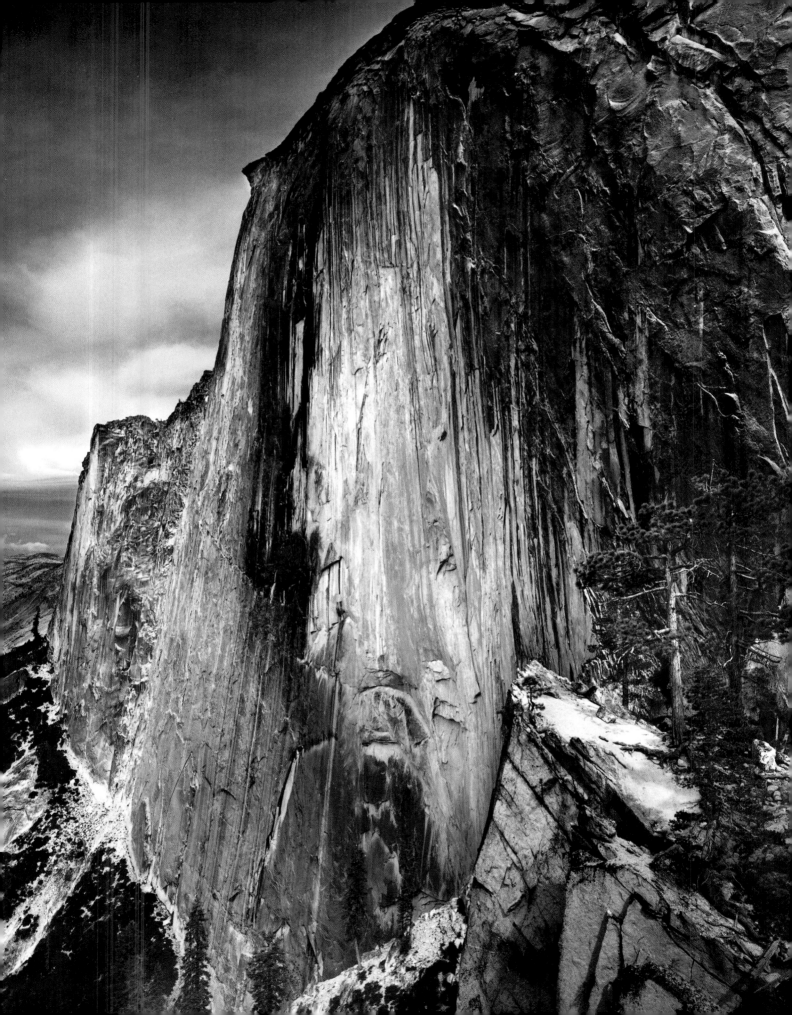

Climbers might not have understood my attitude, but I approached the situation from the viewpoint of a photographer, not a climber.

In the late autumn of 1963, the residuals from the Camel commercial ran out and hence the money. Income from pure photography just wasn't making ends meet. I hadn't yet found a niche where I could ensure a steady stream of income. After an agonizing reappraisal of what I was doing, I decided to return to the East Coast, where I would be closer to some possible markets for my photography.

In Chris Jones's book, *Climbing in North America,* he writes that, disgusted with the treatment by local climbers, I retreated back East. This story seems to have been repeated in other publications. The fact is that economic necessity drove me to move. Less than three years later, I returned to the West Coast for good to pursue photography. Had I wished to continue technical climbing, nobody would have driven me away or stopped me. *Turning my focus to photography as a fine art at the expense of technical climbing was my own decision, several years in the making, and part of my "master plan."*

That year I began to explore other great land-scapes: the ocean, the desert, the forests, and the minutiae of nature. I spent time visiting most of the national parks in the western United States. I came to the realization that the beauty of nature can be found almost anywhere you look.

For the trip back East, I couldn't fit everything into the klunker I owned at the time. (I can't even remember which vehicle it was, since in the period from 1957 to 1966 I had about ten old cars, each one dying in a different part of the United States or Canada.) I made the fateful decision to ship some of my photographic materials by train.

On November 22 of that year, I was visiting my sister and brother-in-law in Kansas City when President Kennedy was shot in Dallas. Practically all who were adults at the time (as well as many who were children) can remember where they were and what they were doing when they heard this news. Similarly, members of an older generation can remember where they were and what they were doing when they heard the news of the attack on Pearl Harbor on December 7, 1941, and members of the current generation will remember where they were and what they were doing on September 11, 2001.

# A FIRE *and a* STRAITJACKET

fter arriving back East in December of 1963, I waited and waited and waited for the arrival of my shipped photographic materials. After a number of queries over a period of a month, I finally received an answer. *All the contents of that shipment had been lost in a railroad boxcar fire.* That was it, with no other details or explanation given.

This was quite a blow, to say the least. I was stunned and sat down to figure out what had been

*Shadow of 80 Pine Street on the Chase Manhattan Building, the New York City "Range." This was one of the very few times I actually took camera equipment into New York City to take pictures. I think of the days that I worked in New York City as my "dark days." On the better days I would imagine that I was in a deep canyon in a range of rock towers, with their own play of light and shadows that changed as the day moved along. On the not so good days, of which there were many more, I just suffered silently.*

lost. In traveling back East, I had taken all my color transparencies and black-and-white prints with me in the car, while I shipped all the black-and-white negatives by freight. The reasoning behind this was that if worst came to worst and something bad happened to one group of photographic materials, I would still have the other group. Although I was able to demonstrate the wisdom of the theory, the worst had indeed happened to one group.

*All the black-and-white negatives I had taken in the period 1960 to early 1963 were lost!* This included all the 2¼x2¼s I had taken on many climbs and a group of 4x5 negatives taken in 1962 and early 1963. I took consolation in the fact that everything had not been irretrievably lost. I had made many black-and-white prints from those negatives, and I had sometimes shot color and black-and-white of the same subjects.

I could (and later did) make copy negatives from some of the color transparencies. Still, there were many more negatives I never printed that had no counterparts in color. I will never know exactly what negatives of historical interest may have been lost.

A financial settlement was finally reached with the shipper; I used the money to acquire more darkroom and camera equipment. Included in the new equipment were a 5x7 Gundlach Bundschu view camera (with supplementary 4x5 back), a 12-inch Turner Reich triple convertible lens, and a 20-inch Bausch & Lomb lens. The latter was a military surplus lens (a spy lens) used for aerial photography.

My parents were kind enough to let me set up my darkroom in their home. My time was split between a shared apartment in New York City and my parents' house, where I might work almost nonstop in the darkroom for two or three days. (I didn't dare bring my darkroom equipment into the city; apartment robberies, especially in the less expensive

sections of the city, were just too common.)

During the summer of 1964, I made a trip to Canada, during which I obtained some of my classic images of the Bugaboos in British Columbia. Sometimes the photography in wild places was no less work than climbing in these same places. I had traded climbing gear for photographic gear, and in many cases the photographic gear proved to be the heavier of the two.

I carried that 5x7 view camera, together with tripod, lenses, and film holders, to near the top of the Crescent Spire to take two views appearing in this book (page 67 and on the jacket—the east face of Bugaboo Spire, page 121—Pigeon Spire). The Bausch & Lomb lens by itself weighed more than *two* pounds.

During this time I kept searching for my niche. During winter months I was a ski instructor on weekends. I printed up a brochure that I had designed about a slide show on the subject of climbing and gave lectures at a number of Eastern prep schools. Once in a while I would sell a photograph for publication or to an individual, but in the latter case the return was not proportional to the effort. I even did some school photography (of classrooms, students, and so forth), but I felt as out of place at that as a fish trying to ride a bicycle.

To add to everything else, I was receiving pressure from my parents to "get a real job." After all, what was my college education for, anyway? This kind of thinking is very destructive to the artistic mind. Had I not been born to create photographic images? Slowly I felt my creative drive slipping away, and by early 1965 I had to admit defeat. I was ready to accept the necessity of the straitjacket called a regular job.

Accordingly, I applied to several brokerage firms for a position as a "customer representative," which

*Pigeon Spire in the Bugaboos of British Columbia. This view of the peak (10,250ft/3,124m) was taken from Crescent Spire looking over the col between Snowpatch Spire (left) and Bugaboo Spire (right). If you look carefully, you can see two people standing on a ledge on Snowpatch Spire. I didn't even know that they were in the picture when I took it and only discovered it the following winter when examining a print made in the darkroom. I later learned that they were two of the noted Vulgarians (a group of climbers from New York famous for their outrageous actions) climbing a route on the southeast side of Snowpatch Spire. This photo was taken from the same spot as the view of the east face of Bugaboo Spire on the jacket.*

is a fancy expression for a salesman of stocks, bonds, and other financial instruments. Many people in the area where my parents lived worked in the financial industry, so I had a ready entrance. My old "master plan" seemed shattered.

I came up with a new plan. I was a whole lot less enthusiastic about my new plan than my old master plan, but at least I allowed myself hope in the new plan. Once I settled on a firm to work for, I would work for eight years, make a pile of money, retire, and spend the rest of my life searching out images of nature.

I did take a job with a brokerage firm and went through their training to become licensed as a "registered rep." I applied myself diligently, yet the "fit" was not right. Things were not too bad when I stayed in New York City, but when I visited my parents on weekends to do some darkroom work, it was dreadful having to return to the city.

Leaving the pleasant countryside of Tuxedo (in New York State, but on the other side of the Hudson River from New York City), I would commute on the "weary Erie" Railroad, down through the industrial area in New Jersey, taking either the Hudson Tubes or the ferry to Manhattan. From that point, I would walk or take the subway (depending on the weather) to my office at 80 Pine Street in the financial district.

Later, our firm moved to 1 Wall Street (I still have some business cards with my name on them, at that address). From that location I overlooked Trinity Church from my office window. During every commute into the city, I would think to myself, "God, how I hate this!" The obligatory suit (I referred to it as my "business costume") soon became my personal straitjacket that I had to deal with each weekday morning. I especially hated wearing a tie, as I always felt it was choking me.

I began to compare this time period with another unhappy period of my life—in the Cathedral Choir School (see chapter 2). However, the financial district was not without a certain type of architectural beauty of its own. Yet the repression of my creative spirit prevented me, with one or two exceptions, from trying to capture images on film of this area. The image on page 119, titled "Shadow of 80 Pine Street on the Chase Manhattan Building, the New York City 'Range,'" is one of the very few photos that I ever felt inspired to take in Manhattan during this period in my life.

Some sounds and images remain in my mind, from a ground floor apartment I had rented on the Lower East Side of Manhattan (I was serious about saving money, and this was a low-rent district). The building had an inner courtyard, and around dinner time this courtyard offered a cacophony of sounds—breaking glass, bouncing tin cans, unwanted food splatting onto the ground, etc.

Tenants just threw out their windows whatever they didn't want, rather than carry the garbage down (the building was a five- or six-story walk-up). Very early in the morning the super, wearing a hard hat to protect himself from falling objects, would go out into the courtyard with a wheelbarrow and a shovel to gather up all the garbage thrown out since his last collection.

In this environment, you learn to live with cockroaches. They seemed impossible to eradicate. The first floor had the advantage of not having stairs but the disadvantage of being damper than higher floors, and you would frequently see very large water beetles wandering around the apartment. Further, rats and mice were also a fact of life.

The year of 1965 was the first time in more than ten years that I hadn't at least visited the Western states. Something had to give. I couldn't take life in New York City. I learned that our brokerage firm had a branch in San Francisco, so I applied for a transfer. I had been a hard worker and had opened many accounts, some by giving investment seminars that were advertised in the *Wall Street Journal* and the *New York Times.* My firm agreed to my transfer to the San Francisco office.

Things started to look up immediately. I now had something to look forward to. I would be able to work in an environment where I could get away on weekends to explore the Western landscape, at least in California. Enthusiastically I began making plans for my new life.

Towers of the Virgin, Zion National Park, Utah. These very impressive rock formations may be seen from the Zion Human History Museum. The Altar of Sacrifice, on the right, is a sandstone formation almost 3,000 feet high.

*Moonrise over the Titan. The Titan is one of the Fisher Towers not far from Moab, Utah. In recent years, Moab has become a popular year-round recreation center, with desert rock climbing as one of the activities. This is one of my all-time favorite images.*

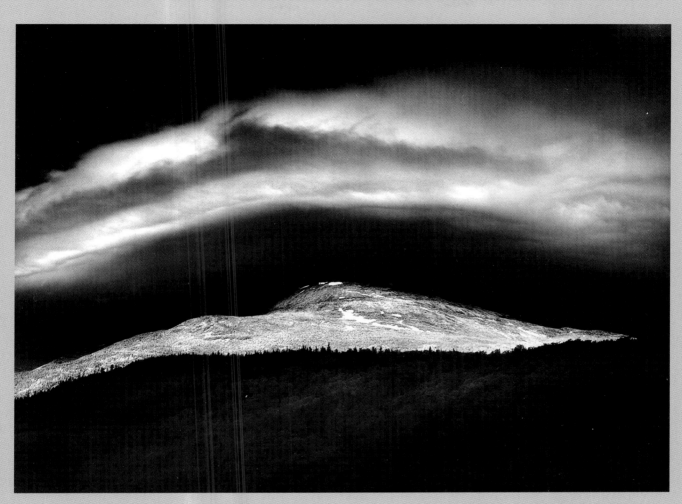

*Lenticular cloud cap over Mt. Washington, New Hampshire. Some of the world's worst weather occurs at the summit of Mt. Washington (6,288ft/1,917m), the highest point in the northeastern United States. Despite its relatively modest size, this mountain holds the record for the highest wind ever recorded at a weather station: 231 mph (372 kph), recorded on April 12, 1934. Higher wind speeds are found only in class F5 and some class F4 tornadoes.*

*Sierra personality profile: Galen Rowell near the beginning of his climbing career, 1963. One immediately sensed intensity and determination on meeting Galen Rowell (1940–2002); these qualities showed through even on this early photo of him climbing. Making a name for himself early on with ascents in the Sierra Nevada, he went on to become a well-known figure in the international mountaineering community, with major first ascents in many mountain ranges throughout the world. With his fresh literary style and fine photography, he was also known for his books in the field of mountaineering adventure. Galen and his wife, Barbara, were killed in the crash of a light plane in Owens Valley, California, on August 11, 2002. With the death of Galen, still youthful and vibrant at age sixty-one, the mountain world lost one of its most dynamic personalities.*

*The contrasts in the personalities between Norman Clyde (see below) and Galen Rowell couldn't have been greater: the one tending toward the solitary and reclusive\*, the other participating actively in many expeditions and giving public lectures on the art of adventuring. Both men had one transcending feature in common, however—their love of the mountains.*

*\*While Norman did write a short autobiography, we will never know of the many spiritually moving experiences he must have had in the mountains.*

*Sierra personality profile: Norman Clyde near the end of his climbing career, 1963. No matter what Sierra Nevada summit you reach, the chances are that Norman Clyde (1885–1972) has preceded you. Further, the more remote the summit, the more likely it is that he has been there, probably by more than one route. Norman was a veteran of ascents numbering in the thousands, and he did what many of us only dream of doing—spending virtually year-round in the mountains—and he did this for half a century. Stories abound about the heavy packs he carried (90 pounds plus) and the books he took along to read (among others, Greek classics in Greek!). I met him near the end of his climbing career and captured on film the sparkle in his eyes as he looked up at the great eastern flanks of the Sierra Nevada, talking of future trips.*

*Debby Cooper, my wife and life companion, 1969. This was taken just before the start of a backpack to Sawtooth Lake in the Sawtooth Mountains of Idaho. Also seen is the VW camper mentioned in the text that crisscrossed the continent several times during this photographer's search for images, from Baja California to Québec's Gaspé Peninsula and from Florida to Alaska.*

*Photographer/author with special telephoto setup, 1970. A 36-inch Dallmeyer lens is attached to an 8x10 Eastman view camera. Note the two tripods required to support this apparatus. A number of the photographs appearing in this book were taken with this setup. The telephoto power of this lens used on a 4x5 format is about equivalent to using a 250mm lens on a 35mm format.*

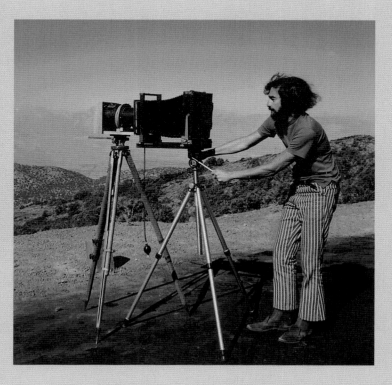

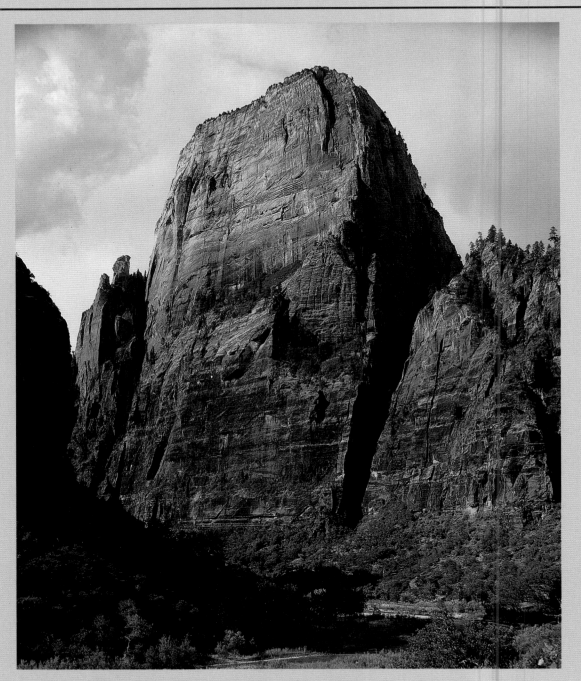

*The Great White Throne, Zion National Park, Utah, 1982. This is one of the great rock formations in the United States and was the subject of a commemorative postage stamp in the 1934 national park series. This formation of Navajo sandstone is to Zion what Half Dome is to Yosemite. In fact, Zion Canyon may almost be thought of as a Yosemite Valley in technicolor, with the size of the walls matching those of Yosemite.*

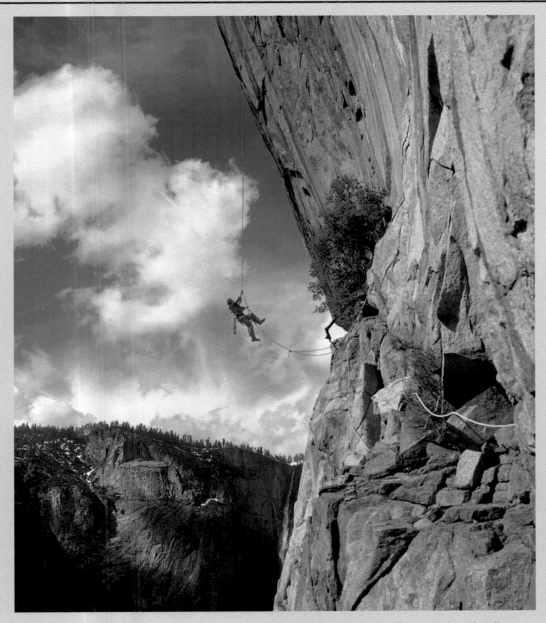

*Warren Harding on Leaning Tower, 1962. The west face of Leaning Tower claims the distinction of having the longest continuously overhanging section of rock in Yosemite Valley, or anywhere in the Sierra Nevada, about 900 feet. Ribbon Falls may be seen in the middle right, across the valley.*

*I packed my camera gear up to the starting point of this climb, to capture this image of the legendary and indomitable Warren Harding prussiking up the first fixed rope of the climb. He was on his way to removing all the fixed ropes that had been placed the previous year (1961) during the first ascent. Warren (1924–2002), irreverent to the end, was best known for the first ascent of the Nose and the Wall of Early Morning Light routes on El Capitan and for his capacity to ingest large quantities of cheap wine.*

# CHAPTER SEVENTEEN

# OUT WEST AGAIN, "LOADED FOR BEAR"

As part of the preparation for my new life, I acquired another view camera: an 8x10 Eastman with 4x5 and 5x7 backs. Also acquired were two sharper lenses to replace existing lenses: a 90mm Schneider Super Angulon and a 300mm Schneider Symmar.

I also outfitted myself with two new lenses: a 65mm Schneider Super Angulon (super wide angle for the 4x5 format) and a 36-inch Dallmeyer (super telephoto for the 4x5 format). The latter was, like my 20-inch Bausch & Lomb, a government surplus aerial spy lens, and by itself weighed more than ten pounds.

With the 36-inch Dallmeyer, I used separate tripods to support the lens and the camera. I custom fitted a Packard shutter on the back of the lens and had available a red gelatin filter and a sheet of Polaroid that would cover the 6-inch diameter of the lens, if I chose to use either of them as a filter. The whole apparatus was complicated to set up and use, but with it I obtained some of the most remarkable mountain images in my collection.

In the years 1962 to 1966, I had learned to "see" in black and white. I could look at a scene in color and visualize what the final black-and-white print should look like. It was a combination of not only taking the picture at the right time of day with the right filter (if any) but also mastering the darkroom technique necessary to actualize the original visuali-zation. This included not only the choice and grade of photographic paper but also the techniques of burning, dodging, and ferricyanide bleaching on the print itself.

Burning consists of giving part or parts of the print more exposure (thus making them darker); dodging consists of giving part or parts of the print less exposure (thus making them lighter); and ferri-cyanide bleaching is used to render highlights or dark areas lighter and is applied with a brush. Making the final print can be called a real work of art.

Before setting off for the West Coast from New York in May of 1966, I bought a new Volkswagen camper (my first new vehicle ever) and stocked up with all types of film in different sizes. I was "loaded for bear," so to speak. I went on a three-month odyssey that took me up through the White Mountains of New Hampshire, around the Gaspé Peninsula in Québec, and on to western Canada and the western United States. For the first time in my life I had every photographic tool at my disposal that I could have wanted and three months to pursue those great landscapes. It was, in short, a trip of joy and discovery.

I resumed my day job in the San Francisco financial district in September. It was a bit of a comedown to go back to work in an office, but every weekend I took off to someplace where I could exercise my photographic eye. It was during

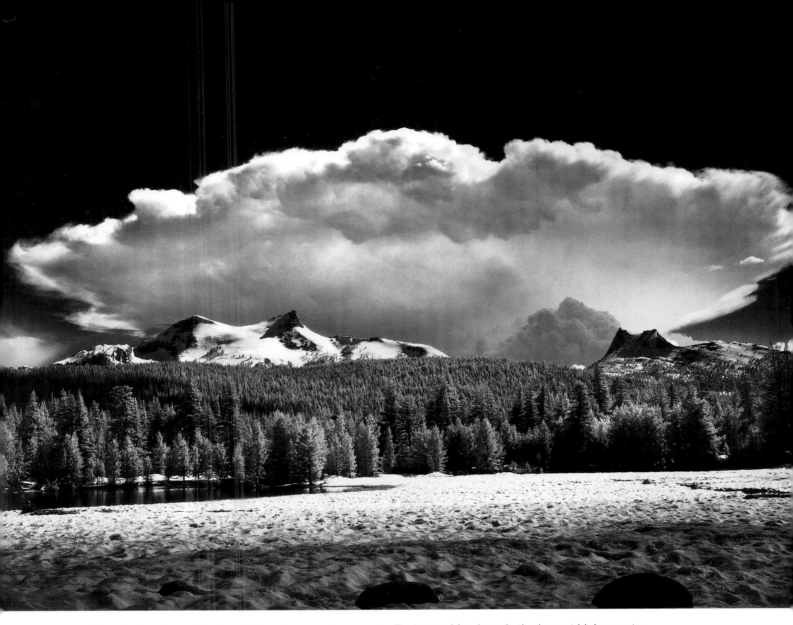

*Thunderhead over Tuolumne Meadows, early summer. Tuolumne Meadows is the largest high-country meadow in the Sierra Nevada, ranging between 8,000 and 9,000 feet in elevation. Unicorn Peak (10,823ft/3,299m) is at left; Cathedral Peak (10,911ft/3,326m) appears on the right. John Muir made the first ascent of the latter peak in September 1869 and wrote, "This I may say is the first time I have been at church in California." This quote is from his book* My First Summer in the Sierra.

this period, in the autumn, that I began to notice groups of young people in strange dress, the males with long hair, in the Panhandle District of Golden Gate Park near Haight Street. I was told that they were called the "diggers," and they gathered for free meals being handed out (and sometimes LSD or marijuana as well).

Starting in December, the San Francisco news-papers began featuring stories on this new "counter-culture," as it was called. The term "hippies" soon replaced the term "diggers." Shortly, papers all over the country were running stories on the phenome-non, and the stage was set for the "Summer of Love." The gospel was Timothy Leary's phrase, "Turn on, tune in, drop out." I had a front seat to watch the entire movement unfold.

That following spring, summer, and autumn, I spent nearly every weekend exploring the great California landscapes, but especially the Sierra Nevada. On one weekend day (June 17, 1967) I took the picture on page 131, Thunderhead over Tuolumne Meadows. I consider it one of the three best cloud shots in my black-and-white files.

Ansel Adams was personally conducting one of his photography workshops just a short distance away. I have always wondered if any of his students managed to capture on film this same cloud. I have been asked many times if I ever met Ansel Adams. While this may be a surprising admission, I just can't remember.

I may have been introduced to him that day or at another time (I mention this possibility in chapter 15). In any case, I later did have some correspondence with him regarding an article I wrote for *Backpacker Magazine,* seeking his opinion on H. W. Gleason, an earlier pioneer photographer. Further, I do know that Adams was aware of my work because he mentioned me as one of a group of younger photographers in an article he wrote for *Playboy Magazine* sometime in the late 1960s or early 1970s.

I found myself affected by the new counterculture springing up around me at this time; certainly it seemed like a lot more fun than my day job! It was during this time period that I met my future wife and life partner, Debby Page. She had also moved to San Francisco in 1966 looking for a new life. She was an Easterner also (Massachusetts), and a computer—back in the earliest days of computer dating—introduced us.

Toward the end of that year, I realized that I could never complete my plan of working eight years in the financial industry, even if it did bring me piles of money—which it probably would not have, considering that my enthusiasms lay elsewhere.

Taking stock of my situation, I resigned from my firm in December of 1967 and never looked back. I moved into the "Sixth Avenue Delicatessen and Commune." It was so named because the front portion of the unit consisted of a former deli while the rear portion consisted of bedrooms and living space, and there were four of us living there.

The new "digs" were located ½ block from Golden Gate Park. I can remember on more than one occasion getting stoned and going to the Steinhart Aquarium in the California Academy of Sciences (admission was free in those days) and watching the octopus crawl along the glass wall.

Life is not all fun and games even when you have dropped out, which I really hadn't in the fashion that many people in that era did. I took my photography very seriously and set up a spacious darkroom in a portion of the old deli. I figured I had saved enough money to live for about a year, and I had better get my act together (i.e., be able to make a living with photography) within that time.

To celebrate my new freedom, I made a trip through the American Southwest in January through March, and planned a grand trip to Canada and Alaska that summer of 1968 to capture landscapes in that magnificent country. In mid-June I set out from San Francisco in my VW camper and got perhaps 50 miles, somewhere near Fairfield, when the engine blew. There I stood by the side of Interstate 80 with a fully loaded dead camper. I guess those little engines were adequate for the VW beetles, but not the campers.

It took about ten days to straighten all this out, and once again I set off. (To this day, every time I travel Interstate 80 I think of the above incident when I pass the spot where the camper died.) The trip to Canada and Alaska provided memorable images of a great land. Debby stayed in San Fran-

cisco, working at San Francisco State, which had a memorable year of its own in 1968, with university president John Summerskill resigning while in Ethiopia, student riots, picket lines, bombs in trash cans, Tac Squad presence, etc.

The end of that year Debby and I got married, and early the next year we moved to a small house that we had purchased near Mendocino, a center of arts along the north coast of California. Photographic sales were now steady, if slow. Most of the income was from sales for editorial use in books and magazines. Books still used considerable black-and-white in this time frame, but I was also beginning to sell publication rights for 4x5 color transparencies, for books, magazines, and calendars. The income was erratic, but a start.

Debby brought in extra needed income working as a waitress, and one winter by "picking crab" at a local fishery (taking the shells off crabs). Every time she came home from work at the fishery, I insisted she take her clothes off in the garage before she came into the house, because they were so "fragrant." Debby always claimed, however (and I believe it), that if you'd been picking crab, cats would follow you anywhere.

In fairness to me, I never insisted that she work at this job even though we needed the income badly. Fortunately for everybody involved, Debby's "crabbing" skills were not great, so the job didn't last very long. Her work output couldn't match that of the locals who picked crab every winter and filleted fish at other times. The under-the-table benefit of eating crabmeat was the only positive feature of this job, she says.

I received a break in early 1969 when the Seattle Mountaineers commissioned me to photograph the Alpine Lakes area, the mountainous region of the Cascade Mountains east of Seattle situated between Stevens Pass and Snoqualmie Pass. The photography was to be used in a book to show the beauty of this area and the need for its protection. I was provided with a home base in the Seattle area and told to "go out and shoot." This was a dream assignment for a photographer.

Debby and I spent about three months total in the area, in different seasons. The book was to be all in color. It was published in 1971 under the title *The Alpine Lakes,* and it was instrumental, luckily, in helping to protect and preserve this delicate alpine environment. Bob Gunning supplied additional photography for the book.

I also experimented with making exhibition prints and displaying them for sale at one of the local art galleries in Mendocino. Much of the summer of 1970 I spent in the darkroom working on this project. There were a few sales, but the results—on the whole—were disappointing. People didn't seem to be willing to pay more than a few dollars for a black-and-white photographic print, no matter how good the quality was. I do remember that one couple who did buy a print told us that they planned to use it to replace an Ansel Adams print of which they had grown tired, which was evidently a compliment!

A further disappointment was the fact that the pay rates for publication of black-and-white were almost always less than those for color. In my opinion, it should have been the other way around. Black-and-white requires more work than color. There was (and still is) no question in my mind that in many cases black-and-white is the more expressive medium.

In 1971 we moved to the Seattle area. We took advantage of the fact that Boeing (the airplane manufacturing company) had gone into one of its periodic slumps, which always lowered the price of real estate.

Also, we felt that this move would be good for the photography business, due to the recent publication of the Alpine Lakes book, despite the fact that the book itself—having been mostly a labor of love—brought in more glory than income. Toward the end of 1971 we were just barely surviving financially with my photography as the main source of income. Debby was working full-time at another job.

An interesting thing happened in the autumn of 1971. We had an auto repair bill of $398 and odd cents (funds we didn't have at the time) for repairs to our only vehicle, the VW camper that had trav-

eled to Alaska in 1968. Just as we had to pay the bill, we received a check for $400, one of our largest single sales made up to that time. We were interested in the exactness of the amount, as well as very grateful. (Debby says that the VW breakdown occurred as we were returning from a Seattle production of *Jesus Christ Superstar.* Make of that what you will.)

It had now been almost four years since I had made the commitment to succeed in photography "or else" (the "or else" never being fully defined). A new business plan was called for, and I came up with one.

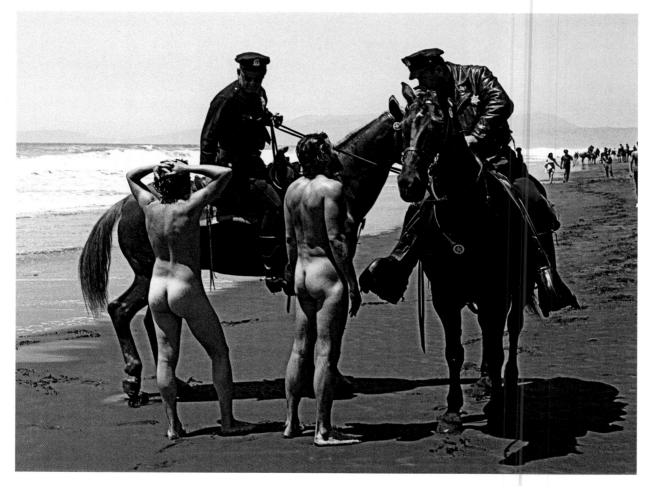

*Nude hippies at Ocean Beach, 1967. Mounted police spoil the fun of some hippies at Fort Funston on Ocean Beach in San Francisco, during the "Summer of Love."*

CHAPTER EIGHTEEN

# STOCK PHOTOGRAPHY *and* "TOPPING" SUMMITS

The new business plan was very simple. Not only was I used to working with a 4x5 camera, but editors of magazines and books liked working with this format. So shooting 4x5 made sales more likely, everything else being equal. I was surprised that this idea hadn't occurred to me before. Further, travel of varying lengths of time was becoming part of my photographic routine. (Most recently we had been in Florida, where my parents had retired, in late 1971 and early 1972.)

We would run a stock photography library of the United States. Once I had arrived at this decision, everything seemed to fall in place. I had found my niche; the "master plan" was fulfilled. All subjects, except for animals and events, would be shot in 4x5 color. I discontinued shooting any subjects in the 5x7 and 8x10 formats. I would continue to shoot black-and-white negatives, but more as an adjunct to color and not the main focus. All gross income except what was needed for living expenses would be reinvested in film and travel to expand the stock photography files.

In 1972 I spent months touching on various subjects in Washington, Oregon, Idaho, Montana, and Wyoming. During the following year our son, Matthew, was born, and we traveled back East to show him off to our relatives. Along the way, I added to my stock photo library with photos of sub-jects extending from New England down the Atlantic Coast to Florida.

On one memorable Sunday I drove my camper truck (the faithful VW camper was no longer our only vehicle) down to Wall Street in New York City; Sunday is the only day you can drive around there easily. While there, I took shots of a number of buildings against the backdrop of the newly completed World Trade Center towers. One of these photos was later published on the cover of the March 1978 *Sierra Club Bulletin,* which seems an unlikely candidate for a city shot. It was used for illustration purposes, opposing the projected "Westway" freeway being considered at that time for New York City.

One time I figured out approximately how many sheets of 4x5 color transparency film were exposed that year (1973), and it was somewhere between 8,500 and 9,000. This is an obvious reflection of the fact that the photography business was doing better.

I did not ignore the mountains; indeed, the focus of many of the trips was various mountain ranges. In 1972 I started a new practice, which was to spend the night with my photo equipment on location. Sometimes it might be a ridge from which there were great views; occasionally it was the top of a mountain (which, for lack of a better term, I called "topping" a peak). In essence, I was reversing the usual procedure for arriving at remote view-points or climbing a mountain.

**Boston Peak seen at sunset.** This view of Boston Peak (8,894ft/2,711m) in the North Cascade Mountains, was taken from the summit of Sahale Peak, located near Cascade Pass. This was not the result of arriving at the summit late because of poor planning; rather, the trip was planned so as to spend the night on the summit (i.e., "topping" the peak).

Usually one leaves very early in the morning in order to arrive at a summit or ridge viewpoint sometime in the middle of the day. From the viewpoint of photography, the middle of the day is when the lighting is usually the flattest and least interesting.

The lighting and colors near sunrise and sunset have much more contrast and interest.

This practice is not without some risk. You may be at the mercy of the weather in such situations, and depending on the peak or viewpoint, there may

*North Cascade panorama, before and after color correction applied. This panoply of peaks, seen from the summit of Sahale Peak in the North Cascade Mountains, was taken the morning after spending the night on top of the peak. Glacier Peak (10,541ft/3,213m), a Cascade volcano, is seen in the distance at right center. Mt. Rainier (14,410ft/4,392m), another Cascade volcano, can just be seen in the far distance on the right. This is an example of color restoration of old transparencies whose colors have shifted. After scanning the image to digital form, a straight print without any color correction was made, in which the magenta-purple cast was overbearing. A simple adjustment in the color balance gave the result seen in the comparison print. For all of you who may have old color slides or faded color photographs in old family albums, take heart! Don't throw them away, as they can be restored like new!*

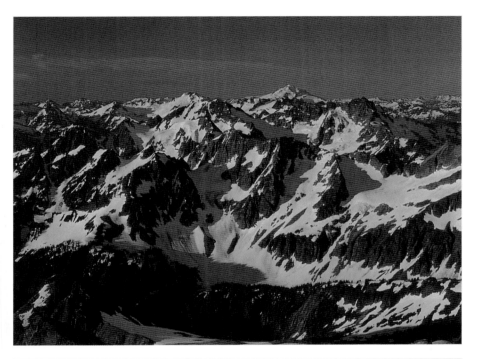

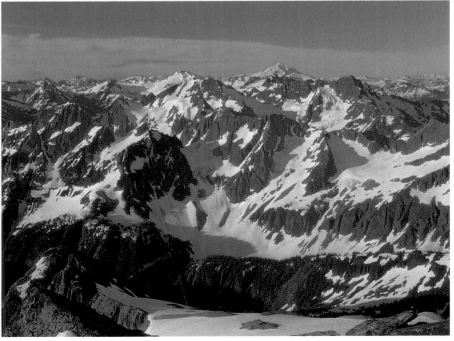

be no possibility of descent at night. Further, I was almost always by myself on these trips, progressing at a slow pace, taking pictures along the way with the view camera. The rewards for such travel, though, are commensurate with the risk. What more beautiful place could one choose to spend the night than the top of a mountain? The oneness you feel with nature is indescribable.

Over the years as an astute student of weather, I had become fairly good at being able to choose the right time, weather-wise, for mountain trips. The first peak I chose to "top," in July 1972, was Sahale Peak in the Cascade Pass area of the North Cascade Mountains. I equipped myself as I would have for an ice climb with a bivouac. To this weight was added all the considerable weight of photo gear.

There was a small ledge perhaps 20 feet below the summit that was suitable for spending the night. It was quite cold and even with my down gear and bivouac sack, I was rather chilly, but it was a marvelous experience. The snow, which had been soft and sloppy when I ascended the previous evening, was now hard and frozen. When I descended, my crampons bit cleanly into the frozen crust, and the ice axe steadied my balance, reminding me of my serious mountaineering days.

That year I also bivouacked right on the High Divide in Olympic National Park, instead of staying at one of the lakes below the divide where it is customary to camp. Unlike my camp spot at Sahale Peak, it would have been possible to descend from the High Divide in case of a storm moving in, in the middle of the night.

My dedication to the mountain environment continued, and in between shooting stock for my general files, I made a point of detouring to obtain mountain views, if any were possible in the area where I was shooting.

# CHAPTER NINETEEN

# BEFORE *and* AFTER *and a* BAD "TOPPING"

Perhaps the reader has noticed that as you slip into a routine of life, the years move inexorably onward, leaving you to wonder where all the time went. So it seemed to me also in my career. There was the hard nitty-gritty of work, lots of it, as the struggle to establish the business proceeded.

In the summer of 1974, Debby and I took our son (then ten months old) to Alaska, where I added to our stock photography of that area. There were many local trips to the mountains out of Everett, Washington, where we lived at the time. It was during this time period that I stopped keeping detailed records of exactly where I went and when. For that reason, there is some photography in this period, and several years that followed, where I can date a photograph only by year, or sometimes even less precisely.

I had already stopped taking detailed notes on exposure times, lens used, etc., in late 1971. Part of

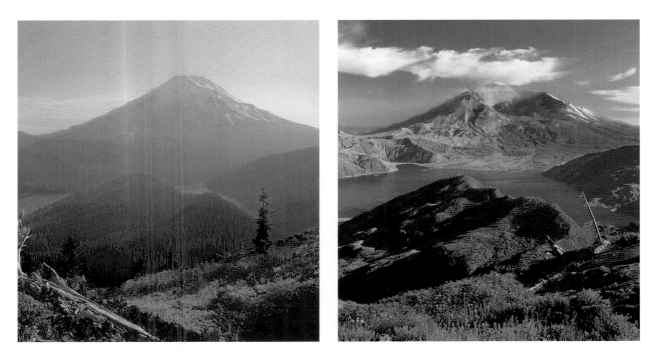

*Mt. St. Helens, before and after eruption, 1976 and 1991. These two views are from the exact same spot near the top of Mt. Margaret before and after the eruption of May 1980. Note that the size of Spirit Lake is much larger in the "after" view. Mt. St. Helens is located in the southern part of the Cascade Mountains of Washington State and is part of the long chain of Cascade volcanoes running from British Columbia to California.*

the problem was that I was shooting so much that it became a major burden trying to keep a detailed record, with everything else I was trying to do to build up the stock photography business.

The following year, 1975, I went to Wyoming's Teton Mountains in February to get some winter shots of that range. Another long eastern trip followed in the spring and summer. One specific trip I do remember that autumn was to Mt. St. Helens.

I had rather ignored this beautiful mountain, which at that time was still "the Mt. Fuji of America" with its beautiful conical shape, before the 1980 eruption changed the mountain's appearance so

drastically. Because of this lack in my photo library up to then, I decided to rectify the situation. Among the photos I obtained was one from near the summit of Mt. Margaret (reached by trail). Nearly sixteen years later, in 1991, I was to search out the exact same spot to make a "before and after" comparison shot.

In May of 1976, I took a sequence of photos of a climber climbing a rock formation called "Trigger Finger" in the Peshastin Pinnacles on the eastern side of the Cascade Mountains of Washington State. Little did I realize that this rock, popular for its short climb, would fall over in two to three years'

*Trigger Finger, before the fall. This is a photograph that can never be taken again—a climber on Trigger Finger in the Peshastin Pinnacles practice area near Cashmere, Washington. This unique rock fell over in the spring of 1978.*

*Trigger Finger, after the fall. This photo was taken from the exact same spot as the photo at left. We tend to think of the mountains as eternal and unchangeable, but this is one example of three in this book that show changes that occur over a very short period of time on the geological scale.*

*Trigger Finger, the shape that gave it its name. While not a great picture, this is the only image in my files that shows the characteristic shape that gave this historic rock its name. (The lean may be a clue as to why this rock fell over in the spring of 1978.) My climbing journal recorded that mine was the eighth ascent of this pinnacle, and I had given my camera to Fred Beckey to take this picture. This was in an era (1958) when you knew all the climbers who did any technical climbing and what they had climbed.*

time. Fortunately no climbers were on it when it fell, but to this day I wonder if all the ascents of this pinnacle had anything to do with weakening this delicate formation. I had climbed it two or three times myself. In July 2001 I returned to this location and shot the scene from the exact same spot showing the dramatic difference (see facing page).

A third "before and after" sequence that is chronicled in photos here is that of Devils Postpile in the Sierra Nevada of California. No fewer than five

Devils Postpile, 1963 and 1980. These two nearly identical views of the basalt columns at Devils Postpile National Monument were taken seventeen years apart. These formations are tucked away at 7,600 feet just under the western side of the main Sierra crest near Minaret Summit in the Sierra Nevada of California. The yearly cycle of rain, snow, frost, and minor earth tremors endemic to this area takes its toll, as can be seen by comparing the two photos. Note: There has been movement of magma below ground and a detectable rise in elevation of this area. It is on the watch list of volcanologists.

Devils Postpile, 1963 (upper photo): No fewer than five columns appearing in this picture have fallen over in the seventeen-year interval. **Arrows point out the columns no longer standing** (compare with Devils Postpile, 1980). This fairly significant rate of attrition came as a surprise to me when, upon comparing the two photos, I noticed the difference.

Devils Postpile, 1980 (lower photo): While taken from almost the exact same spot as the 1963 view, this was taken earlier in the day, so the shadows are somewhat different.

of the basalt columns had fallen over in a seventeen-year period between 1963 and 1980; I have two photos taken from almost exactly the same spot.

Changes are going on all around us constantly. No mountain or rock formation is eternal. While the changes may not be as dramatic as those shown in this book, they are nevertheless taking place.

In 1976 and 1977 I took two trips to Hawaii, totaling three and a half months to photograph that tropical paradise (and another trip to Alaska in 1977). The two 13,000-foot volcanoes on Hawaii's Big Island (Mauna Kea and Mauna Loa) are shield volcanoes and look like oversize hills for the most part, although they are massive in size.

At 13,796 feet (4,205m), Mauna Kea is the site of a number of world-class telescopes and features some of the best "seeing" to be found in the astronomical world. It is also the highest mountain in the world if measured from its base on the ocean floor—32,000 feet. At the older end of the Hawaiian Island chain, the island of Kauai contains valleys and fluted cliffs along the Na Pali coast that would please any mountain lover.

It was around this time that I started the prac-

*Columnar basalt at Devils Postpile. This unusual view of the top of one of the columns, showing a hexagonal form, was taken from above while I leaned over and balanced on the edge. This particular column is now one of the fallen, lying at the base in pieces together with the other broken ones seen below. The columns at Devils Postpile range from three sided to seven sided, so they're not always hexagonal.*

tice of jogging. As I reached forty years of age, I realized I couldn't just count on being able to take off into the mountains on a moment's notice for some extended hike or climb without the proper conditioning. The body seems to be lazy by nature, and unless it is confronted by some sort of a physical challenge, it is perfectly happy being a couch potato. I had to force my body into activity on a regular basis so that I could retain my ability to enter the mountain wilderness at irregular intervals.

I must add that regular exercise in the form of jogging never gets easier. It is always difficult, and it becomes more difficult as you get older. Some "experts" have commented that you get a "high" on running. I have never, ever, noticed that to be the case. It is just plain old hard work. (*Note:* I had noticed in the past, on certain climbs, that I got a natural high, but perhaps that was caused by an excess of adrenaline flow.) In 2004 I replaced jogging with working out on a stepper, which is much easier on the joints.

Sometime in 1976 I stopped taking black-and-white negatives altogether. The last black-and-white prints I had made in the darkroom had been on

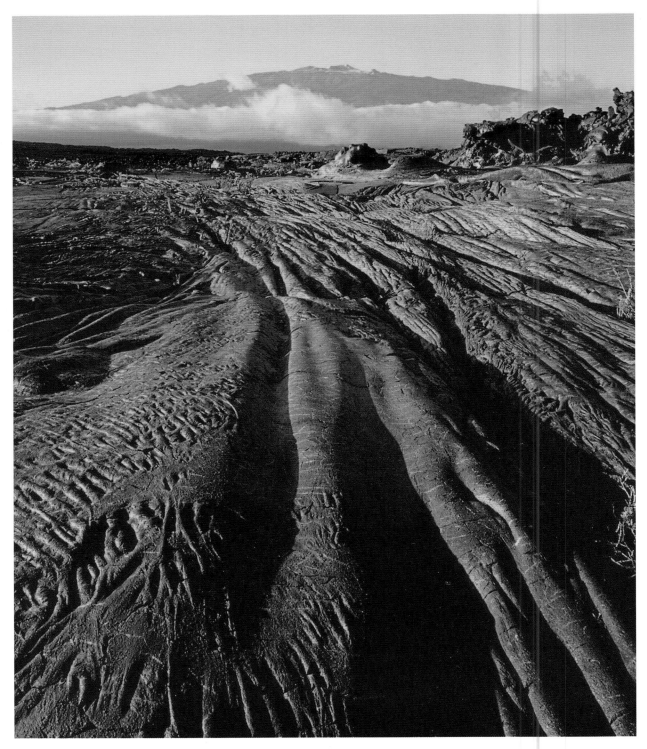

*Lava flow patterns on Mauna Loa volcano, Hawaii. Located on the island of Hawaii, Mauna Loa and Mauna Kea volcanoes are very close in height, 13,677 feet (4,169m) for the former and 13,796 feet (4,205m) for the latter. Mauna Kea volcano may be seen in the distance, and there is some snow in the summit area. These two shield volcanoes have very broad shapes. Both look like large hills when viewed from sea level, yet they are both well above timberline, and Mauna Loa is one of the most active volcanoes in the world. Both of these volcanoes exceed the height of Mt. Everest when measured from their base on the ocean floor.*

January 15, 1973, and I didn't know when or if I might resume. Already there was a backlog of several thousand black-and-white negatives that I had never printed. It seemed pointless to keep adding to the total when virtually all our photography income was coming from the sales of various rights to reproduce photos from color transparencies. I did resume, selectively, shooting black-and-white negatives in 1988 with the idea of eventually returning to the darkroom.

The Pacific Northwest in terms of beauty is surely "God's Country," but the long, cloudy winters took a toll on our spirits, especially mine. I feel myself to be a creature of the sun and thrive in that environment. As early as 1975, we made plans to return to California. We looked at property in California's wine country north of San Francisco, and in 1978 we purchased a parcel of land in the oak-covered hills above the Sonoma Valley, which became the site of our future home.

Knowing that we were going to move away from the Seattle area, I stepped up the pace of mountain excursions in the Northwest. In 1978 I took my view camera all the way in to Mt. Olympus in the Olympic Mountains (but only took the 35mm camera to the summit pinnacle). Two years later, the year we moved, I crossed the Olympic Mountains from east to west, going up the Dosewallips River Trail, over Anderson Pass, and then down the Enchanted (Quinault) River Valley, truly one of the most beautiful valleys to be found anywhere.

In June of 1979 I thought it would be a fine idea to "top" (spend the night on top of) Mt. Baker, in the North Cascade Mountains of Washington State. According to plan, I arrived at the summit late in the day, probably about 7:00 p.m. It was clear, but there was a strong wind blowing, averaging between 40 and 50 mph (an educated guess),

and the temperature was below freezing. I searched the large summit area for perhaps half an hour looking for even the slightest shelter, but there was not even a large rock.

I finally decided that the large furrows in the snow (seen photo below), caused by the action of

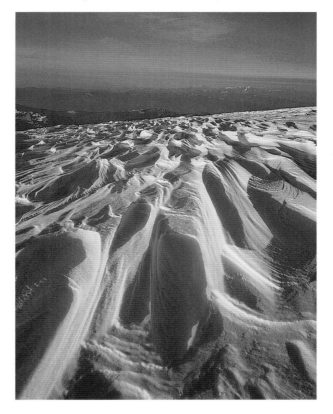

Snow patterns on Mt. Baker summit. These deeply furrowed snow patterns are caused by the action of the wind and the sun and make for very tiring walking. Mt. Baker is located in the North Cascade Mountains of Washington State. A thin layer of air pollution over the Fraser Valley to the north (in Canada) can be detected near the horizon. This photo was taken on my attempt to "top" Mt. Baker.

the wind and sun, offered the best shelter available. I started to lay out my bivouac gear in one of these furrows and watched as wind-driven ice particles (torn off the top of the furrows by the force of the wind) gradually covered the gear and even blew into all cracks and openings. I had gone up there to

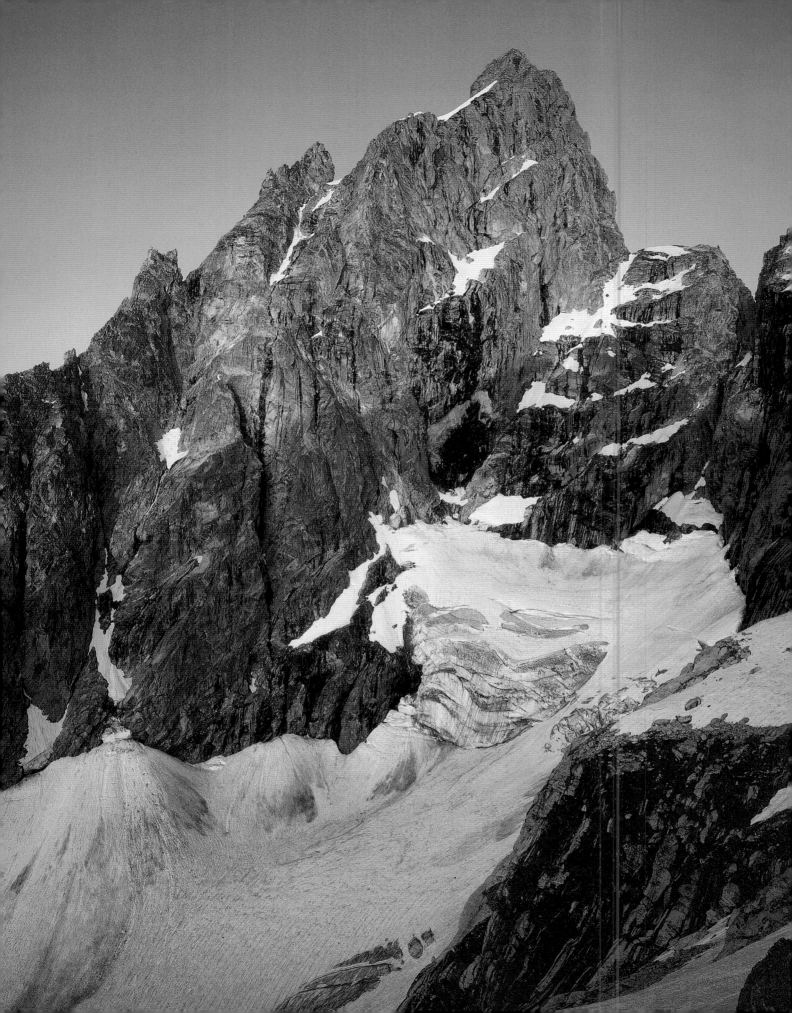

enjoy the experience and not to participate in an exercise in survival, which it would surely have been. Regretfully, I packed up all my gear and started down just as the sun was setting.

Fortunately the moon was out, enabling me to see quite well on the glacier and avoid all crevasses, and I arrived back at the car some time after midnight. The next morning a cloud cap covered the summit of the peak. How fortunate I had come down; not only would the night have been an experience in survival, but the morning (and finding my way down off the summit area) would have been one as well. There's an obvious lesson here. No matter how sure you are that the weather is going to remain clear at night in the mountains, you can't be absolutely sure!

This was brought home to me in spades three years later. I decided to climb to, and spend the night on, the connecting ridge between Mt. Owen and Teewinot Mountain in the Teton Range in Wyoming. I wanted to get some sunrise pictures on the north face of the Grand Teton. The Tetons are very vulnerable to afternoon thunderstorms, which are typical of the Rocky Mountains in the summer. I was very cautious and was prepared to turn back at any time the weather looked questionable, but it remained clear all the time that I was climbing to the ridgetop.

On the way to this ridgetop, there is some very tricky third-class climbing on down-sloping slabs covered with rock scree, which would be impossible to descend at night, especially in a hailstorm. Just as it became too dark to go anywhere, I heard the first rumble of thunder in the distance off to the west. What a predicament! The only place on the ridgetop that offered any kind of protection from the elements was a small cave underneath a large pinnacle, and the pinnacle was an obvious target for lightning.

I spent the night squatting on a small ledge, close enough to the cave to afford some protection from falling hail and snow, which soon started. I was, however, several feet away from the back of the cave and the ceiling, so that if lightning traveled down the pinnacle it wouldn't use me as a shortcut. A ground current might burn my feet, but I did have on boots with rubber soles, which might afford protection. That night was one of those times of sheer terror that simply had to be endured. The storm passed after three or four hours, and the image obtained the next morning appears on the facing page.

That same year as my trip to Mt. Baker (1979, described above), I bivouacked just below the summit of the Middle Sister in Oregon's Cascade Mountains, approaching the peak via a long but scenic route from McKenzie Pass. The area of the Sisters is one of the best places from which to view the string of Cascade volcanoes marching off into the distance. After descending, I raced back to Seattle in time to witness the birth of our daughter, Elisabeth, in August.

*The north face of the Grand Teton seen at sunrise. The north face, rising above the Teton Glacier, is one of the classic climbs in North America. This view was taken from the connecting ridge between Mt. Owen and Teewinot Mountain in the Teton Range of Wyoming.*

## CHAPTER TWENTY

# POSTCARDS *and* MORE POSTCARDS

We made the move to Sonoma, California, in April of 1980, just before Mt. St. Helens blew its top in May. In the next two to three years, I revisited many of the same spectacular mountain settings I had experienced in the state of California fifteen or more years earlier, and searched out new scenes as well.

With all the interest in Mt. St. Helens, I wanted to revisit the area when I heard that a new road had just been opened to the Spirit Lake area from the east. (The old road had been from the west, portions of which now lie buried beneath 200 to 300 feet of rock.) It was in 1982 or 1983 that I took our son, Matthew, up to see the devastated area. We spent the night at the end of the road, at which point Mt. St. Helens is hidden by an intervening ridge.

I awoke in the middle of the night to sounds that I interpreted as explosions. I even saw flashes of light that I interpreted as lava being thrown in our direction. Panic took over as I imagined that we were going to be engulfed in glowing hot ash. It took probably a minute to realize that it was a lightning storm raging about the peak. It was not surprising to make such a mistake considering the closeness in time to the 1980 eruption. Further, unlike the Rocky Mountains, thunder and lightning are relatively uncommon phenomena on the western slopes of the Cascade Mountains, where Mt. St. Helens is located.

In 1981 a recession hit the business of stock photography particularly hard. One of the first things that art directors and editors do when there is a budget crisis is to cut back on photography. At its peak, Ed Cooper Photography employed six people, my wife and myself included, with two of the six part-time. We had to cut back as well, letting one person go and reducing another to part-time employment.

There are things in life that all of us do, and in the future when we look back at it, we kick ourselves for having done it. As an economy measure in 1981 or 1982, I sold my Eastman 8x10 view camera and 36-inch Dallmeyer lens (equivalent to 914mm). The amount I received for the sale really made no difference in the long term, and I came to regret this action in 1992 when I decided to resume some limited shooting in the 5x7 format.

The 8x10 camera had had a 5x7 back on it and had been a much sturdier camera than my 5x7 Gundlach Bundschu camera, which was partially broken. I could also have used a triple convertible Nikkor-T lens with the longest focal length of approximately 1,000mm with the Eastman 8x10 view camera. I never did acquire this particular lens because I didn't have a camera with a long enough bellows extension.

We actively looked around for ways of increasing income. We had noticed that there seemed to be

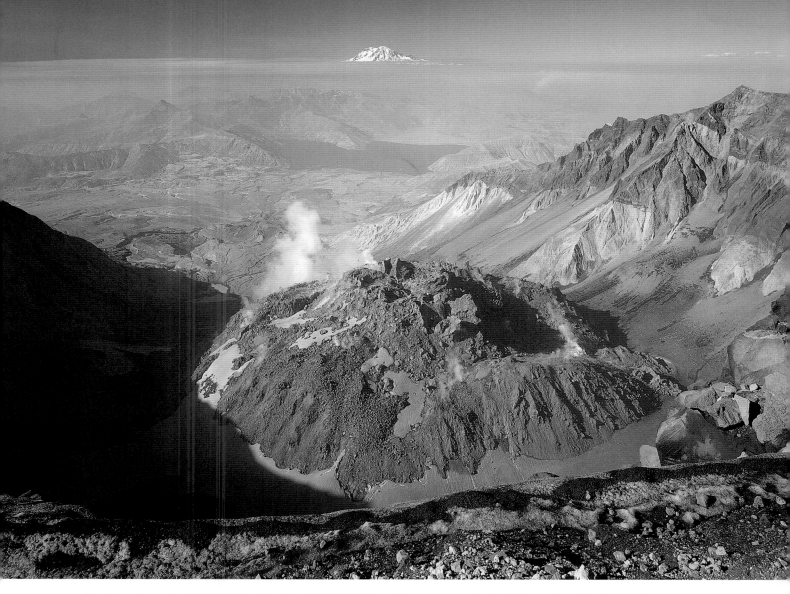

*The lava dome in Mt. St. Helens' crater, 1990. This formation arose gradually in the crater after the great eruption of 1980. Here it is viewed from the top of Mt. St. Helens. Mt. Rainier rises in the distance.*

no good line of postcards of the wine country, the beautiful area where we had made our home. I already was building a collection of photographs of the area, since we were so handy to the Sonoma and Napa wine country.

As luck would have it, I had met Brad Wagner in Hawaii in 1977. Brad had founded a company called Impact that specialized in creating high-quality posters and postcards that were being sold in increasing numbers in the national parks, and his company for several years had been buying our scenic views to use in their product line. We told the

folks at Impact how uninspired the local postcards were, and they suggested a sort of joint venture, where they would print, and we would market, some postcards of our own views to compete with the cards that were then available.

In 1982 we selected eight vineyard and grape views to make into 5x7 postcards and have them ready to sell at the start of the 1983 season. We chose a name for the business—Cooper Classics. The cards found ready acceptance, and it soon became clear we needed a whole line of cards so we could fill floor racks with different wine country–related views.

By 1985 we were placing nice wooden floor racks in winery gift shops and large retailers like Long's Drug Stores. By 1987 we were the largest distributor of postcards in the wine country and produced cards showing areas from the redwoods in the north to San Francisco in the south. Year by year we grew more successful, but we also were growing more exhausted. We were doing virtually all the distribution ourselves, which didn't help. Also, we were always expanding the number of products we offered, and we added posters, magnets, and other souvenir-related items to our line.

The business was doing well financially, but one thing I came to realize was that we weren't controlling it—it was controlling us. It is nice for a photographer to see his/her work published and disseminated so widely. This is what we were doing, but you reach a point where you get so involved with the publishing details that you lose your creative edge (or the burden of details sucks it out of you). Most of my photography in the 1983–84 period involved necessary new images for our product line.

Starting in 1986, I decided to once again make a point of spending time in the mountains, away from all the craziness of the postcard business, to "center" myself. I made a number of trips to the eastern Sierra Nevada, climbing various peaks

*Wheeler Peak, Nevada. Eastern Nevada is the unlikely setting for this major mountain peak. At 13,063 feet (3,982m), it is the only mountain in the Great Basin that contains permanent ice. The Great Basin is that large area of land in the United States that has no drainage to an ocean. It covers most of Nevada and smaller portions of Utah, California, Oregon, Idaho, and Wyoming. In the foreground is seen a lichen-covered boulder; above it can be seen part of the rock glacier (that contains the ice referred to above) below the northeast face of the peak.*

(including "topping" Mt. Gould, 13,005 feet, 3,964m) to get in shape for a one-day climb of Mt. Whitney. I wanted to surprise our son, Matthew, at the summit. He was on his first hike of the John Muir Trail, and I knew when his group was expected to reach the top.

Everything went according to schedule, and we did meet at the summit at about 11:00 a.m. (I left Whitney Portal about 1:00 a.m.) Matthew even took a picture of the stone shelter at the summit (with me peeking around the corner) without realizing that I was in the picture. Matthew subsequently hiked the "JMT" (as the John Muir Trail is referred to) in 1987 and again in 1989, when I was able to accompany him. Along the way on the 1989 JMT hike, I "topped" two summits, and at the end our entire party spent the night on top of Mt. Whitney, watching lightning flashes off to the east (where they were no threat) and watching the Perseid meteor shower (it was the night of August 10–11).

Earlier in 1989, as part of my conditioning for hiking the John Muir Trail, I had "topped" Wheeler Peak (13,063ft/3,982m) in eastern Nevada. As I have mentioned on a number of occasions, the mountains throw surprises at you when you least expect them. And so it happened on Wheeler Peak. When I reached the top in very early evening, the weather was calm and pleasant, and I had no reason to expect anything different for the next morning. I took a large number of pictures and settled down in my bivouac gear for a night under the stars.

I was awakened at dawn by the sound of wind racing over me. During the night the high pressure over the area had collapsed, causing these winds. The wind was so strong I couldn't stand up directly in its path (I estimated gusts up to 70 to 80 mph). I literally had to crawl off the top of the mountain until I could get to the partial shelter of a ridge

where I was able—albeit very carefully—to assume an upright position.

Meanwhile, the work of the postcard business continued, occupying a major part of our time in the spring, summer, and autumn. During the winter months we planned additions to our line. Parts of the business were all right. Trips to Napa Valley to peddle our products were usually pleasant, even if we would rather be doing something else with our time. We were often rewarded with large orders from winery gift shops.

Other parts weren't so okay. I remember one occasion where I delivered and set up six large wooden racks in one day to accounts in or near the vicinity of San Francisco. It was a nice day with the sun shining, and I could think of all sorts of places I would rather have been (especially out in the field taking photos). The routine for every stop of this kind (chain store) was the same.

Matthew Cooper just below the summit of Mt. Whitney, 1989. This was taken at the end of the John Muir Trail hike with our son, Matthew, in the Sierra Nevada of California. The hike was started at Tuolumne Meadows in Yosemite National Park and ended at Whitney Portal (below Mt. Whitney), a distance of some 200 miles. Ever the joker, Matthew poses in what looks like a very difficult and dangerous position, but he was in fact completely safe. He was standing on a large ledge.

I would have to enter the back of the store at Receiving, look for a clerk (often a time-consuming procedure), or wait behind other vendors in line for the receiving clerk to check me and the products in, and then, when everything was okayed, wheel the rack into the store and carefully fill all the pockets with cards. After that I would fight fierce traffic to the next stop and repeat the procedure all over again.

Cold prospecting was also part of the business. You had to ignore the managers who looked at you suspiciously when you approached them with what were obviously sample books trying to sell them something. It seemed like we encountered more than our share of Philistines in the process—managers who seemed to have no appreciation for the beauty of the product we were selling.

We would sometimes get that "What am I doing this for?" feeling, especially when we would see displayed the sign that says, "We shoot every third

salesman." (In fairness to the wineries and wine-related businesses, most of the managers there were very receptive to our products. Non-winery stores, however, could be tough.) Sales of postcards kept food on the table and helped us toward the day when we would not have to sell them anymore. And I did find time to go into the mountains, every so often.

In July of 1990, I "topped" the new Mt. St. Helens (my only other climb of the peak had been in 1955). I found a fairly level and safe spot about 40 or 50 feet below the summit. The crater walls dropped off sharply from the summit ridge itself, which was unstable. It was quite a thrill to spend the night on top of a live volcano. From the top I obtained the photo (see page 149) of the lava dome in the crater (built up after the 1980 eruption), with Mt. Rainier in the background.

Shortly after that, I went up to the North Cascades where I backpacked my 4x5 Ikeda field view camera to Luna Ridge in the Northern Pickets to get pictures of the north side of the Southern Pickets. (See chapter 12, where the climb of the North Face of Mt. Terror in the Southern Pickets is described.) Seldom have I had to work so hard to obtain a few photos.

It was probably a little crazy of me to go in there by myself. If something had gone wrong after I left the Big Beaver Creek Trail, I would never have been found. The off-trail terrain to cover to reach Luna Ridge, typical of the North Cascades, includes the major river crossing of Big Beaver Creek. The picture appearing in this book of the northern side of the Southern Pickets (see page 93) was taken from Luna Ridge.

Early the following year (1991) I acquired a new telephoto lens: one of the Nikkor-T telephoto lens

series for view cameras. It was a triple convertible lens with focal lengths of 360mm, 500mm, and 720mm lens. It was not quite as powerful as the 36-inch Dallmeyer had been, but it was a whole lot easier to use, and once again telephoto views on the 4x5 format became possible. I had been using a Chromar-T 400mm lens, acquired about 1980, for telephoto shots, but its magnification was not enough for many of the type of pictures I liked to take.

March of that year was called "Miracle March" in California because of the heavy rains (and snow in the mountains) that saved the state from experiencing yet another drought year after several in succession earlier. I happened to be in the Owens Valley part of that March and captured many fine images of the Sierra Nevada draped in fresh snow. The image on page 76, "Winter Winds over Mt. Williamson," was taken at this time.

That year found me searching out the exact same spot on Mt. Margaret, from which I had taken a picture of Mt. St. Helens in 1976 (see chapter 19). In order to make sure it was the exact same spot, I took along one of the original 1976 transparencies and also the same lens that I had used to take the original picture. It wasn't from the actual summit of Mt. Margaret as I had thought, but somewhat below the summit and to the west. I lined up the transparency against the image in the ground glass until the skyline profiles (except for the missing top of the mountain) matched exactly.

In addition, that year I "topped" Mt. McLoughlin and South Sister in Oregon and wandered about many of the other Oregon volcanoes, shooting them from different angles, some views of which are included within the pages of this book.

# CHAPTER TWENTY-ONE
# "I KNOW YOU!"

It should not be thought that the peaks or mountain ranges mentioned in this book were the only objects of my mountain visits. I traveled in many lesser-known ranges or ranges with lower elevation or more "moderate" peaks. There was simply not space in this book to cover all of them. For this book I concentrated on those peaks and mountain ranges that were the most breathtaking in terms of their raw beauty, and I searched out the views that in my opinion showed these peaks at their most spectacular.

I have images showing the usual complement of flowering meadows, forests, waterfalls, deep valleys, and all the other things that attract people to the mountains, but with a few exceptions, this book has a very narrow focus in terms of images, as the book concentrates on the peaks and rocks themselves.

In the autumn of 1992, I returned to the Canadian Rockies for the first time in fourteen years. For this occasion I resumed shooting black-and-white images in the 5x7 format. Nowhere else in North America are such a great concentration of mountain peaks laid out within plain view for the photographer/mountain lover.

Within a few days after arriving there, I needed some information on the trails in the Banff area. Someone had told me that Tim Auger was on duty at the warden's office. He and a partner had made the second ascent of the Grand Wall of the Chief near Squamish, British Columbia, several years after Jim Baldwin and I had climbed it (see chapter 11). I

had never met Tim, and our climb had been thirty-one years earlier. I decided that when I asked for trail information, I would also introduce myself.

I went to the warden's office and waited in line while Tim was giving a woman information about the campgrounds. She left and I stepped up to the window. Tim looked at me, his eyes widened, and he said, "I know you!" And indeed he did know who I was—I was almost completely floored by this.

He had never met me and had not known that I was coming. But apparently the pictures taken during the first ascent and all the accompanying publicity in the Vancouver area (where he was from) had been burned into his memory. Even the fact of my being thirty-one years older than my 1961 pictures was not enough to prevent him from recognizing me.

Another time on that trip, I was taking pictures with my view camera along the side of the road. Another photographer walked up to me casually and studied my equipment and obvious expertise working with the equipment. After some small talk he stated he knew just about all the well-known photographers who worked with the large format except for one—Ed Cooper—and wanted to know if that was me. For the second time in a span of several days, someone who had never met me guessed correctly who I was. When writing this text, I couldn't recall at first who it was, and it wasn't until I accidentally found some of my notes from that 1992 trip that I found out. It was Carr Clifton, a photographer well known for his work using the 4x5 format.

*Actual photo gear taken on a four-day backpack.*

This trip took me into the Trinity Alps of Northern California (the only mountain range in the contiguous United States that has glaciers yet is located entirely below timberline). The equipment is displayed on a standard-size card table and is listed from left to right, top to bottom (more or less):

- *200 sheets 4x5 Ektachrome E-6 film and empty box for exposed film*

- *changing bag*

- *lightweight tripod*

- *Ikeda field view camera*

- *supplementary small pack (red) for holding 35mm equipment*

- *Pentax Super ME 35mm camera with 40mm lens*

- *80–200mm zoom lens for 35mm camera*

- *6 rolls of Ektachrome 35mm film*

- *4 lenses for the view camera: 65mm, 150mm, 210mm, 400mm*

- *4x5 Polaroid film holder*

- *pack of 20 Polaroid-type 54 B&W (for testing for correct exposure for color)*

- *supplementary pack of 20-4x5 Ektachrome ready load for Polaroid holder*

- *4x5 B&W film pack holder and supplementary pack of 16 Tri-X*

- *miscellaneous filters, lens caps, and cable release*

- *12-4x5 film holders*

In addition to all this equipment, I would take along a large backpack containing such "nonessentials" as food, extra clothing, sleeping gear, etc.

I made somewhat of a replay of this Canadian trip in May of 1996, visiting many of the same locales. The conditions and appearance of the north and east faces of the peaks in May were more akin to midwinter than spring.

During the early 1990s Debby and I continued working with the postcard sales, but in the fall of 1994 we decided it was time to hang it up. Serendipity had smiled on us in our investment program, and twelve years of schlepping cards was enough. We found a buyer, and in March of 1995 we were out of the Cooper Classics self-publishing business. It had been a business that had served us well, but we were glad to be free from its demands and to be able to devote time to those things that were important to us.

I embarked on a program of property improve-ment that was to last more than five years. In between, I continued to make forays into the mountains. Debby's poetry began to flourish (she has won a number of prizes and published several chapbooks), and she has more time to devote to singing in groups (usually alto, but tenor or soprano as necessity demands). Debby also undertook learning Spanish, which was a great help when we visited Costa Rica several years later.

Our daughter was married in 1997, and in 1998 and 1999 we prepared for a Y2K crisis, which thankfully never materialized, despite predictions by some alarmists that the end of Western civilization was at hand. We decided to err on the safe side and stocked up on so many items that some still remain with us to this day.

*East face of Howse Peak. The extraordinary façade of the east face of Howse Peak, 10,793 feet (3,290m), is one of the most daunting-looking walls in the Canadian Rockies. Only the fact that it is set back to the left behind Mt. Chephren, which literally looms over the Icefields Parkway, prevents it from being better known to the casual viewer.*

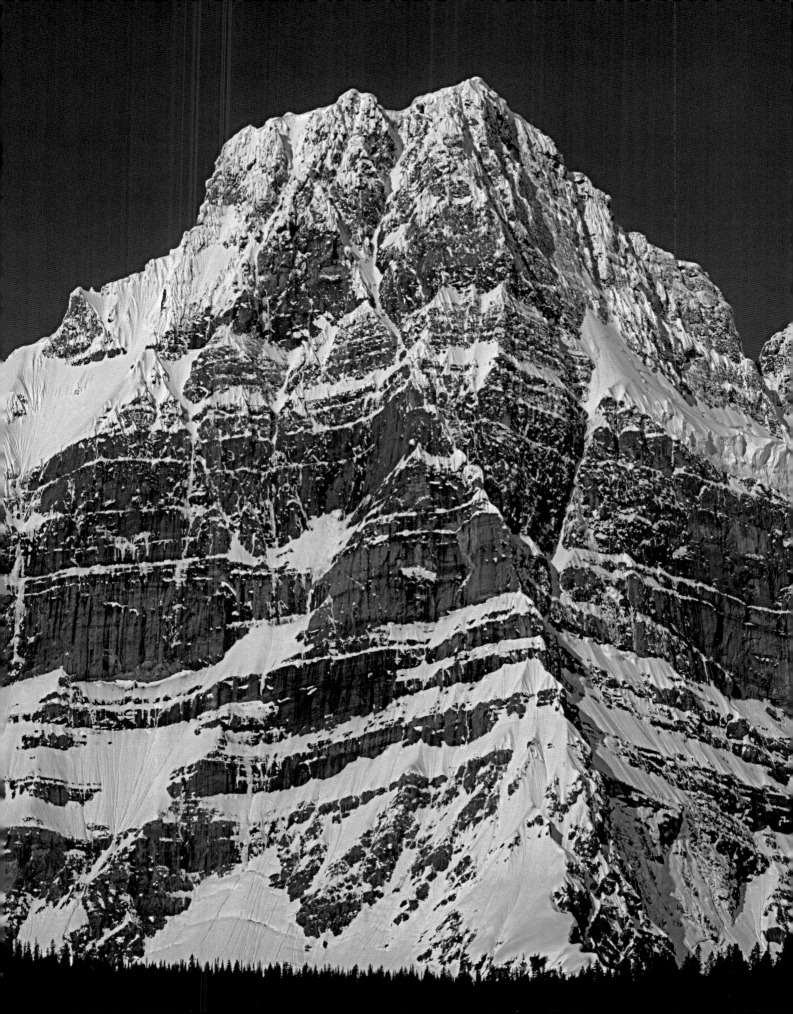

## CHAPTER TWENTY-TWO
# ONE NASTY TUMBLE

As 2001 rolled along, the house remodel project began to wind down (the final inspection was passed that summer), and I was able to turn my attention to the mountains once again.

In April I had a reunion with Mike Swayne, with whom I had made a number of climbs forty years earlier. We talked ourselves into another trip into the North Cascades—this time to the Northern Picket Range. We planned a traverse of the North Cascades starting at Ross Lake on the east, climbing Mt. Challenger, and then exiting by Ruth Creek on the west. This was an ambitious project even for a young person. There is no trail on a large segment of this projected trip, and we would experience it as we might have forty years earlier.

We also had the company of Jim Nelson, mountain guide, guidebook author, photographer, and owner of a shop that specializes in lightweight high-mountain gear. (Jim and Peter Potterfield coauthored the foreword to this book.)

Everything on our North Cascades trip went smoothly except for one nasty tumble I took on a steep rockslide area on the third day out, when a rock I stepped on shifted position, throwing me off balance. I fell headfirst onto the rocks below me. After the shock of the fall had worn off, I yelled up to my companions, "Nothing is broken." I think I may have spoken too soon. For months afterward one of my fingers gave me considerable pain if I put pressure on it in the wrong way. It's all right now,

but it is slightly crooked where it used to be straight. I think only a broken finger bone could have caused that (I never had an X-ray). That fall also caused a few deep gouges that are now permanent scars.

Other than that, the trip was all we could have hoped for, and we chose the perfect weather window. Besides the excellent climbing, we encountered world-class bushwhacking, some of the "best" the North Cascades has to offer. But I forgive this: It was worth the price to visit this wildly beautiful and isolated mountain location that few others are privileged to visit. We were out six days, and the rain started falling only one hour after we wound up the trip at the west end—and that rain was heavy!

I have told many people about the good luck with the weather that I have had in the North Cascades over many years, and most of them look at me in disbelief. One of the photos taken on this trip, "Climbers in the Northern Pickets," appears on the facing page.

*Climbers in the Northern Pickets, 2001. Jim Nelson, left, and Mike Swayne, right, against a backdrop of the north face of Mt. Fury in the Northern Picket Range in the North Cascade Mountains. The East Peak (8,288ft/2,526m) is seen in this view. This view was taken about 600 feet below the summit of Mt. Challenger, alongside the Challenger Glacier.*

I also attended the fortieth anniversary celebration of the first ascent of the Grand Wall of the Chief, near Squamish, British Columbia (described in chapter 11), where I was wined and dined. I felt sorry that Jim Baldwin was not there to share in the festivities. The owner of the town pub where climbers gather had even named a beer after Jim and me, called Baldwin-Cooper Best Bitter. (What more could you ask for than to have a beer named after you! "Plenty!" says my wife.)

When I returned home after this trip, Debby remarked—with a smile—that it must be tough to go from celebrity status in Canada back to plain civilian status in Sonoma, California. But I didn't mind—it is always good to return home.

Starting in the fall of 2001, I began a project to organize my photo files into a form that would make them easier and more understandable to look through. Many of the black-and-white negatives were only partially labeled as to location or people appearing in the negatives. As of this writing, I am still working on this particular project.

As mentioned in a previous chapter, I had a backlog of thousands of never printed (and barely even looked at) black-and-white negatives up to 1976, when I stopped shooting black-and-white. Since resuming shooting black-and-white in 1988, I have added considerably to the earlier total. There will be no lack of projects to work on in the darkroom, wet or digital (see below)!

I have been watching the progress of digital photography since its infancy almost fifteen years ago. It has now come of age, and the resolution of digital images, at least for 35mm, seems close to equal to that of traditional silver halide photography.

Printer and scanner technology is sufficiently advanced and reasonably priced so that it offers an excellent entry into the digital world for almost any photographer. And so it was in my case, enabling me to work with my existing photography. After setting up a "digital darkroom" in the fall of 2003, I wondered what had taken me so long. This new technology opened up a whole new world, one of being able to restore the original color and brilliance of thousands of old Ektachrome E-3 transparencies (and old color prints) that had faded and shifted in color. Once again I am experiencing the joy of working in the "darkroom," only this time one without chemicals and corrosive substances. I feel like a kid let loose in a candy shop.

But there is nothing like the sharpness and full range of tones found in a traditional silver halide image made from a large-format negative in a wet darkroom. For black-and-white, it may be easier in some cases to make a print using the wet darkroom process, rather than scanning large negatives requiring hundreds of megabytes of computer space each. Only experimentation will tell.

There is one caveat to going digital. Technology is making such large advances in the field that you can't be sure what you buy today will be compatible with what will be used fifteen to twenty years from now. You may have carefully written and catalogued a library of your images on CDs or DVDs only to find that at some point in the future there is no medium available that enables you to work with them.

This is not idle speculation. I still have a box of four-track audio tapes (as well as a few eight-track audio tapes), but there is no place to play them, and probably no one under thirty has ever heard of tapes of this kind. Then there was the beta format for video tapes, which looked like a possible winner in the late 1970s and early 1980s. (And I still have lots of phonograph records, not only 33s but even some 78s!) More recently there were the 5¼-inch floppy disks, and even now the 3½-inch floppies are on the

The main crater on Volcán Poás (Poas Volcano), Costa Rica. In the foreground is the Sombrilla de Pobre (Poor Man's Sunshade) plant in bloom. At an altitude of 8,871 feet (2,704m), this active volcano lies in the cloud forest zone, and many visitors to this area never see the crater because it's covered by clouds.

way out. Think about the possible obsolescence factors in what you acquire.

In early 2002 my wife and I spent five weeks in Costa Rica visiting friends, seeing the sights, and exercising our Spanish. We rented a vehicle and spent part of our time visiting volcanoes. The image above is of Volcán Poás, one of Costa Rica's more active volcanoes. While we were there, I also hiked up the highest peak in the country, Cerro Chirripó (12,530 feet, 3,819m).

Chirripó (which is *not* a volcano) is particularly interesting because during the last ice age, there was a small ice sheet in the area, and there are still lakes in basins scooped out by the glaciers. One is not apt to think of glaciers in connection with Latin America! This area also marks the northernmost extent of the rather bleak and desolate high-elevation páramo country of the Andes Mountains of South America.

That same summer, in the Canadian Rockies, I returned to another area that I had visited in the very early 1970s. I refer to the Ramparts, a spectacular row of peaks rising above two lakes in the Ton-

*The Ramparts seen from the meadows above Amethyst Lake. This is as fine a grouping of peaks as can be found anywhere in North America. The ridgecrest of the peaks throughout most of its length forms the boundary between Alberta (this side) and British Columbia, and coincidentally the boundary between Jasper National Park (this side) and Mt. Robson Provincial Park (British Columbia). The view continues to unfold as you follow the trail to Moat Lake, where another grouping of peaks (seen here at the right side, edge on) displays itself in a panorama. This is truly the stuff of Elysian Fields for the mountain lover.*

quin Valley, reachable only by trail.

My first visit into this area had not been pleasant. Only weeks before I went in, hikers had been mauled and one killed by grizzly bears that frequent the area. But it is such a spectacular area, and my desire to see and photograph these peaks overcame my trepidation. I hauled a 5x7 view camera and all the associated gear the 14 miles into a camp. That night was a nightmare. Every flap of the canvas of the tent by the wind was a grizzly bear about to tear

the tent—and me—to shreds, or at least so it seemed.

I got up the next morning just glad to be alive. I did get some very nice pictures, but I couldn't bear the thought of spending another night there, so after a morning session of photography, I hiked all the way out and was just barely able to walk by the time I reached my vehicle.

My second visit was an entirely different matter. In order to avoid the worst exposures to the grizzly

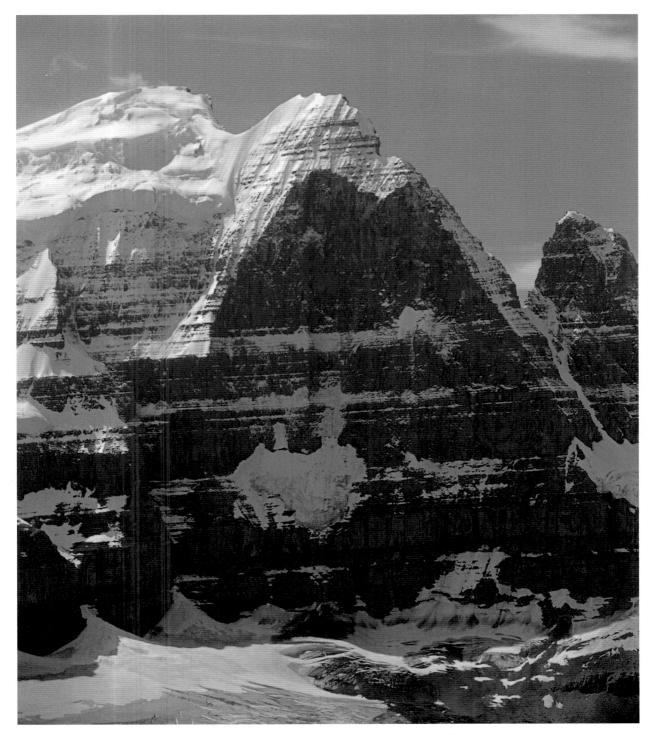

*North face of the North Twin. This face, almost 5,000 feet (approximately 1,500 meters) in height, has sometimes been referred to as the Eigerwand of North America. The summit, at 12,085 feet (3,684m), is the third highest in the Canadian Rockies and is located in Jasper National Park in Alberta, on the north edge of the Columbia Icefield. The first ascent of this great face, by Chris Jones and George Lowe in 1974, took six days with a final bivouac in the summit area. The climb could only be termed as "desperate." This dark face is in the shade most of the year, receiving only a little sunlight even in the longest days of summer. It cannot be termed beautiful, but it is certainly a powerful and awe-inspiring sight.*

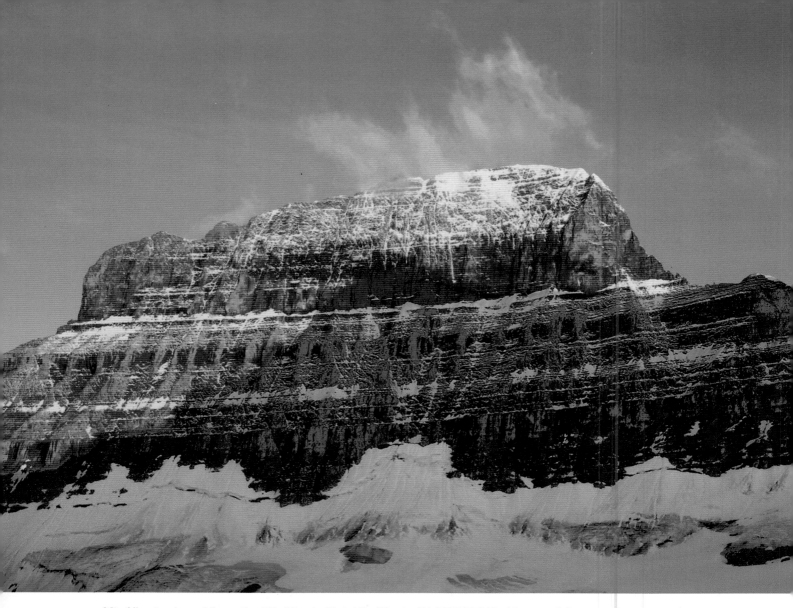

*Mt. Alberta viewed from the Mt. Alberta Hut. Mt. Alberta (11,874ft/3,619m) is one of the more famous peaks of the Canadian Rockies. It is located in Jasper National Park, Alberta, but it cannot be seen from any road. It gained worldwide attention when a party of Japanese made the first ascent in 1925. All I had to do to take this picture was to roll out of a comfortable bunk in the Mt. Alberta Hut and step outside. Reaching the hut is an entirely different matter, however, and takes a long and strenuous daylong backpack (unless you happen to be in super shape), which includes fording a major river (the Sunwapta) as well as crossing a glacier. This view of the peak is from the east. The large shadow on Mt. Alberta is cast by Mt. Woolley, itself 11,170 feet (3,405m).*

bears, which still roam the Tonquin Valley, I decided to ride a horse and (an unaccustomed luxury for me when traveling alone) stay in the Tonquin Valley Lodge next to Amethyst Lake. On the way in we met some hikers who had had an unpleasant encounter with a grizzly bear on the trail, which reinforced the wisdom of choosing to ride a horse. The only down-side is that I had to be practically lifted off the horse upon arrival at the lodge. My leg muscles were almost frozen into a bowlegged position!

I did miss a grizzly bear and two cubs on the trail to Moat Lake in Tonquin Valley by only half an hour—shortly after returning to the lodge, I saw them crossing the trail where I had been.

As you can tell from the above account, I am not a fan or advocate of grizzly bears. Humans and grizzly bears are mutually incompatible in the same environment. Either a grizzly bear area should be totally closed to people, or if it is open, people hiking in this area should be sternly warned of the great risk and carry, at the minimum, pepper spray.

The height of folly in camping and traveling in grizzly bear country was reached in 2003 by a man named Timothy Treadwell. He camped among the Alaska brown bears (a close relative of grizzly bears) and chanted in a high-pitched, singsong voice "I love you" to the bears. He promoted to others the idea of "getting close to the bears to show they were not dangerous." Further, he said, "I would be honored to end up in bear scat." He got his wish, unfortunately, taking a woman companion with him.

Only a few days later, I revisited the "Black Hole of the Canadian Rockies" forty years after my first trip. (Then I had attempted a new route on the west face of Mt. Alberta with George Whitmore, but we had been turned back well up on the face by a frightening lightning storm.) This is an otherworldly place. Once you reach the Mt. Woolley shoulder, you are presented with an incredible vista. There is nothing gentle-looking ahead of you. Your attention is taken up by Mt. Alberta and the north face of the North Twin. No forests or meadows are visible.

Both I and my companion, Neil Bennett, a noted Canadian climber, stared in awe, but not for long. A ferocious numbing wind greeted us and we hurried on to reach the Mt. Alberta Hut. Two pictures taken with my 4x5 field view camera appear in this chapter.

In retrospect, it is sobering to realize that my first climbs in the 1950s are much closer in time to George Mallory's and Andrew Irvine's disappearance on Mt. Everest in 1924 than they are to the present. Early on in my climbing days, I thought that the mysterious disappearance of those two British climbers was ancient history. Strange how a person's perception of time changes as the person ages!

In one of those strange quirks of fate, I discovered a few years back that George Mallory's daughter (only eight years old at the time of her father's death) was living in the same retirement community as my father-in-law, less than 25 miles distant from our home in Sonoma, California.

In closing, I want to remind my readers of another one of my favorite quotes from John Muir: "Climb the mountains and receive their good tidings."

I have done this for most of my life and will continue as long as I am able to do so.

The north face of Mt. Siyeh. Seen here is the upper portion of this 4,000-foot face. Mt. Siyeh (10,014ft/ 3,052m) is located in Glacier National Park, Montana. I detoured slightly off the easy climbing route on this peak to view the mighty chasm dropping down to the Siyeh Glacier and Cracker Lake directly below. In 1997 a base jumper leaped off this summit and his parachute snagged on some rocks 400 feet down. A difficult and dangerous rescue ensued; the base jumper suffered only minor injuries but was fined $9,000.

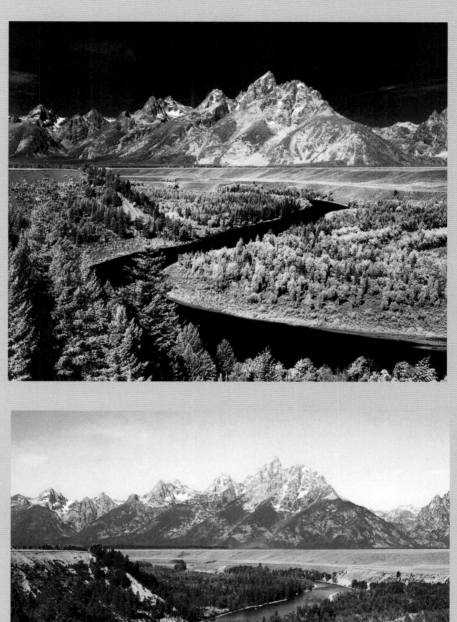

*The Teton Range seen from the Snake River overlook. Rising above Jackson Hole and the Snake River, the Teton Range of Wyoming presents one of the most alpine profiles to be found in North America. The Grand Teton (13,770ft/4,197m), at right center, is the highest peak in the range.*

*The Teton Range seen from the Snake River overlook #2. This view identical to the image above was taken at the same time and place with the same camera. This illustrates the difference that the choice of film and filters can make in the final print. What I "saw" at the Snake River overlook was the image above, but what regular panchromatic film "saw" was this exposure. There is almost the difference between night and day between the two prints. The one (above) shows the mountains shining; the other shows a pleasant but rather dull landscape. See technical details for the differences between the two.*

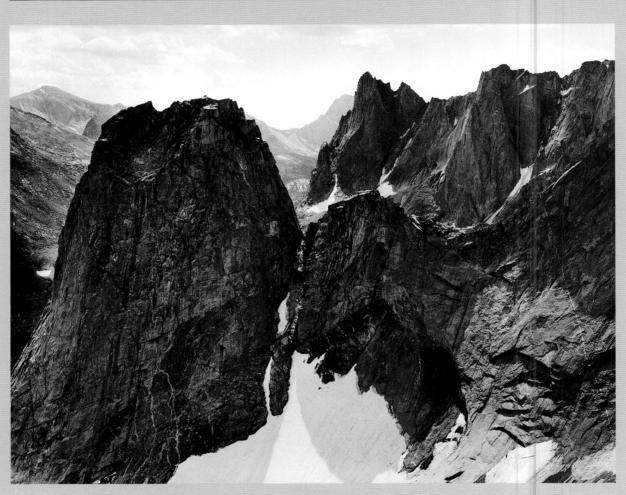

*Cirque of the Towers, Wind Rivers. Tucked away at the southern end of the Wind River Range of Wyoming is a group of peaks that, were they any closer to civilization, would be overrun by climbers and backpackers (some say this is the case now). This view from near New York Pass looks over the ridge in the foreground into Cirque of the Towers. At left is Pingora Peak (11,884ft/3,622m). The pointed summit to the right of Pingora, in the middle distance, is War Bonnet Peak (12,369ft/3,770m). The next major summit to the right of War Bonnet Peak is Warrior I.*

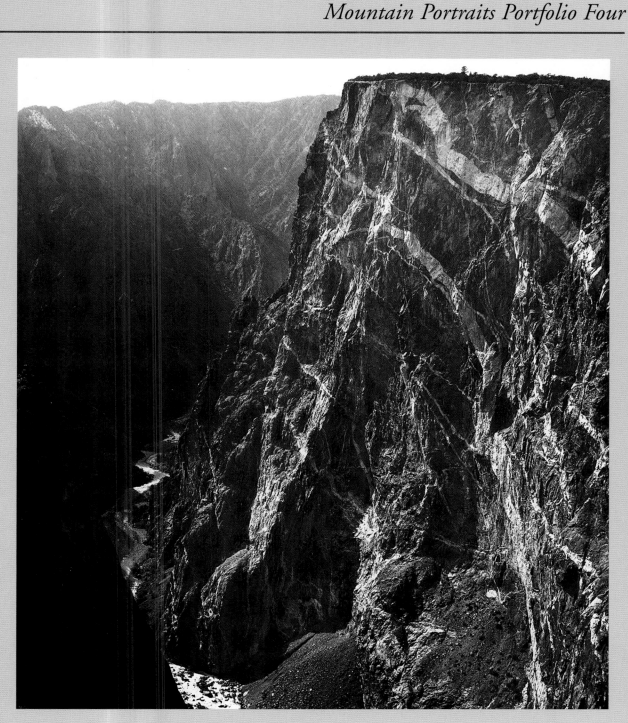

*The Painted Wall, Black Canyon of the Gunnison. This viewpoint looks at the Painted Wall from the south rim of the canyon. The words of geologist Wallace R. Hansen (with the U.S. Geological Survey) in the mid-1950s still are perhaps the best description of this canyon: "No other canyon in North America combines the depth, narrowness, sheerness, and somber countenance of the Black Canyon." The canyon depths range from about 1,700 to 2,700 feet in the 14-mile stretch within Black Canyon of the Gunnison National Park. At its narrowest, it is only 1,100 feet across.*

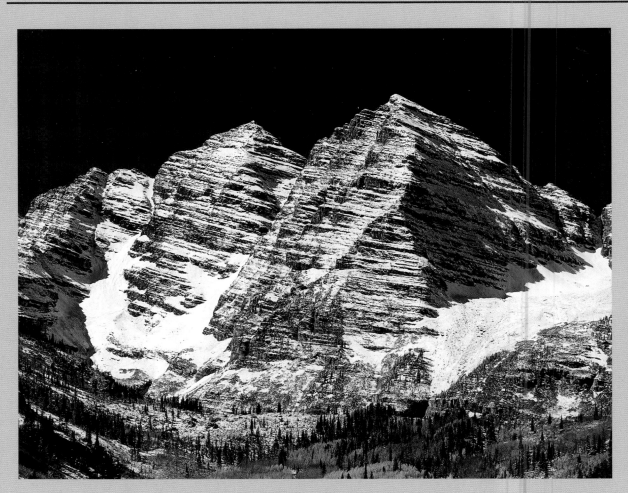

*Maroon Bells near Aspen, Colorado. Located not too far from Pyramid Peak (see page 175) is this spectacular peak. The higher appearing North Peak on the right (14,014ft/4,271m) is actually lower than the South Peak on the left (14,156ft/4,315m). A fresh snowfall highlights its similar appearance to many peaks in the Canadian Rockies, caused by conspicuously layered late paleozoic sedimentary rock. This view is from near Maroon Lake, an area crowded with sightseers, photographers, and hikers during the portion of the year that the road is not blocked by snow.*

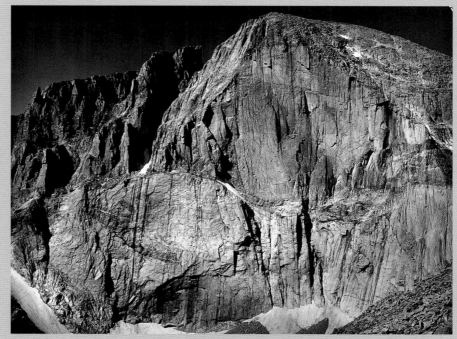

The east face of Longs Peak, Colorado. Longs Peak, at 14,255 feet (4,345m), represents the heart and soul of the Colorado Rockies. It is, in fact, a magnet for hikers and rock climbers from all over the country. The upper portion of the face is referred to as the Diamond because of its shape.

The east face of Longs Peak seen from Chasm View. This viewpoint is somewhat reminiscent of Half Dome seen from the Diving Board in Yosemite Valley, California, in the awesome power of the rock that almost overwhelms the viewer. Six climbers are visible (circled) on the face on this busy day in August.

171

*The Sawtooth Range and the town of Stanley. The high peak seen at the right is Horstmann Peak (10,470ft/3,191m). Stanley, Idaho, is a town that still retains a Western flavor and, at over 6,000 feet high, sits in the sagebrush of the Sawtooth Valley, to the north and east of the Sawtooth Range.*

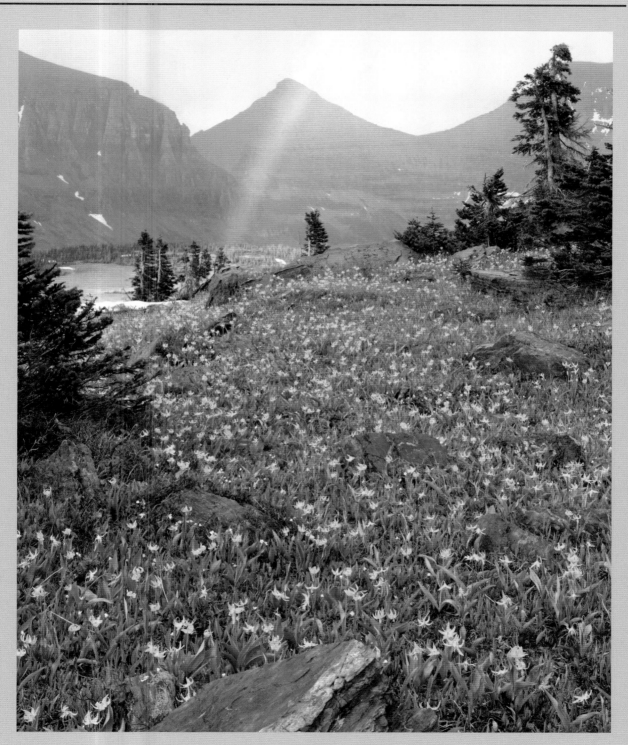

*Glacier lilies and rainbow near Logan Pass, Glacier National Park, Montana. An upside of getting caught in an afternoon thunderstorm in the mountains is that when (hopefully) it clears, you may—if you are lucky—capture an image like this.*

173

*Squaretop Mountain and Upper Green River Lake. At 11,695 feet (3,565m), this is the best known and most photographed peak in the Wind River Range of Wyoming. It is no wonder, as the steep walls give this peak a formidable and distinct appearance.*

174

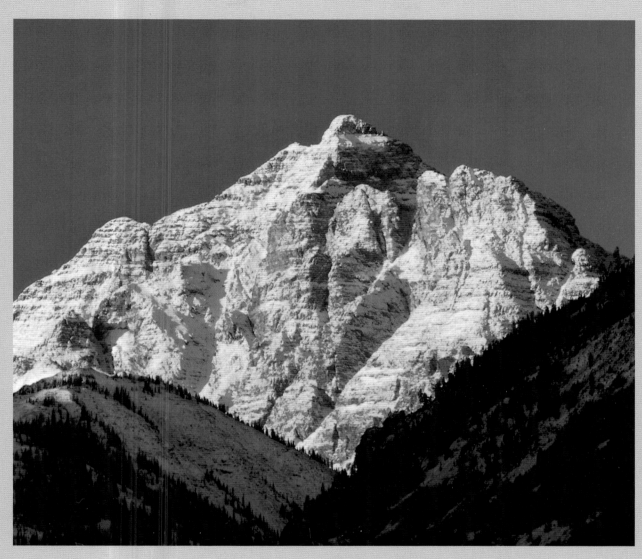

*Pyramid Peak seen from near Aspen. Aspen, Colorado, is blessed not only with good skiing, but also with some very nice-looking 14,000-foot peaks in the vicinity. Pyramid Peak (14,018ft/4,273m), seen here from the northeast, is one of those peaks. The scene looks like midwinter, but all the snow is from a large September snowstorm, not at all unusual in the high mountains of Colorado.*

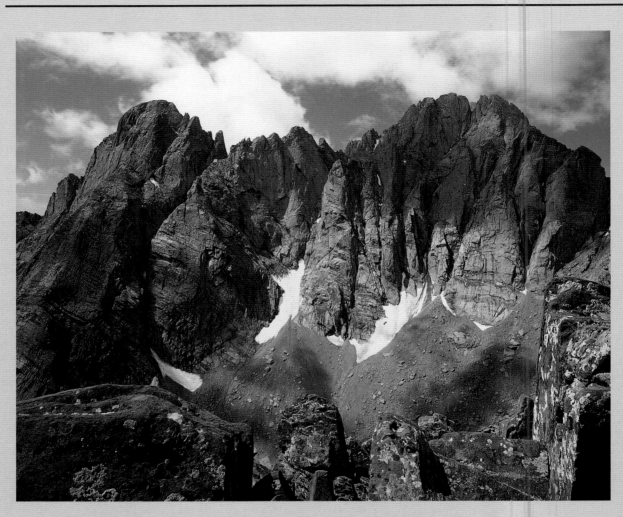

*Crestone Needle (left) and Crestone Peak (right). Located in Colorado's Sangre de Cristo Range, both peaks exceed 14,000 feet. Crestone Needle is 14,197 feet (4,327m), and Crestone Peak is 14,294 feet (4,357m). Colorful lichen-covered rock appears in the foreground.*

# ADDENDUM

While reviewing photography for the book, I came across several pictures that show a favorite hard hat I used to wear in 1960–61, before it was broken on the east face of the Middle Peak of Mt. Index in August of 1961 (see chapter 12).

On the front of it I had written the initials HBFC. Below that I had written FSSSCCPNS. Though many years had passed, I remembered what HBFC stood for (the Herman Buhl Fan Club), but no matter how hard I tried, I couldn't recall what the other initials stood for.

*View showing initials on favorite hard hat of photographer/author. It took some searching to find an image that showed the initials referred to in the Addendum in a readable manner. Though it is a bit difficult to make them out, they are as legible in this photo as any photo extant. This photo was taken by Jim Baldwin using my camera, which I had preset. This particular view is looking down on the last pitch of the upper section of our climb on the Chief, 1,600 feet above the ground (see chapter 11). The original was a 2¼ black-and-white taken in June 1961 and was one of a group of black-and-white negatives lost in a fire, as explained in chapter 16. The image seen here is reproduced from a black-and-white positive made from the original negative by contact process (making a black-and-white slide) before the original was destroyed. This portion represented an area amounting to about 5 percent of the original negative. It is comparable to making a print from a 35mm negative using only 17 percent of the film area. The contact film used was Kodak fine grain positive, a virtually grainless blue sensitive only film.*

*In an earlier version of this image for this book, I had scanned the original black-and-white print (representing 56 percent of the original negative) at 1,000 dpi. The original print was very dark in the area of the figure. The final result, after cropping and using the lasso tool in combination with the brightness and contrast controls, as well as the clone stamp tool, was readable but too grainy. I discovered only in September of 2005 that I had the contact positive in my old picture files. Working with this, and the digital tools available, I produced this image. The sharpness and clarity of this print would probably approach that of a similar enlargement made from the original negative, if it were available. There is no separate technical data provided for this image other than that provided in this caption.*

I found out quite unexpectedly in January of 2003 when Mike Swayne sent me an e-mail with an attached jpeg image. Mike Swayne had been scanning slides and prints in the process of compiling a historical library of the Trail Blazers (see chapters 9 and 12), the fish stocking club to which he belonged. In doing this scanning, he had run across the note reproduced here.

The jpeg image was of a photo taken July 4, 1964, by Doug Barrie (also a member of the Trail Blazers) when he and Mike climbed Mt. Garibaldi near Squamish, British Columbia. (This is the northernmost in the chain of Cascade volcanoes, ending at Lassen Peak in California.) It was the note I had left in the summit register in 1961, with all the initials written out in full. FSSSCCPNS stands for the Francis Sydney Smythe Solo Climbing Club, Pacific Northwest Section.

These weren't official clubs—I just admired both of these well-known climbers because of the solo climbing for which they were known, and adopted them as role models at a time when I was a full-time climbing bum. I also recall having signed some summit registers with the postscript "Nothing too difficult, Nothing too dangerous," which evaluates my state of mind at that time.

This note also solved another mystery. I had lost almost all track of this climb. I knew that I had climbed Mt. Garibaldi, and probably by a new route, but I couldn't recall when I did it or anything about the route. The note gave a brief description of where I had gone. By the date (June 24, 1961) I know that this climb must have been right after Jim Baldwin and I had completed the climb of the Grand Wall of the Chief (see chapter 11). I was looking for a difficult way to ascend Garibaldi.

In my library I have a copy of *Alpine Guide to Southwestern British Columbia* by Dick Culbert, with a copyright date of 1974. Looking in the guide, I know that the climb I made wasn't the standard route (Route 1), as I made a point of avoiding that to look for something more difficult, by contouring to the right around Mt. Atwell (also referred to as Diamond Head) until I was below the southeast face of Garibaldi. It wasn't any of the other three routes described because they were climbed from a different direction, so it must have been a new route, unrecorded by my knowledge until now.

Mike Swayne achieved a watershed year in 1964. Three weeks after the picture of this note was taken, Doug and Mike made an ascent of Mt. Sir Donald in the Selkirk Mountains of British Columbia. This particular peak is located in the Glacier National Park in Canada.

On the descent, a rock fell from the upper part of the mountain and hit Doug. He fell into a bergschrund, almost but not quite pulling Mike (on the other end of the rope) along with him. Doug Barrie's injuries proved to be fatal. Exactly as I had done a year or two earlier, Mike underwent a reappraisal of his life goals and changed direction.

*Note left by photographer/author on Mt. Garibaldi summit. This is a reproduction of the actual note left in the summit register of Mt. Garibaldi on June 24, 1961. The story behind this note is related in the Addendum. I would like to express gratitude to Mike Swayne, the Trail Blazer librarian, for providing this. The original was a photograph taken by Doug Barrie.*

JUNE 24, 1961

ED COOPER  FRANCIS SYDNEY
SMYTHE SOLO CLIMBING CLUB —
AFFILLIATED WITH THE HERMAN
BUHL FAN CLUB OF MUNICH, GY.

7 hrs from "Base Camp" via the
SE Face (a probable first ascent
kept contouring past ordinary
route below a rock ridge, up
an ice fall to broken S.E. Face,
ascended to 250' below summit
where one of ordinary routes
(E ridge?) was joined. missed
other party by 5 minutes. climb
was class III

# TECHNICAL DATA

The technical data behind the photography are arranged in alphabetical order by the mountain, mountain range, area, or person (whichever is predominant in the image). All images appearing in the book are given titles, which are used to arrange them in this order. In addition, each photograph is assigned a number or alphanumeric designation, which represents the photographer's number. The only exceptions are two historical photographs and a jpeg file, which have no such designation.

The technical data are given where known. At various times in my photographic career, I have been more careful about recording the information than at other times. When I was busy building up the stock photography library for general sales, I was doing so much shooting that trying to record and preserve the details simply became too much of a burden. In a few cases I have made educated guesses on the camera and lens used, based on when the photograph was taken and my knowledge of the peak and angle of coverage needed by a lens to capture the image.

The type of head used on the enlarger (for black-and-white prints) is specified because there is about one contrast grade difference between a cold light head and a condenser head, the latter giving the higher contrast.

Almost all the black-and-white prints received burning and dodging to some extent (and a few some ferricyanide bleaching as well), but the details

of the treatment for each print would take up too much space. I mention this treatment in only a few specific instances where it seemed especially relevant and where I wanted to show the image I "saw" and not just the image recorded by the camera. Printing black-and-white photographs in the darkroom is really an art, and is rapidly becoming a lost art at that.

The digital darkroom is to a large extent now replacing traditional wet darkroom printing. It enables one to use techniques for controlling the image output to a degree undreamed of in silver halide photography, but it may be some time yet before affordable digital photography can reproduce the sharpness obtained from black-and-white negatives or color transparencies of a size 4x5 inches or larger.

More than thirty images reproduced in this book were rescued from obscurity or improved by converting original transparencies or black-and-white prints to digital files where various corrections could be applied. The technical data include notes regarding such operations. An additional dozen or so were converted to digital files for the convenience of the publisher. More than a dozen other photos, added during production for design considerations, were also converted into digital files.

In no case were any digital files altered in a way unfaithful to the original photograph; i.e., no objects or people were added to the final image or moved to another location in the final image.

### Adirondack Mountains, Mt. Haystack [T-131801] Page 29

Original is a 2¼ transparency, type unknown, taken February 4, 1956, with an Ansco Panda camera. Because the original has faded and undergone a color shift, I converted it to a digital file, where the necessary corrections were made.

### Adirondack Mountains, Tim Bond on the trail [T-131802] Page 28

Original is a 2¼ transparency, type unknown, taken February 2, 1956, with an Ansco Panda camera. The lens on this camera was sharp only in the center of the images; sharpness fell off at the corners and edges, which can be detected here. Besides suffering from fading and a color shift, this transparency has a chemical stain or gouge in the area of the sign. I converted this image to a digital format and corrected the overall color balance and saturation. Repairing the sign required more work. I cloned an "A" from one part of the sign and pasted it over the damaged "A." Parts of two other letters also had to be cleaned up. While working at the level of ten pixels or so, I discovered that Tim was actually holding an unlit match above the sign, as kind of a joke.

### The Alaska Range, rock wall in [T-501301] Page viii

Original is a 2¼ Ektachrome E-3 transparency taken in June 1958 with a Voightlander Perkeo camera. This is one of three aerial photos appearing in this book. The colors in this transparency had faded, so I scanned it into digital form where I made the necessary corrections.

### The Angel Crack, Castle Rock, photographer/author climbing [104604] Page 57

Original is a 2¼ black-and-white negative taken with a Voightlander Perkeo camera in the spring of 1960. I gave my camera to someone and asked him to take a picture of me. Original negative was lost in 1963 as explained in chapter 16. I had only one 8x10 and one 5x7 print from the negative, probably made on Kodabromide F paper.

### The Angel Wings [M-M6815] Page 80

Original is a 35mm transparency using a polarizing filter, taken July 14, 1988. A 28mm wide-angle lens was used on a Pentax Super ME camera. Accompanying me on this backpack were (1) mosquitoes, (2) biting no-see-ums, and (3) biting blackflies. They made almost any kind of stop at mid-elevations nearly impossible in these hottest days of the entire summer.

### Baldwin, Jim [T-806612] Page 91

Original is a 2¼ Ektachrome E-3 transparency taken with a Zeiss Super Ikonta IV on November 25, 1962. Because the original Ektachrome E-3 transparency had shifted so much in color balance, I chose a black-and-white print that I had made from this image for inclusion in this book. Once I had the technology, I looked again at the 2¼ and restored the colors after a digital scan. In this particular instance, the color version captures Jim's spirit better than the black-and-white.

### Bear and tourists, the way it used to be [T-203503] Page 2

Original is a 2¼ color transparency taken with a Voightlander Perkeo folding camera in September 1957. The colors have now faded. A 4x5 copy negative was originally made on Panatomic-X black-and-white film, and a print was made from that negative on Kodak polycontrast paper. Armed with digital technology, I revisited this image. Scanning the original transparency, I restored the original colors, and the result now appears in this book.

### Bell, Charlie [T-302408] Page 101

The original is a 2¼ transparency taken with a Zeiss Super Ikonta IV in late July 1961. The image was

converted to digital form, where the color shift over the years was corrected.

### Bjørnstad, Eric, on the north face of Howser Peak, Bugaboos [T-202707] Page 63

Original is a 2¼ Ektachrome E-3 transparency taken with a Voightlander Perkeo camera in July 1960. It was only when I became adept at working with the digital darkroom that I decided to include this picture in the book. The original was so degraded it looked like a hopeless candidate for restoration. Not only were the colors faded to an extreme degree, but also a mold or fungus on the surface of the transparency had left hundreds of red spots of varying sizes. I spent many hours working on the digital image, but I was rewarded with this image come to life once again.

### Boston Peak seen at sunset [1M4333] Page 136

Original is a 4x5 Ektachrome E-3 transparency taken in July 1972, using a polarizing filter. A 5x7 Gundlach Bundschu view camera, utilizing a 4x5 back, was used. An unpleasant magenta-purple color shift was corrected by converting the transparency to the digital format, so that the true colors could be restored.

### Bugaboo Spire, east face [102756] Page 67

Timing is very important for most pictures but is crucial for obtaining the effect seen here: the "glow" of the sun reflecting off the face toward the viewer. Original is a 5x7 black-and-white negative, using infrared film and a red filter, taken August 16, 1964, at 1:30 p.m. A 150mm Schneider Symmar lens was used on a 5x7 Gundlach Bundschu view camera. The original final print (after several tries) was made, using a cold light head, on Agfa Brovira Grade 5 paper. Considerable dodging and burning were employed in making this print, as well as ferricyanide bleaching to bring out some highlights.

In March of 2006, working from the original 5x7 negative, I produced a digital version of this print. A side-by-side comparison of the two prints shows that the silver halide version still shows a greater brilliance, but working with a high-end pigment based printer, I was almost able to match the brilliance of the silver halide image. The difference is subtle enough that it wouldn't show up in printed reproductions and can only be seen in a side-by-side comparison. The advantage of the digital version is the much greater control in working with the print, and the ability to easily overlay the title for the book on the image using layers in the photo program. The digital version was used for the cover.

### Camp Muir on Mt. Rainier [T-204806] Page 34

Original is a 2¼ Ektachrome transparency taken June 23, 1956, using a Voightlander Perkeo camera. I scanned it into digital form to restore the faded colors in this image.

### Castle Rock in Washington [104660] Page 68

Original is a 5x7 Ektachrome E-3 transparency taken July 3, 1969, using a 300mm Schneider Symmar lens on a 5x7 Gundlach Bundschu view camera. I used the tilts and swings of the view camera to the maximum to correct for the perspective distortion normally seen in photographs when you take a picture looking upward at a steep angle.

This image had faded badly, so I scanned it into digital form where I was able to restore the original colors that had been present in this scene.

### Cathedral Spires, Mt. Augustin [101561] Page 10

This is an aerial photograph. Original is a 5x7 negative using Tri-X film, taken on July 20, 1968. A 5x7 Linhoff Press camera with a 150mm Schneider Symmar lens was used. The print was made on Agfa Brovira Grade 4 paper using a cold light head.

### Cathedral Spires, Middle Triple Peak [101565] Page 11

This is an aerial photograph. Original is a 5x7 negative using Tri-X film, taken on July 20, 1968. A 5x7 Linhoff Press camera with a 150mm Schneider Symmar lens was used. Print was made on Agfa Brovira Grade 5 paper using a cold light head. There was some very complicated burning and dodging required in this print, as there was a light reflection or light flare in the negative.

This print and #101561 (above) are two of the three aerial photographs in this book. I was somewhat disappointed with the sharpness of these negatives. Perhaps it was due to the changing air pressure as the plane moved up and down, perhaps moving the film out of its flat plane in the film holder, or perhaps the lens position in the press camera was not rigid enough for the wind. In any case, this was the only time I ever used this camera, which for years now has been collecting dust on a shelf in the garage.

### Cathedral Spires in Yosemite Valley [1M6715] Page xi

Original is a 4x5 Kodak Plus-X B&W negative taken March 10, 1970, at 10:00 a.m., with an exposure of 1 second at f32, using a red filter and a 300mm Schneider Symmar lens. A Gundlach Bundschu 5x7 view camera with a 4x5 back was employed. It was printed on Agfa Brovira Grade 3 paper using a cold light head.

### The Chief and Mt. Garibaldi [1M2926] Page 85

Original is a 4x5 Fujichrome Velvia transparency taken on July 12, 2001, around 7:00 p.m., using a polarizing filter. A 210mm Topcor lens was used on a 4x5 Ikeda field view camera.

The picture location (at the top of the Papoose) is not easy to reach. Even though the Papoose is located right next to the main highway leading to Squamish, there is no good trail to the top, and there is only one good open viewpoint, at the north end of the summit. As I was descending the Papoose after taking this picture, my tripod fell (or was ripped off by brush) out of my pack and I didn't discover this until I had returned to the car. As it was not an expensive tripod, it wasn't worth a search. It may still be up there somewhere.

### The Chief, climbing the Split Pillar [302910] Page 87

Original was a 2¼ black-and-white taken in May 1961 with a Zeiss Super Ikonta IV camera. The negative suffered the same fate as other black-and-white pictures taken on the Chief (see #302902 page 184). But I had made a number of prints of this view, probably with Kodak polycontrast paper.

### The Chief, Jim Baldwin in the Roman Chimney [T-402912] Page 89

The original is a 2¼ transparency taken with a Zeiss Super Ikonta IV in June 1961. The colors of this Ektachrome E-3 transparency had faded so badly that this image did not make the final cut for the book. In addition, this is one view that did not translate well to black-and-white. Without the color contrast, Jim Baldwin virtually disappears from notice. In one final review of photography for the book, I chose this view for renewal by the magic of the digital darkroom. Restoring the original colors brought this image back to life once again.

### The Chief, photographer/author at Jim Baldwin memorial plaque [702908] Page 91

Original is a 2¼ black-and-white taken with a Zeiss Super Ikonta IV camera in August 1968. Print was made on Agfa Brovira Grade 2 using a condenser head on the enlarger. When I went to look up data on the negative for this writing, the negative was missing from its sleeve. Either I lost it, misfiled it, or

(less likely) I loaned it out to someone and never received it back.

### The Chief, view of traffic jam from [302902] Page 86

The original was a 2¼ black-and-white taken in May 1961 using a Zeiss Super Ikonta IV. The negative was lost in a fire as explained in chapter 16, but luckily I had made a black-and-white print. This was one of my earlier darkroom prints and lacked contrast. I was able to greatly improve the appearance of this image by converting it to the digital format and using the brightness and contrast controls.

### Chimney Rock, sunset on [107020] Page xiv

Original is a 4x5 Ektachrome E-3 transparency taken in July 1972, using a 90mm Schneider Super Angulon lens on a 5x7 Gundlach Bundschu view camera with a 4x5 back. I scanned the image into digital form where I made the necessary color corrections on this faded chrome.

### Cirque of the Towers, Wind Rivers [209615] Page 168

Original is a 4x5 black-and-white negative, using Plus-X film and a red filter, taken August 26, 1969, at 12:30 p.m. Exposure was ⅛ sec @ f18 using a 150mm Schneider Symmar lens on a 5x7 Gundlach Bundschu view camera with a 4x5 back. Print was made on Agfa Brovira Grade 4 using a condenser head on the enlarger. Considerable dodging and burning were employed.

### Clements Mountain, storm clouds over [1M8251] Page vi

Original is a 4x5 Ektachrome E-6 transparency taken in July 1985, using an Ikeda field view camera. The colors on this image were good, but I scanned this image into digital form for the convenience of the publisher. It was reproduced in the book from this scan.

### Climbing gear, collection of, for El Capitan [306606] Page 114

Original is a very underexposed (dark) 2¼ color transparency taken in February or early March of 1962, and was taken as an afterthought after all the gear was organized. It looked almost hopeless to make any print from it. Working with that transparency, I made a 4x5 black-and-white copy negative on Professional Line Copy black-and-white film, ordinarily used for graphic arts applications. This extremely contrasty film gave a usable negative of this transparency from which I was able to make a passable, if not good, print.

Once again, in 2006, I returned to the original transparency to see what sort of print I could make from it in the digital darkroom. I scanned it in 16-bit to give me the maximum latitude in expanding the contrast range. The only channel with usable information was the red channel (I had originally used daylight film on a subject illuminated only by incandescent light), and the transparency had undergone a color shift in the same direction as well. Working in the red channel, I used curves and the shadow/highlight filter to improve contrast (without losing highlight detail) to all areas of the image. After converting the image to grayscale, I then further refined the image by using the lasso tool to outline selected areas (with a feathering radius of 30 pixels) to change the brightness and/or contrast of those areas. The final work was done with the clone tool to clean up the many spots, dust specks, and scratches in the image. The result seen here was almost like a miracle to me, especially when viewing the original transparency! Although it is a bit grainy (not at all surprising in view of the many operations I did to increase contrast), it looks as though the original might have been taken by a high-speed black-and-white film that was properly exposed.

### Clyde, Norman [206402] Page 126

Original is a 2¼ black-and-white negative taken in July 1963 with a Zeiss Super Ikonta IV. I have to thank William E. "Smoke" Blanchard, himself a climber and longtime resident of Owens Valley, for obtaining this portrait. Smoke knew where Norman lived, as caretaker of some ranch property, at that time. Smoke (1915–89) traveled the world's mountain ranges and died, ironically close to home, in an automobile accident in the Mojave Desert.

### Cooper, Debby [T-07305] Page 127

Original is a 2¼ Ektachrome transparency taken August 12, 1969, using a Zeiss Super Ikonta IV camera.

### Cooper, Matthew, on Mt. Whitney [6MM6401-04] Page 152

Original is a 35mm transparency, probably Ektachrome film, taken August 10, 1989. The slide itself is not labeled with the film type. During the John Muir Trail hike, another person who accompanied us went back to civilization at one point and returned with an assortment of transparency film for me—everything that was available at the store.

### Crestone Needle and Peak [210926] Page 176

Original is a 4x5 Ektachrome E-6 transparency taken in August 1985 using a 4x5 Ikeda field view camera. As with many summer days in the Rocky Mountains, this day dawned clear. The first clouds started forming in two to three hours (as seen in this picture), and by noon it was totally cloudy and raining, ending all further exploration of the high country for the rest of the day.

### Devils Postpile, 1963 [306346] Page 142

Original is a black-and-white negative using Panatomic-X film, taken July 8, 1963. Exposure was ⅕ sec @ f28 using a 150mm Schneider Symmar lens on a 4x5 Speed Graphic. Print was made on Agfa Brovira Grade 3 using a condenser head on the enlarger. Fallen columns at the base were given more exposure in printing.

### Devils Postpile, 1980, changes after 17 years [3M6344] Page 142

Original is a 4x5 Ektachrome E-6 transparency taken in late September 1980. The same camera lens was used as in the above photo.

### Devils Postpile, columnar basalt [306305] Page 143

Original is a 2¼ black-and-white negative taken with a Zeiss Super Ikonta IV on July 8, 1963. Print was made on Agfa Brovira Grade 2 using a cold light head on the enlarger.

### El Capitan [106661] Page 112

Original is a 4x5 Ektachrome E-3 transparency (whose colors have since faded) taken May 1962 with my first 4x5 camera, a 4x5 Speed Graphic. A 5x7 black-and-white copy negative was made on Verichrome Pan film. Print was made on Agfa Brovira Grade 4 using a cold light head on the enlarger. Considerable dodging, burning, and ferricyanide bleaching were employed to achieve the effect seen here (which is the way I saw it in my mind's eye).

I also took a 4x5 black-and-white original negative (from which I made one print), which was lost as explained in chapter 16. The print from the copy negative, made about December 1971, was far superior to the print from the original black-and-white negative, made in early 1963, though not quite as sharp to the discerning eye. I attribute this improvement in the appearance of the finished print to the skills I had developed in the darkroom in the intervening eight-plus years.

### El Capitan, Jim Baldwin on [206611] Page 111

Original was a 2¼ black-and-white negative taken with a Zeiss Super Ikonta IV in April 1962. All the

black-and-white negatives of the El Capitan climb were lost as explained in chapter 16, but I made a number of prints of the better negatives in early 1963. All the 2¼ color transparencies of this climb are still intact despite some color shifts.

### Enchantment Peak, ice rime on [204645] Page 13

Original is a 4x5 black-and-white negative using Plus-X film, taken October 4, 1969, at 5:00 p.m. Exposure was ⅒ sec @ f45 using a 150mm Schneider Symmar lens on a 5x7 Gundlach Bundschu view camera with a 4x5 back. Print was made on Agfa Brovira Grade 3 from a cropped portion of the negative. The look of an "animal monster" created by the patterns of ice on the rock prompted me to capture this image.

### Forbidden Peak, climbing on the East Ridge [T-04401] Page 45

Original is a 2¼ Ektachrome E-3 transparency taken May 25, 1958, using a Voightlander Perkeo folding camera. Converting the image to digital form allowed me to restore the original colors, as well as to clean up numerous dust specks and some chemical contamination on the transparency.

### Glacier National Park, glacier lilies and rainbow near Logan Pass [1M8252-A1] Page 173

Original is a 4x5 Ektachrome E-6 transparency taken on a 4x5 Ikeda field view camera. I'm not sure when this one was taken except that it was between 1981 and 1985. I do remember climbing Mt. Reynolds that day and waiting out a downpour in the partial protection of a boulder for about an hour on the way down, but I still got soaked. In situations where I suspect I will be rained on, I carry plastic bags for my camera gear.

### Glacier Peak and Image Lake [1M4423] Page v

The original of this beautiful image is a 4x5 Ektachrome E-3 transparency taken in August 1972, using a 150mm Schneider Symmar lens on a 5x7 Gundlach Bundschu view camera with a 4x5 back. This image required considerable work to restore. Not only were the colors badly faded, but the lower part of the image was underexposed while the upper portion was overexposed. Further, the image suffered from many dirt specks apparently embedded in the emulsion, requiring extensive use of the cloning tool. The reward for all the work was this image, which looks as good as actually being there. . . well, almost.

### The Grand Teton north face seen at sunrise [1M9380] Page 146

Original is a 4x5 Ektachrome E-6 transparency taken in August 1982. I spent the previous night on a ridgetop in order to obtain this view. A lightning storm raged for several hours that night while I was in this vulnerable position.

### The Great White Throne, Zion National Park [312480] Page 128

Original is a 4x5 Ektachrome E-6 transparency taken in late June 1982. A 150mm Schneider Symmar lens was used on a 4x5 Ikeda field view camera. This view, which includes the Virgin River, was obtained by climbing from the road to the base of some very large sandstone cliffs above the road.

### Half Dome, northwest face [406716] Page 117

Original is a 4x5 black-and-white negative, using Panatomic-X film and a red filter and polarizing filter in combination, taken September 14, 1963, in late afternoon. Exposure was 1 sec @ f32 using a 90mm Schneider Angulon lens on a 4x5 Speed Graphic. Print was made on Agfa Brovira Grade 5 using a cold light head on the enlarger, and a cut mask to burn in the sky (which was overcast and much lighter than the rest of the picture). I was drawn to visit this hard-to-reach location after viewing the Ansel Adams picture taken from this same location in 1926.

*Harding, Warren, on Leaning Tower [106718]*
*Page 129*

Original is a 4x5 Ektachrome E-3 transparency taken with a 150mm Schneider Symmar lens on a 4x5 Speed Graphic camera in April 1962. This is one of the earliest 4x5 color transparencies I took after acquiring the above camera—my first 4x5. Like many old Ektachrome E-3 transparencies, this one had undergone an unpleasant color shift toward magenta. After this was converted to a digital image, it was quite a thrill to restore and to see again the original colors of this dramatic view.

*Howse Peak, east face of [1M3645] Page 157*

Original is a 4x5 Ektachrome E-6 transparency taken May 24, 1996, using a 300mm Komura lens used on a 4x5 Ikeda field view camera. No filter was employed.

*Keeler Needle, east face, seen from Mt. Whitney [2M6431] Page 72*

Original is a 4x5 Ektachrome E-6 transparency taken July 13, 1982, the day after the sunrise view on the east face of Mt. Whitney, appearing in the frontispiece of this book (#2M6420), was taken. A 90mm Schneider Super Angulon lens with a polaroid filter was used on a 5x7 Gundlach Bundschu view camera with a 4x5 back.

*Liberty Bell Mountain, sunrise on [2M4215]*
*Page 17*

Original is a 4x5 Ektachrome E-3 transparency taken at sunrise on September 30, 1972, using a polarizing filter. A 20-inch Bausch & Lomb lens was used on a Gundlach Bundschu 5x7 view camera with a 4x5 back. This was the first clear day after a large September snowstorm had plastered the peaks with snow, giving the area more the appearance of mid-winter. The North Cascades Highway was opened in 1972. The colors on this image had shifted from the original brilliant blue-white-gold to an unpleasant purple-magenta cast masking the scene. I converted this to the digital format and once again brought this vibrant mountain portrait to life.

*Lizard Head, rappelling on [T-110502] Page 54*

Original is a 2¼ transparency, probably Ektachrome E-3, taken October 22, 1959, with a Voightlander Perkeo camera. The original contains some scratches and dust specks in the sky as well as a significant color shift to a reddish-purple cast. After this image was converted to digital form, a little work removed the defects and restored the original colors.

*Longs Peak, east face [210526] Page 171*

Original is a 4x5 black-and-white negative using Plus-X film and a red filter and polarizing filter in combination, taken July 28, 1963. Exposure was 1/5 sec @ f18 using a 150mm Schneider Symmar lens on a 4x5 Speed Graphic camera. Print was made on Kodabromide F Grade 4 using a cold light head on the enlarger.

*Longs Peak, east face seen from Chasm View [310218] Page 171*

Original is a 4x5 Ektachrome E-3 transparency taken in August 1976 in mid-morning. Shortly after I took this picture, the sky became overcast, prelude to one of the afternoon thunderstorms that are very common in the Rocky Mountains. This image was scanned to digital form, where color corrections were applied.

*Maroon Bells near Aspen [210455] Page 170*

Original is a 5x7 black-and-white negative, using Panatomic-X film and a red filter and polarizing filter in combination, taken September 26, 1970, at 11:30 a.m. A 300mm Schneider Symmar lens was used on a 5x7 Gundlach Bundschu view camera. Print was made on Agfa Brovira Grade 4 using a cold light head. This area presents so many photographic opportunities that the senses are almost overloaded.

### Mauna Loa, lava flow patterns on [100908] Page 144

Original is a 4x5 Ektachrome E-3 transparency taken in March 1976. A 90mm Schneider Super Angulon lens was used on a 5x7 Gundlach Bundschu view camera with a 4x5 back. Because of color shifts in the original transparency, I converted this to a digital image and made the necessary color balance corrections.

### Middle Sister, party of Mazamas on [T-105609] Page 26

Original is a 2¼ transparency taken August 7, 1955, just as the sun was rising, using an Ansco Panda box camera. At first, for this book, I scheduled a black-and-white print made from a 4x5 black-and-white copy negative (made on Panatomic-X film with a red filter over the enlarging lens) to bring out more detail in the sky and clouds. Over the years I had forgotten the dramatic color lighting in this scene. I digitally restored the colors of the original image to see what it looked like and was surprised by the intensity of the colors. I chose the color for this book. Not surprisingly, the print is not really sharp, but it does show a good sense of composition, which seemed to come to me naturally. This climb, as the text says, was the last one I made with a large organized group.

### Mt. Adams, viewed from the north [5M4909-E] Page 60

Original is a 4x5 Fujichrome Velvia transparency taken July 23, 1997, at sunset, using the 720mm rear element in a Nikkor-T lens on a Gundlach Bundschu 5x7 view camera with a 4x5 back. *Note:* The Nikkor-T is a telephoto lens for large-format cameras with three different rear lens elements that are easily switched, giving 360mm, 500mm, and 720mm focal lengths, all sharp.

### Mt. Alberta viewed from the Mt. Alberta Hut [1M3753] Page 164

Original is a 4x5 Fujichrome Velvia taken at 6:30 a.m. on August 12, 2002. A 150mm Schneider Symmar lens was used on a 4x5 Ikeda field view camera. No filter was employed.

### Mt. Assiniboine [103460] Page xvi

Original is a 4x5 Ektachrome E-3 transparency taken July 15, 1966, at 5:00 p.m., using a 300mm Schneider Symmar lens on a 5x7 Gundlach Bundschu view camera with a 4x5 back. I scanned it into digital form where I made color corrections to restore the beauty of this exciting image.

### Mt. Baker, Coleman Glacier Headwall [3M4222] Page 36

Original is a 4x5 Ektachrome E-3 transparency taken near sunset in the autumn of 1972. A 36-inch Dallmeyer lens was used on an Eastman 8x10 view camera with a supplementary 4x5 back. Over the years this image had faded and undergone a significant color shift, so I converted the image to a digital format. The original colors were restored, color saturation was improved, and the sky darkened a bit, to match my feeling of awe when I viewed this scene those many years ago.

### Mt. Baker, snow patterns on summit [1M4233] Page 145

Original is a 4x5 Ektachrome E-6 transparency taken about forty-five minutes before sunset in June 1979. A 90mm Super Angulon wide-angle lens was probably used. The striking patterns bear some similarity to sand dunes.

### Mt. Deborah, south face [101421-V] Page 9

Original is a 4x5 black-and-white negative, using Tri-X film and a red filter and polarizing filter in combination, taken August 6, 1968, at 10:00 a.m.

Exposure was 1 sec @ f22 using a 36-inch Dallmeyer lens and an Eastman 8x10 view camera with a 4x5 back. Print was cropped vertically from the horizontal negative and was made on Agfa Brovira Grade 5 paper using a condenser head on the enlarger.

### Mt. Garibaldi note [jpeg] Page 179

The original is a 35mm color slide, but this note came to me in the form of a jpeg file. In order to retain detail in both the very dark volcanic soil and white paper, I used curves in the photo program. Because there wasn't much color, I converted the jpeg from color to grayscale. Some of the letters in the note were barely readable, so I used a brush 5 pixels wide, set at 50 percent opacity, to touch them up. The various operations increased the file size, and the final result is easily readable.

### Mt. Hood, Memorial Day on [105204] Page 24

Original is a 2¼ transparency taken with a Voightlander Perkeo camera on May 30, 1957. A 4x5 black-and-white negative was made on Kodalith Pan using a red filter over the enlarging lens. Print was made using a condenser head on the enlarger and Agfa Brovira Grade 6 paper in order to maximize contrast. The choice of copy film made here might be considered extreme (Kodalith Pan is a high-contrast film normally used in graphic arts). I "saw" a final print in my mind that could be achieved only by boosting the contrast greatly in the two steps necessary to make the black-and-white print from the color transparency, which was—in itself—quite flat.

### Mt. Hood from the Hood River Valley [1M5117] Page 25

Original is a 4x5 Ektachrome E-3 transparency using a polarizing filter, taken on October 18, 1972. A 20-inch Bausch & Lomb lens was used on a 5x7 Gundlach Bundschu view camera with a 4x5 back. This was a lovely Indian summer day. The next day a

storm moved in and winter settled in over the Northwest. Because of a significant color shift of this transparency toward magenta due to the passage of time, I converted it to a digital image and easily restored the original rich and brilliant colors.

### Mt. Index, the Three Peaks of [104597] Page 58

Original is an 8x10 black-and-white negative, using Tri-X film and a red filter, taken February 24, 1969, at 2:00 p.m. Exposure was ⅕ sec @ f32 using a 36-inch Dallmeyer lens on an 8x10 Eastman view camera. This is a contact print made on Agfa Brovira Grade 3. Some snow areas were burned in. An 8x10 Ektachrome E-3 exposure, taken at the same time, was used as a wraparound cover on the January 1972 issue of *Audubon Magazine*.

### Mt. Jefferson, summit pyramid of [T-205302] Page 31

The originals are two 2¼ transparencies taken with a Voightlander Perkeo camera on July 8, 1956. The field of view was too wide to encompass the entire summit pyramid in one picture, so I took two photos. Like the avalanche shot, the colors held fast on these two transparencies. I converted the two separate images to digital form, fit them together vertically on the computer screen, cleaned up all the dirt and dust specks with the clone stamp tool, and came up with the composite image seen.

### Mt. Jefferson, wet snow avalanche on [T-205301-B] Page 30

Original is a 2¼ transparency, type unknown, taken with a Voightlander Perkeo camera on July 8, 1956. The colors on the transparency had not shifted significantly, which leads me to believe that the film was not Ektachrome E-3. Of all the pictures in this book, this was the most difficult to work with. It wasn't until early 2006, after I had been working with digital restorations for more than two years, that I managed

to make what I felt was a decent print. The original transparency, taken in bright sunlight, was so overexposed that it didn't look possible to extract any detail in much of the sunlit snow. In addition, there was an area of dark rock in the picture. This reproduction is only a small portion of the original.

I scanned the original at 4,800 dpi in 16-bit. The advantage of 16-bit over 8-bit is that it allows you to greatly expand the contrast range of low-contrast images with a smoother gradation of tones. It also doubles the file size (in this case 280 megabytes). Working with a combination of curves, shadow/highlight filter, brightness/contrast control, and lasso tool, I was finally able to produce the result seen here—detail in both the bright sunlit snow and dark rock. The one disadvantage of expanding the contrast range to this degree is that every defect in this fifty-year-old transparency was magnified many times over, requiring several hours of working with the clone spotting tool to arrive at the final finished image.

### Mt. McKinley and cotton grass [1M1370] Page 40

Original is a 4x5 Ektachrome E-6 transparency taken in July 1977. I was looking for a foreground that was a good representation of this near Arctic wilderness. I found it in this cotton grass, which sometimes grows in large patches and brightens the tundra.

### Mt. McKinley, climbers at 14,000 feet [T-501315] Page 43

Original is a 2¼ transparency taken with a Voightlander Perkeo camera in late June 1958. I made a 4x5 black-and-white copy negative but did not record the type of film used, and I don't recognize the notch code of the film. Print was made on Agfa Brovira Grade 4 paper. There is a nice combination of elements in this picture, leading from the climbers in the foreground to the peak in the distance.

### Mt. McKinley, cloud cap over [101366-E] Page 41

Original is a 5x7 black-and-white negative, using infrared film and a red filter, taken August 4, 1968, about 3:00 p.m. Exposure was ½ sec @ f32 using a 36-inch Dallmeyer lens and an 8x10 Eastman view camera with a 5x7 back. Print was made on Agfa Brovira Grade 6 using a condenser head on the enlarger. The upper part of the print received about twice the exposure of the lower part.

### Mt. McKinley, igloo at 17,100 feet [T-501317] Page 44

Original is a 2¼ transparency taken with a Voightlander Perkeo camera in early July 1958. A 4x5 black-and-white copy negative was made on Panatomic-X film with a red filter over the enlarging lens. Print was made on Agfa Brovira Grade 6 (in order to bring out contrast and details in the snow). A condenser head was used on the enlarger.

### Mt. McKinley igloo camp [T-501313] Page xv

The original of this image is a 2¼ Ektachrome E-3 transparency taken in June 1958, using a Voightlander Perkeo camera. This transparency had large red streaks through it, so I copied this transparency onto Fine Grain Positive film, a blue sensitive only film. This film did not record the red streaks and left me with an image free of streaks on this high contrast film. The corresponding operation in digital photography would be to choose only the image information in the blue channel. A subsequent print made on high contrast paper produced the image seen here.

### Mt. Morrison, storm clearing over [406328] Page 69

Original is a 4x5 black-and-white negative, using Panatomic-X film and a red filter and polarizing filter in combination, taken October 10, 1963, near sunset. Exposure was ⅛ sec @ f13 using a 150mm

Schneider Symmar lens on a 4x5 Speed Graphic camera. Print was made on Agfa Brovira Grade 5 using a cold light head on the enlarger, employing considerable dodging and burning so as not to lose detail in either the sunlit windblown snow or the shaded mountain ramparts.

The night after I took this photo, the weather was so cold that a gallon water bottle inside my car (at the campground at Convict Lake below the peak) froze solid. I would sleep scrunched up in the backseat of one of the many klunkers I drove around in during those early years. That same weekend in October the Mammoth Mountain Ski Area opened for the season, which was an unusually early opening.

### Mt. Morrison, winter sunrise on [3M6397] Page 75

Original is a 4x5 Ektachrome E-6 transparency taken March 7, 1991, at sunrise, using the 720mm rear element in a Nikkor-T lens on a Gundlach Bundschu 5x7 view camera with a 4x5 back. A polarizing filter was used. Setting up the camera on snow-covered ground in very cold weather was neither easy nor pleasant.

### Mt. Olympus, mountain goat, and Blue Glacier [MA-659] Page 16

Original is a 35mm high-speed Ektachrome taken August 1978 with a Pentax ME Super. This was one of those chance shots. I was working with a 4x5 view camera near my camp alongside the upper part of the Blue Glacier on Mt. Olympus when a noise caught my attention, and I saw the mountain goat heading in my direction. I did manage to take two or three exposures with my 35mm camera before the goat saw me and headed back in the opposite direction.

### Mt. Rainier, climbing on the Tahoma Glacier [T-104807] Page 33

Original is a 2¼ Ektachrome E-3 transparency taken

with a Voightlander Perkeo camera on September 2, 1956. Since the original colors had faded badly, I converted the image to the digital format, where the necessary color corrections were made. There were hundreds of green specks on the image, possibly a fungal growth, which required several hours of work with the clone tool.

### Mt. Rainier, guided party on [T-904801] Page 3

Original was a 2¼ transparency, type unknown, taken August 12, 1953, with an Ansco Panda box camera on my first climb of Mt. Rainier. While the colors hadn't faded as badly as some transparencies of this age, this transparency was exceptionally dirty. I scanned it and then spent several hours cleaning it up, mostly with the clone tool, and restored the original colors as well. (I might add that before scanning, I always clean transparency film with PEC-12 archival photographic emulsion cleaner, but it didn't seem to make much difference in this case.)

### Mt. Rainier, ice cliffs on top of Willis Wall [T-904802] Page 103

Original is an Ektachrome E-3 transparency taken June 21, 1962, using a Zeiss Super Ikonta IV camera. This transparency had remained undisturbed and unviewed in my files for almost twenty-five years before I chose this picture for the book in April 2007. (It's amazing what a photographer can discover in old files!) It was even fairly clean for a transparency of its age, most probably because it hadn't been disturbed after I filed it. I scanned the image, corrected the color balance, and produced this awesome and almost terrifying image of the ice cliffs on top of Willis Wall.

### Mt. Rainier, Willis Wall: a kinder, gentler appearance [2M4856] Page 108

Original is a 4x5 Ektachrome E-6 transparency using a polarizing filter, taken in late July 1977. A

5x7 Gundlach Bundschu view camera with a 4x5 back was used. It was probably taken with an f stop of about 45, using the swings and tilts to make sure the flowers in the foreground and the mountain in the background all came to a sharp focus on the film plane.

### Mt. Rainier, Willis Wall, Boulderfield Cliff [704809] Page 107

Two folding 2¼ cameras were taken along on this climb: a Zeiss Super Ikonta IV, loaded with color transparency film, and a Voightlander Perkeo, loaded with black-and-white film. This print was made from one of the black-and-white negatives (this one taken June 21, 1962) that were subsequently lost as explained in chapter 16. Print was made in late 1962 or early 1963, probably on Kodabromide F.

### Mt. Rainier, Willis Wall, the day before the climb [704807] Page 105

Original was taken with a 2¼ Voightlander Perkeo camera, loaded with black-and-white film. This print was made from one of the black-and-white negatives (this one taken June 20, 1962) that were subsequently lost as explained in chapter 16. Print was made in late 1962 or early 1963, probably on Kodabromide F.

### Mt. Robson, climber on cornice [702411] Page 96

Original is a 2¼ transparency taken with a Zeiss Super Ikonta IV on July 30, 1961. The colors of the original Ektachrome E-3 have now shifted significantly to the magenta. In the mid-1960s, I made a copy transparency on 4x5 duplicating film, whose colors are still good.

Also made near that time was a 4x5 black-and-white copy negative from the transparency onto fine grain positive film. This is a blue sensitive only film and seemed to yield even sharper results than the original transparency. This could actually be the case if there were any chromatic aberration present on the original transparency. Print was made on Agfa Brovira Grade 4 using a condenser head on the enlarger.

### Mt. Robson, clouds wreathe [102496] Page 49

Original is an 8x10 black-and-white negative, using Tri-X film and a red filter, taken August 18, 1968, about 10:00 a.m. Exposure was ½ sec @ f38 using a 36-inch Dallmeyer lens on an 8x10 Eastman view camera. Print made from about a 5½x7 section of the negative on Agfa Brovira Grade 6 using a cold light head. Considerable dodging and burning were used in making the print.

### Mt. Robson, north ice face [102489-E] Page 50

Original is an 8x10 black-and-white negative, using a pan film and a red filter, taken July 26, 1966, about 10:30 a.m. Exposure was ⅕ sec @ f13½ using a 20-inch Bausch & Lomb lens on an 8x10 Eastman view camera. Print made from about a 3x4 section of the negative on Agfa Brovira Grade 6 using a condenser head on the enlarger.

A special technique was used on making this enlargement to correct for the great foreshortening effect as seen from Berg Lake, more than 7,500 feet below the summit. *Note:* The foreshortening was too severe for even the swings and tilts of the view camera to compensate for the distortion. In printing, the enlarging lens was tilted in one direction and the easel was tilted in the opposite direction to try to restore the original proportions, with the lower end of the easel receiving more exposure. This is the only picture appearing in the book that has received this treatment.

### Mt. St. Helens, before eruption [1M4903] Page 139

Original is a 4x5 Ektachrome E-3 transparency taken September 1975, using a 150mm Schneider Symmar

lens on a 5x7 Gundlach Bundschu view camera with a 4x5 back. The height of Mt. St. Helens at that time was 9,677 feet (2,950m). Since the colors of the original transparency had shifted to a large degree, I converted this to a digital image and corrected the color, restoring the green to the forests, which had developed a brownish-purple cast.

### Mt. St. Helens, after eruption [1M4948-01] Page 139

Original is a 4x5 Ektachrome E-6 transparency taken on July 20, 1991, using the same lens as above, on a 4x5 Ikeda field view camera. The height of the peak is now 8,365 feet (2,550m). This view was taken within 10 feet of the earlier view.

### Mt. St. Helens, lava dome [1M4934-03] Page 149

Original is a 4x5 Ektachrome E-6 transparency taken July 9, 1990, in the late afternoon. A 90mm Super Angulon lens was used on a 4x5 Ikeda field view camera.

### Mt. St. Helens, mass assault on [T-04901] Page 23

Original is a 2¼ transparency, type unknown, taken with an Ansco Panda box camera on June 12, 1955. This is one of two transparencies reproduced in this book that I chose from my "dead" files: that is, pictures for which I had no use, or for which I expected to never have a use, but that I had nevertheless saved. The color and contrast were poor, so I converted the transparency to the digital format. It took some work to remove all the dust specks and scratches, and to restore the color balance and contrast to what it might have been originally.

### Mt. Shasta, post-sunset [3M6110-01] Page 71

Original is a 4x5 Ektachrome E-6 transparency taken about 10:00 p.m. on June 28, 1995, using a 4x5 Ikeda field view camera. This was a time exposure of perhaps fifteen to thirty seconds.

### Mt. Shuksan, Bob Working on the northwest couloir [T-504102] Page 35

Original is a 2¼ transparency taken with a Voightlander Perkeo camera on July 20, 1957. I scanned the original, which had not faded as badly as many others that old, and digitally made some color corrections to arrive at the image reproduced here.

### Mt. Siyeh, north face [108105] Page 166

Original is a 2¼ transparency taken with a Voightlander Perkeo camera in August 1957. A 4x5 black-and-white copy negative was made on Panatomic-X film. For some reason I never recorded the details about making the print. This stunning viewpoint is definitely on my list of places to revisit sometime.

### Mt. Stuart, clouds over [304638] Page 14

Original is a 4x5 black-and-white negative, using Plus-X film and a red filter, taken July 6, 1969, at 12:30 p.m. Exposure was ½ sec @ f27 using a 150mm Schneider Symmar lens on a 5x7 Gundlach Bundschu view camera with a 4x5 back. Print was made on Agfa Brovira Grade 4 using a condenser head on the enlarger. The clouds were burned in. I climbed some smaller peak (whose name escapes me) near Mt. Stuart to obtain this view.

### Mt. Thielsen, sunrise on [1M5520] Page 19

Original is a 4x5 Ektachrome E-6 transparency taken at sunrise on July 12, 1991, using a 4x5 Ikeda field view camera. I hiked to the "back" side of the mountain as seen from Diamond Lake and searched out and spent the night on top of a nearby ridge to capture this image.

### Mt. Torment–Forbidden Peak ridge [504407] Page 47

Original is a 2¼ color transparency taken on August 4, 1958, from Sahale Peak, several days after Walt Sellers and I completed the first Torment-Forbidden

traverse. The details of the print together with the black-and-white copy negative have been lost. Due to light snowfall the previous winter and unbelievably good summer weather, the area appeared more the way it might look in late September or early October before any new snowfall.

### Mt. Victoria, avalanche on [1M3545-01] Page 15

Original is a 4x5 transparency taken October 3, 1992, on Ektachrome E-6 film using a 4x5 Ikeda field view camera. When I started out in the morning from the parking area at Lake Louise, the weather was clear. By the time I reached this viewpoint, the sky had mostly clouded over, with the sun making brief appearances between passing clouds. My hope was to get a good avalanche picture, but it is a very iffy thing. You can wait hours without a single large chunk of ice breaking off (although you can hear the sound of falling rock pretty frequently).

When what I was waiting for actually occurred (after about half an hour), I had to rush the shot because the action happened so fast. Because of constantly changing lighting, I didn't have time to set a proper exposure and just quickly set the shutter at $\frac{1}{100}$ of a second and guessed at the f stop. The resulting exposure, though dramatic, was too dark. It was not until I had been working in the digital darkroom for more than two years that I was able to extract all the beauty and drama of the original scene.

### Mt. Washington, lenticular cloud cap over [135765] Page 125

Original is a 5x7 black-and-white negative, using infrared film with a red filter and polarizing filter in combination, taken June 4, 1966, at 10:00 a.m. Exposure was 2 sec @ f16 using a 300mm Schneider Symmar lens on a 5x7 Gundlach Bundschu view camera. Print was made on Agfa Brovira Grade 6

using a cold light head on the enlarger. It was difficult to find a representation of Mt. Washington that matched its aura (which is out of proportion to its deceptively modest size), but I feel that this image succeeded.

### Mt. Whitney, east face [2M6420] Frontispiece

Original is a 4x5 Ektachrome E-6 transparency taken July 12, 1982. A 150mm Schneider Symmar lens was used on a 5x7 Gundlach Bundschu view camera with a 4x5 back. My choice of camp spot in this wilderness canyon was dictated by discovering where I would be in a good position for the first light on the face without having to move or unpack any equipment.

### Mt. Williamson, winter winds over [2M6474] Page 76

Original is a 4x5 Ektachrome E-6 transparency taken March 11, 1991, at sunrise, using the 720mm rear element in a Nikkor-T lens on a 5x7 Gundlach Bundschu view camera with a 4x5 back. *Note:* The Nikkor-T is a telephoto lens for large-format cameras with three different rear lens elements that are easily switched, giving 360mm, 500mm, and 720mm focal lengths, all of them sharp.

### New York City "Range" [131X04] Page 119

Original is a 2¼ black-and-white negative taken with a Zeiss Super Ikonta IV camera sometime in 1964 or 1965. The original very powerful print was made on Agfa Brovira Grade 6 using a cold light head on the enlarger. Working from the original negative, I remade the print digitally, lowering the contrast slightly to show more detail in the shaded areas. This latter image is the one reproduced in this book.

### North Cascade panorama, before and after color correction applied [1M4336] Page 137

Original is a 4x5 Ektachrome E-3 transparency using

a polarizing filter, taken in July 1972. A 5x7 Gund-lach Bundschu view camera, utilizing a 4x5 back, was used. The transparency was scanned at 2,400 dpi. Once in digital form, the color correction was applied. The final digital image size was about 300 megabytes.

### North Palisade, sunrise on [2M6451] Page 73

Original is a 4x5 Ektachrome E-6 transparency taken July 16, 1982. A 20-inch Bausch & Lomb lens was used on a 5x7 Gundlach Bundschu view camera with a 4x5 back.

To take this picture, I bivouacked on the moraine at the end of the Palisade Glacier. To save weight, I didn't carry a sleeping bag, though I did have a warm down parka, and huddled inside a one-man bivouac sack to conserve warmth. Despite the fact that it was the middle of July, it was much cooler than I had anticipated, with a cool wind blowing off the glacier all night, and I felt very stiff and awkward the next morning. However, the moment the first rays of the sun struck the North Palisade, all was forgiven, and the discomfort of the night only served to accent this primal scene.

### The North Twin, north face of [1M3752] Page 163

Original is a 4x5 Fujichrome Velvia transparency using a polarizing filter, taken August 12, 2002, at noon. A 400mm Chromar-T lens was used on a 4x5 Ikeda field view camera. I took this view from the glacier right below Mt. Woolley. Reaching this point is a bit of a haul and involves fording the Sunwapta River, which can be difficult or impossible at times.

### Northern Pickets, climbers in [M-04294] Page 157

The original is a 35mm Ektachrome transparency taken on July 25, 2001, using a Pentax ME Super camera and a polarizing filter over the standard 50mm lens. I carried two Pentax cameras on this trip, one loaded with color transparency film, the other loaded with T-Max 100 black-and-white film. This shot was posed, but despite this it still came out quite nicely. Jim Nelson alerted me to this view-point; he had been in the same area a number of years before and remembered this particular spot.

### Nude hippies at Ocean Beach, 1967 [706X03] Page 134

Original is a 2¼ black-and-white negative taken in "The Summer of Love" in 1967, when newspapers around the country were sensationalizing the new hippie culture. A Zeiss Super Ikonta IV camera was used. I had never printed this negative and didn't even remember that I had it. I "discovered" it when I went through my files looking for a picture to illustrate the hippie era. I scanned the negative, from which the reproduction seen here was made.

### Olympic Mountains, "deer in love," Hurricane Ridge [MA-181] Page 16

Original is a 35mm high-speed Ektachrome taken in August 1977 with a Pentax ME Super using an 80-200mm zoom lens.

### The Painted Wall, Black Canyon of the Gunnison [210365] Page 169

Original is a 5x7 black-and-white negative, using Tri-X film and a polarizing filter, taken October 14, 1970, at 2:30 p.m. A 150mm Schneider Symmar lens was used on a 5x7 Gundlach Bundschu view camera. Print was made on Agfa Brovira Grade 6 using a cold light head on the enlarger.

### The Palisades seen from Sierra Point, White Mountains [2M6457-A] Page 74

Original is a 4x5 Ektachrome E-6 transparency taken on February 28, 1987. Sierra Point is not normally reachable by road in the winter, as it is not plowed or maintained and is about 9,000 feet in elevation. Only a very low snow year (the first in a

series of drought years) enabled me to get this far by vehicle. The cold was bitter, and it took great willpower to crawl out of a warm sleeping bag and venture into an arctic wind to take a number of sunrise and early-morning exposures.

### Photo gear taken on four-day backpack [MXX-128] Page 155

Original is a 35mm Kodachrome transparency taken on my spare Pentax Super ME with a 50mm lens on August 4, 1990. Once I had laid out all the equipment on the card table, I used a stepladder to climb to a vantage point where I could take a picture of all the photographic gear. On some backpacks I have carried both 35mm cameras (in addition to the 4x5 gear), one 35mm loaded with a slow fine-grained color transparency film, and the other loaded with a faster transparency color film for quick-action photography.

### Photographer/author on first hike, at age 3½ [no number] Page 5

Original is a black-and-white negative of a strange size, 2¼ by 4¼ inches, taken in August 1940. I think the photo was taken with a folding camera of the sort that was popular in that era. Sometime in the late 1990s, while looking through some old family photo albums, I saw an original black-and-white print, which had writing in ink on its face. I found the negative for it in the summer of 2002, while looking through an old box of family memorabilia saved for me by my mother years before.

I scanned the negative and, working with the image on screen, removed scratches and dust specks. Applying select contrast and lightness/darkness controls to various parts of the image, I produced this print from the full original negative.

### Photographer/author at age eleven in school uniform [no number] Page 7

Original is a 2¼x3¼-inch black-and-white negative

taken in the spring or autumn of 1948, probably by my father. Like the picture of me at 3½ years old, I didn't see it until the late 1990s, and found the negative for it in the summer of 2002.

In the early stages of this book, before I had mastered digital technology, I had a 5x7 print of this made at a custom lab. The print, while sharp, didn't differentiate well between the dark uniform and the background. Further, parts of the cathedral in the background were either too light or too dark and distracted from the overall appearance of the photograph. Working from this print, I later produced a digital image. Using the tools available to me in the digital format, I corrected all the deficiencies listed above and produced this much-improved, well-balanced photograph.

### Photographer/author, with special telephoto setup [T-406405-A] Page 127

Original is a 2¼ transparency taken with a Zeiss Super Ikonta IV camera on September 18, 1970, by my wife, Debby. This particular location was near or at Sierra Point in the White Mountains of California, from where there are great views looking toward the Sierra Nevada.

### Photographer/author, with 4x5 gear on top of Lynx mountain [1002402] Page 98

Original was a black-and-white negative taken in July 1962. The details of the negative and print have been lost (see chapter 16), but this may have been taken with a 2¼x3¼-inch folding camera that I had bought around this time. This camera had bad light leaks; I used it rarely and never after 1966. The only black-and-white print had very noticeable light leaks that made vertical streaks on the sky. I scanned the print and converted it to the digital format, where I was able to minimize the effects of the light leaks. Further, I brought out details in the 4x5 press cam-

era that were barely discernible in the original black-and-white print.

### Photographer's portable home [no number] Page 83

This black-and-white photograph was taken sometime in the period of 1960–62. I only had one picture of this, a 3x3 print. The original negative was lost in a fire, as explained elsewhere in this book. The reproduction seen here is a cropped portion of that print.

### Pigeon Spire, Bugaboos [102760] Page 121

Original is a 5x7 black-and-white negative using Panatomic-X film, taken August 16, 1964, at 2:15 p.m. A 20-inch Bausch & Lomb lens was used on a 5x7 Gundlach Bundschu view camera. Print was made on Kodabromide F Grade 4 using a cold light head.

### Pigeon Spire, Layton Kor on east face, Bugaboos [202705] Page 65

Original was a 2¼ black-and-white taken with a Voightlander Perkeo camera in August 1960. The negative was lost in a fire as explained in chapter 16, but I had made an 8x10 print, probably on Kodak polycontrast paper, and several 5x7 prints. These were some of my earlier darkroom prints; their contrast was poor and they had a lot of dust specks. I scanned the 8x10 print and produced a digital image. Working with this image on screen, I removed all the dust specks and improved the overall appearance of the image. Even with very careful work, I could only bring out minimal detail in Layton Kor's face because it was so dark.

Subsequently, in September 2005, I discovered in my old files a contact positive film made from the original negative (for the purpose of slide viewing). It was made on Kodak fine grain positive, a virtually grainless blue sensitive only film. I recovered good detail from Layton Kor's face from a scan of this image and imported it into the existing scan of the black-and-white print. The picture now shows the detail that would have been available from the original negative.

### Prusik Peak, south face [204636] Page 12

Original is a 4x5 black-and-white negative, using Plus-X film with polarizing and red filters in combination, taken October 4, 1969, at 10:15 a.m. Exposure was ⅛ sec @ f18 using a 300mm Schneider Symmar lens on a 5x7 Gundlach Bundschu view camera with a 4x5 back. Print was made on Agfa Brovira Grade 3 using a condenser head on the enlarger. The lower part of the print was burned in to balance the light in the final print.

### Pyramid Peak seen from near Aspen [210418] Page 175

Original is a 4x5 Ektachrome E-3 transparency using a polarizing filter, taken September 26, 1970, at 7:30 a.m. A 36-inch Dallmeyer lens was used on an 8x10 Eastman view camera with a 4x5 back. This reproduction is a cropped portion of the original transparency. Because the photo had undergone an unpleasant color shift over the years, I converted it to a digital image, where I made the necessary color corrections.

### The Ramparts seen from the meadows above Amethyst Lake [1M3859-01] Page 162

Original is a 4x5 Fujichrome Velvia transparency using a polarizing filter, taken August 8, 2002, in mid-morning. A 90mm Schneider Super Angulon lens was used on a 4x5 Ikeda field view camera.

### Rock Creek Canyon, sunset on peak [506320] Page 70

Original is a 4x5 black-and-white negative, using Panatomic-X film and a red filter and polarizing filter in combination, taken October 8, 1963. Exposure

was 1 sec @ f20 using a 150mm Schneider Symmar lens on a 4x5 Speed Graphic camera. Print was made from about a 2x2½-inch section of the negative on Agfa Brovira Grade 5 paper using a condenser head on the enlarger.

This was one of the lesser peaks near the head of the canyon, but I immediately noticed this striking lighting and used the filters to focus attention on the form of the rock. Through the years, this representation has continued to speak to me and, to this day, remains one of my very favorite images.

### Rowell, Galen [T-406701-B] Page 126

Original is a 2¼ Ektachrome E-3 transparency taken in the spring of 1963 with a Zeiss Super Ikonta IV camera. Because of color shifts, this photo was converted to a digital image, where I applied the necessary color corrections.

### San Francisco, "The Summer of Love" in [206X07] Page 134

Original is a 2¼ black-and-white negative taken in "The Summer of Love" 1967, when newspapers around the country were sensationalizing the new hippie culture. A Zeiss Super Ikonta IV camera was used. I had never printed this negative and didn't even remember that I had it. I "discovered" it when I went through my files looking for a picture to illustrate the hippie era. I scanned the negative, from which the reproduction seen here was made.

### The Sawtooth Range and the town of Stanley [207355] Page 172

Original is a 4x5 Ektachrome E-6 transparency using a polarizing filter, taken in August 1985, near sunset. A 4x5 Ikeda field view camera was used. This view was taken from a small hill near Stanley that can be reached either by foot or by vehicle.

### Sentinel Rock seen from Union Point [306758] Page 79

Original is a 5x7 Ektachrome E-3 transparency taken May 13, 1967. A 90mm Schneider Super Angulon lens was used on a 5x7 Gundlach Bundschu view camera. Originally I had scheduled this photo to be reproduced in this book as a black-and-white, the print being made from a Plus-X black-and-white negative taken at the same time. The original 5x7 transparency had shifted colors to such a degree (everything looked brown) that reproducing it in color seemed like a hopeless task. Nevertheless, with some digital darkroom magic, I was able to restore the original colors.

This amount of snow is very unusual for the date and resulted from one of the heaviest April snowfalls ever seen in the Sierra Nevada. I found myself wading hip-deep in loose, unconsolidated snow as I neared Union Point, having approached via the Four Mile Trail from the base of Sentinel Rock. The shorter approach from above, starting from the Glacier Point Road, could not be used because the road had not yet been opened for the summer.

### Shiprock, New Mexico [214154] Page 53

Original is a 5x7 black-and-white negative, using Tri-X film and a red filter, taken October 16, 1970, at 6:00 p.m. Exposure was ⅕ sec @ f16 using a 36-inch Dallmeyer lens on an 8x10 Eastman view camera with a 5x7 back. Print was made on Agfa Brovira Grade 6 using a cold light head on the enlarger. Shiprock presents excellent views from almost every angle, and one could spend several days there doing nothing but searching for different and unique views of this rock.

### Snoqualmie Pass, Photographer's car at, March 1957 [T-104701] Page 37

Original is a 2¼ Ektachrome E-3 transparency taken

with a Voightlander Perkeo camera. I scanned the transparency, cleaned up the image with the clone tool, and restored the original colors from the faded transparency. It makes a great illustration of the move from the east coast to west coast, when I left in one snowstorm and arrived in another. This image is yet another example of digging deep in my files and finding images undisturbed for many years, in this case fifty years, to illustrate the text in this book.

### South Sister, view from top [1M5451] Page 27

Original is a 4x5 Ektachrome E-6 transparency using a polarizing filter, taken on July 27, 1991, near sunset. A Topcor 210mm lens was used on a 4x5 Ikeda field view camera. The night spent on top of the South Sister was one of the "toppings" referred to in chapter 18.

### Southern Picket Range, northern cirque wall [4M4233] Page 93

This viewpoint is definitely off the beaten path and will not be reached except by the most determined photographer. Original is a 4x5 Ektachrome E-6 transparency using a polarizing filter, taken July 17, 1990. A 4x5 Ikeda field view camera was used.

### Split Mountain, southern Sierra Nevada seen from [4MM6437] Page 77

Original is a 35mm Ektachrome transparency taken on a Pentax Super ME camera using a polarizing filter, taken August 1, 1989, about an hour after sunrise. In order to arrive at the top of the peak at sunrise, I left a campsite—at an altitude of about 11,600 feet—at 1:00 a.m. It seemed like an intrusion into the environment to use a flashlight, and I turned it off shortly after leaving camp. As I stumbled along in almost total darkness (there was no moon), my eyes slowly grew accustomed to the starlight, and I felt a great peace descend upon me. With almost my total consciousness concentrated within, I felt at one not only with the mountain but

also with the universe. I arrived at the summit just at sunrise, and for the three hours I spent there, there was nowhere else on earth that I wanted to be.

### Squaretop Mountain [1M9418] Page 174

Original is a 4x5 Ektachrome E-6 transparency taken in August 1985, using a 4x5 Ikeda field view camera. I hiked up a rise between Upper and Lower Green River Lakes to obtain this image. The photographer/author, together with Ron Niccoli, had climbed a new route on the face of Squaretop in 1960.

### The Teton Range seen from the Snake River overlook [309217] Page 167

Original is a 4x5 black-and-white negative, using infrared film and a red filter and polarizing filter in combination, taken August 6, 1963. Exposure was 1 sec @ f32 using a 150mm Schneider Symmar lens on a 4x5 Speed Graphic camera. Print was made on Agfa Brovira Grade 3 using a condenser head on the enlarger. In recent years this viewpoint has become crowded with not only tourists but also photographers trying to capture this scene. A would-be photographer may now have to jockey for space to set up equipment.

### The Teton Range seen from Snake River overlook #2 [309215] Page 167

Original is a 4x5 black-and-white negative, using Panatomic-X film and no filter, taken August 6, 1963. Exposure was 1/25 sec @ f32 using a 150mm Schneider Symmar lens on a 4x5 Speed Graphic camera. Print was made on Kodak Kodabromide F5. I gave the mountains about twice the exposure of the rest of the print.

### Three Fingered Jack Mountain [1M5321] Page 18

Original is a 4x5 Ektachrome E-6 transparency taken with a 4x5 Ikeda field view camera on July 16, 1991. At first I thought of trying to take the picture

without showing my shadow, but after studying it for a moment, I realized that the shadow added an important element to the overall effectiveness of the scene. I used one of my wide-angle lenses, probably the 90mm Schneider Super Angulon.

### The Titan, moonrise over [612751] Page 124

Original is a 5x7 black-and-white negative, using Contrast Process Pan film and a red filter, taken October 12, 1970, at 6:00 p.m. Exposure was ⅒ sec @ f20 using a 36-inch Dallmeyer lens on an 8x10 Eastman view camera with a 5x7 back. Print was made on Agfa Brovira Grade 4 using a cold light head on the enlarger.

Contrast Process Pan film is not normally used as a camera film, being of very high contrast. I chose it in this case because of the fact that the lighting at sunset (in the direction opposite from the sun) is very flat and needs a boost in contrast that is not afforded by regular film. The only problem with such a film is that it magnifies many times over the effect of dust and lint that may have been on the surface of the film when the picture was taken. Considerable spotting was required on the final print.

It is a frequent practice among poster and postcard producers to add a moon to the picture. These fake moons can usually be recognized because the rest of the scene is cross-lighted, which is never the case with a full moon. The moon here is real and not quite full, allowing a few shadows to form on the vertical rock.

### Towers of the Virgin, Zion National Park [212476] Page 123

Original is an 8x10 black-and-white negative, using Tri-X film and a red filter, taken March 13, 1968, at 11:45 a.m. Exposure was ⅒ sec @ f30 using a 20-inch Bausch & Lomb lens on an Eastman 8x10 view cam-

era. This was a contact print made on Agfa Brovira Grade 6, using the illumination of a 7½ watt bulb.

### Trigger Finger, Peshastin Pinnacles, before fall [1M4647] Page 140

Original is a 4x5 Ektachrome E-3 transparency taken in May 1976. A 150mm Schneider Symmar lens was used on a 5x7 Gundlach Bundschu view camera with a 4x5 back. Because of a color shift in the original transparency, it was converted to a digital image, where the necessary color corrections were applied.

### Trigger Finger, after fall [1M4660] Page 140

In order to find exactly the same spot from which I had taken the original shot, I took one of the original transparencies with me when I hiked up into the Peshastin Pinnacles on July 16, 2001. It took me a while to locate the spot, and when I did, I matched the original transparency to the view on the ground glass on the back of the Ikeda 4x5 field view camera that I had set up. I used the same lens as was originally used (150mm Schneider Symmar), so I obtained a faithful approximation of the original view to within a few feet. The transparency film used was Fujichrome Velvia.

### Trigger Finger, the shape that gave it its name [T-04601] Page 141

Original is a 2¼ Ektachrome E-3 transparency taken with a Voightlander Perkeo camera on April 27, 1958. This is one of two transparencies reproduced in this book that I chose from my "dead" files: that is, pictures for which I had no use, or for which I expected not to have any use, but that I had nevertheless saved. Since the color was poor, I converted the transparency to the digital format, where—with a little work—I was able to make a reasonably decent image out of it.

### Tuolumne Meadows, thunderhead over [606577] Page 131

Original is an 8x10 black-and-white negative, using infrared film and a red filter, taken June 17, 1967. A 300mm Schneider Symmar lens was used on an 8x10 Eastman view camera. This is a contact print made on Agfa Brovira Grade 6, using a condenser head on the enlarger as the light source. I saw this thunderhead developing in the afternoon and quickly set up my camera so that when the cloud was about the right size, and in the right position, I was able to capture this image.

### Volcán Poás, main crater, Costa Rica [1M51120] Page 161

Original is a 35mm Fujichrome transparency taken on a Pentax Super ME on February 8, 2002. A 28mm wide-angle lens was used. My wife and I visited this volcano on my sixty-fifth birthday and, given the prevailing cloudiness that day, felt fortunate to see it on our only visit to the area. There is a fascination in looking at a primitive scene such as this, keeping in mind that volcanoes have reshaped much of the surface of the earth over the eons and will continue to do so in the future.

### Wheeler Peak, Nevada [311364] Page 150

Original is a 4x5 Ektachrome E-6 transparency taken in July 1981. This basin that contains the rock glacier also contains ancient bristlecone pine trees. I found myself stopping every 100 yards or less to take another picture with the view camera. Since each stop can be up to half an hour or more, progress can be very slow indeed! I found it very difficult trying to decide which image of Wheeler Peak to include here.

### White Mountains, bristlecone pine wood frames Mt. Humphreys [1N6953] Page 81

Original is a 4x5 Fujichrome Velvia transparency taken June 23, 1997. A 4x5 Ikeda field view camera was used. The road through the ancient bristlecone pine area is filled with so many spectacular views of both the trees and the mountains in the distance that it is very difficult for a photographer to make much progress. There is always another stunning view around the next bend in the road.

### Yosemite Valley, storm clearing over [2M6633-02] Page 78

Original is a 4x5 Ektachrome E-6 transparency taken May 11, 1989, shortly after sunrise, using a 4x5 Ikeda field view camera. I got caught up in the moment and probably took twenty or more color exposures here, unmindful of the dollar signs ringing up each time I clicked the shutter. After an all-too-brief interlude of sunshine, the clouds closed in again, and it rained the rest of the day.

# INDEX

*Outfit Your Mind*

---

FALCON.COM